TREASURES

of the Natural History Museum

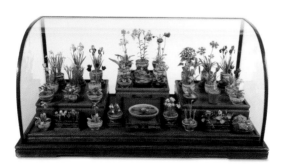

Published by the Natural History Museum, London

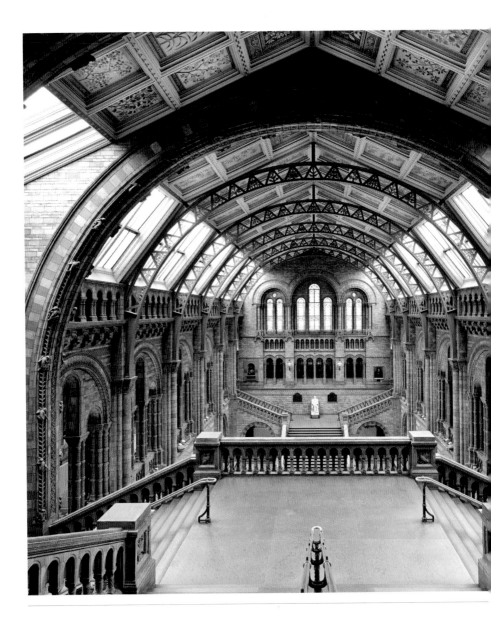

CONTENTS

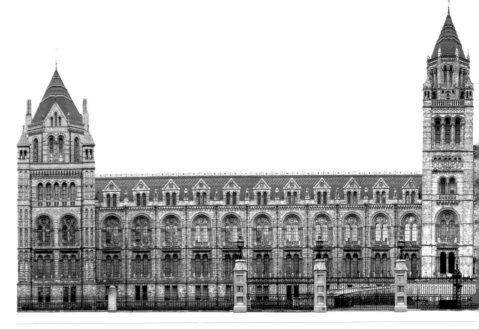

INTRODUCTION

We have been on our site in South Kensington for over 135 years and we are
home to one of the largest and most important natural history collections in
the world – with more than 80 million specimens, over one million books and
half a million artworks. *Treasures of the Natural History Museum* is a celebration
of some of these exceptional natural history objects including world-famous
specimens and little known curiosities, together with a selection of architectural
treasures of the glorious building itself. The treasures are selected both from
objects on display and those stored behind the scenes; some are familiar and
some never seen by the public before. They have all been chosen for a variety
of reasons – scientific importance, striking beauty or sometimes simply because
they have an interesting story to tell. Through talking with both the scientists
and curators who know the collections so well and with the public-facing staff,
we have brought together this eclectic selection of treasures in celebration
of the wonders of the natural world. Discover a tiny snail no bigger than a
letter on this page and one of the first signs of life on Earth in the form of a
3.5 billion-year-old fossil. *Treasures of the Natural History Museum* is a celebration
of the best of the Museum, including the rare, the beautiful and the unusual.

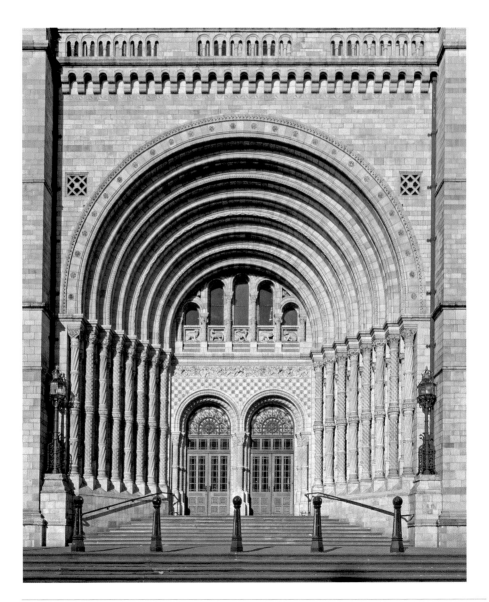

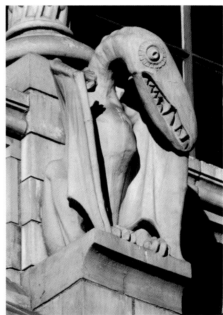

THE BUILDING

The Museum's gothic towers, grand arches and spectacular exterior have led many to wonder if it was originally a cathedral. But it was built as a natural history museum, in the words of its first director Richard Owen, 'a cathedral to nature', to display all of 'God's creations'.

Owen campaigned for 25 years to rescue the overcrowded and deteriorating natural history collections at the British Museum, which he became Superintendent of in 1856. His dream was to create a new museum, where everyone could see and enjoy the diversity of life on Earth in suitably magnificent surroundings. And while his initial plans were deemed by some to be 'foolish, crazy and extravagant', Parliament approved the purchase of 12 acres in South Kensington in 1863.

Owen worked with rising young architect Alfred Waterhouse to create the gothic masterpiece. Using modern techniques of an iron and steel frame and a terracotta facade, and inspired by German Romanesque architecture, the building gradually took shape. It was adorned with all sorts of creatures and plants – monkeys grip the soaring arches, birds perch on the columns, fish swim among seaweed on the walls. More than 17,500 visited on the day it opened, Easter Monday, 1881.

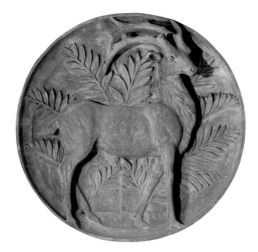

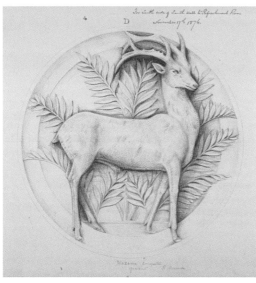

THE ENGRAVINGS

These delicate, detailed and beautiful drawings of a Pampas deer (*Ozotoceros bezoarcticus*) (bottom left) and a dodo (opposite bottom) are the originals created by Alfred Waterhouse, the architect of the Natural History Museum's world-famous building. They were used to create the wonderful terracotta motifs of animals and plants that decorate the building's sculptured columns and arches, both inside and out. His designs were unveiled to huge acclaim when the Museum opened its doors for the first time in 1881.

The Natural History Museum was the first building in England to have a terracotta front. It is a cheap and durable material, favoured by craftsmen and designers for its ability to produce accurate shapes from moulds, true to the artist's work. Waterhouse produced the fine drawings from actual specimens, then passed the drawings on to modellers Farmer & Brindley to bring to life in terracotta. The terracotta motifs were divided into two main classes, with the living ones being used to decorate the west half of the building and the extinct ones used to decorate the east.

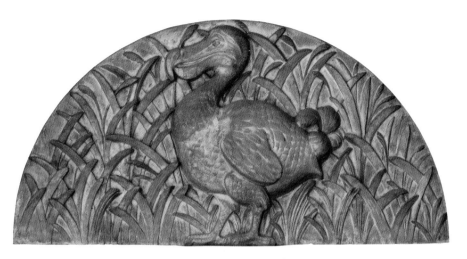

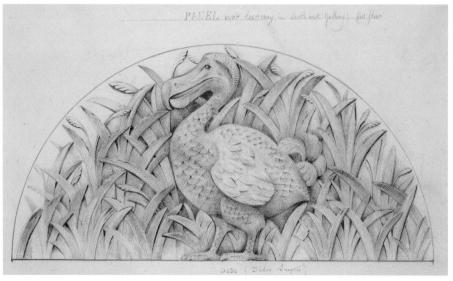

PANEL over doorway in south east Gallery first floor

DODO (Didus ineptus)

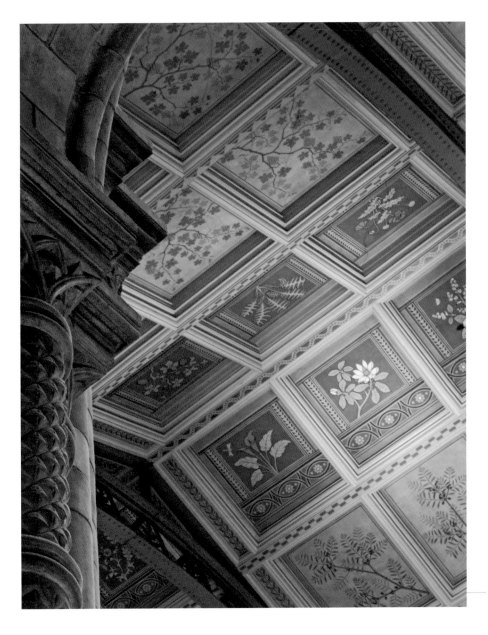

THE PAINTED CEILING PANELS

Soaring high above visitors to the
Museum is a wonderful garden of plants,
162 painted ceiling panels that have been
there ever since the Museum first opened
in 1881. Each of these panels tells a story
– of plants that have made and broken
empires, of plants that have been the
cause of terrible human suffering, or of
plants that have brought joy through
their beauty.

The plants depicted are a mix of
native species and those from far-away
colonies. There are no records of
precisely why or when Richard Owen
and Alfred Waterhouse chose these
particular ones, but we do know they
were painted straight on to the ceiling
plaster, the artists presumably lying down
on scaffolding and painting above their
heads. Each plant twists and turns over
six panels, giving the ceiling a wonderful
sense of growth and movement.

Over the years the colours inevitably
faded and cracks appeared. In 1975, the
ceiling was covered for one year while it
was restored to its current stunning
condition, reinstating the rich colours
and gilding of the original paintings.

GOSSYPIVM·BARBADENSE

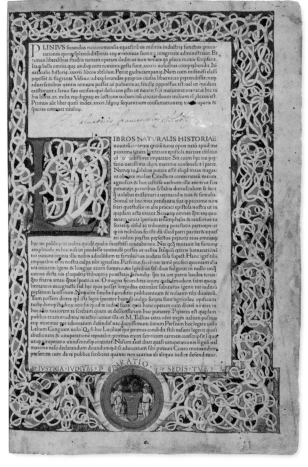

OLDEST BOOK

Naturalis Historia is the oldest book in the Museum's collections. It is by the Roman natural philosopher and author Pliny the Elder. He compiled the book in AD 69, but this is one of the first printed versions to be made, and was produced in Venice in 1469, less than 30 years after the invention of the printing press. It was the first publication to cover all areas of natural history: zoology, botany, geography, human physiology, metallurgy and mineralogy. It contains extracts from a vast number of earlier works and, at the time it was first compiled, it was the single most important source of natural history information and remained so until the Renaissance, some 1,300 years later. The book also became a model for all later encyclopedias in terms of the breadth of subject matter examined.

As well as being a valuable record of the customs and beliefs of past cultures, *Naturalis Historia* is a work of art in its own right. Some of the 355 pages of Latin letters in this edition have been decorated in gold leaf or painted, a beautiful addition to an already valuable work.

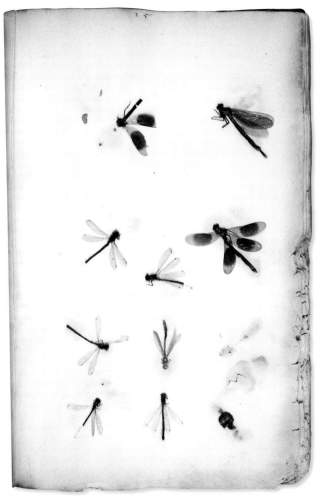

THE PLUKENET COLLECTION

Older than any other collection, what makes these 1,700 insects particularly special is the careful way they have been flattened and glued to each page of a book, like beautiful pressed flowers. It's no surprise they were mounted by a botanist, Leonard Plukenet (1642–1706), in around 1690. The collection caught the eye of Hans Sloane, a noted collector at the time, who bought the book. When Sloane died, his vast collection founded the British Museum, from which the Natural History Museum later budded, hence this book's place in the collection today.

It's easy to look at treasures such as this and imagine the person who compiled it was well known, but very little has been written about Plukenet. We know he was a contemporary of Sloane's and that he had a small botanical garden in Westminster, central London. We also know he hoped the garden would one day contain all the plants of the world, and by the time he died 8,000 grew there. Plukenet also became the superintendent for the royal gardens at Hampton Court.

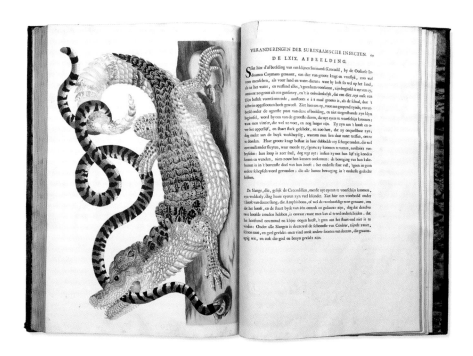

VERANDERINGEN DER SURINAAMSCHE INSECTEN. 69
DE LXIX. AFBEELDING.

[Dutch text in two paragraphs describing the illustration, partially legible]

Maria Sibylla Merian in Surinam

The vibrant paintings in artist and naturalist Maria Sibylla Merian's book *Metamorphosis Insectorum Surinamensium* reveal a woman before her time. It was first published in 1705, and each of the 60 half-metre-tall pages brought South America's butterflies, plants and other wildlife to an impressed audience in Europe.

The book focuses on Merian's fascination with metamorphosis, and her input to the mysterious subject, so widely researched now, was huge. That Merian spent two years in South America at the age of 52, far from her home in Amsterdam, was radical. Being a Calvinist, a Protestant movement that encouraged equality and education among women, allowed her to take charge of her life, divorce her husband and travel with her daughter to a Calvinist mission in Surinam, near Venezuela in northern South America. Using the mission as her base, she observed not just local wildlife, but also the cultural aspects of this small country.

Enslaved Africans and indigenous Americans sometimes helped her, leading her, for example, to become the first European to record the plant *Caesalpinia pulcherrima*, parts of which were used by the enslaved women to induce abortion.

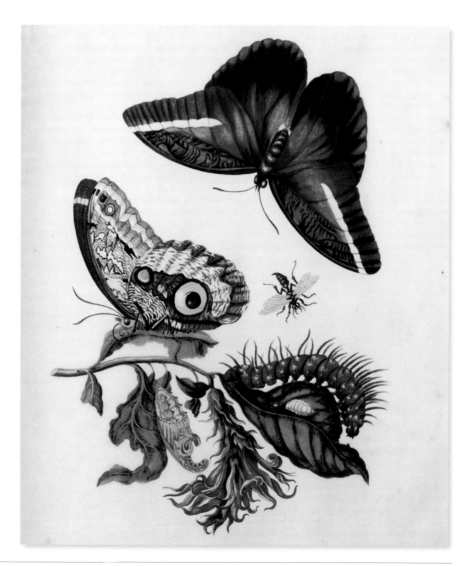

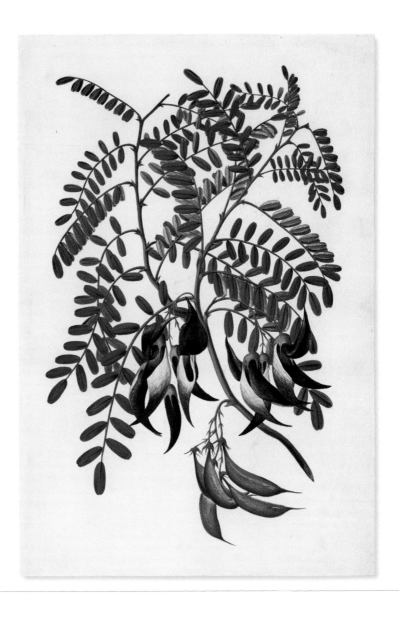

Parrot's Bill Plant

This magnificent watercolour of the plant, parrot's bill (*Clianthus puniceus*) was made on one of the most famous voyages of all, the *Endeavour* (1768–1771). It was painted by the young and talented artist Sydney Parkinson, appointed natural history artist for the voyage by Sir Joseph Banks, a great benefactor of scientific discovery. It is paintings such as this that showed Western eyes what lay beyond their shores before the invention of photography. The *Endeavour* set sail from England, captained by the English explorer and navigator Captain Cook, to record the transit of Venus across the face of the sun, in Tahiti. But at the last minute Banks and his team of scientists, artists, servants and two dogs, boarded to realise another, secret, mission: to investigate rumours of a huge land mass known as Terra Australis Incognita. They were away for three years, during which they confirmed New Zealand was not joined to Australia and also mapped the entire east coast of Australia. It was hard work for Parkinson and sadly he never made it home, dying of dysentery and fever on the return journey, aged 26.

Georg Ehret

This artwork is a powerful insight to the greatest and most prolific botanical artist of the 1700s. Georg Ehret's finished watercolours are without doubt magnificent, but his sketches reveal the artist behind them. They show the time he took to understand a subject before trying to depict it on paper, his notes and thoughts, scrutinising not just the adult plant but the seeds and flowers. Ehret (1708–1770) was a lover of plants first, and an artist second.

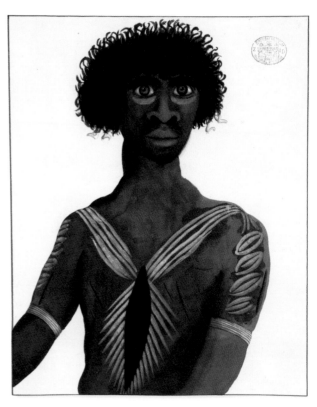

AUSTRALIAN ABORIGINE

This is one of the first paintings of an Australian aborigine by a European, the convict Thomas Watling (1762–1814). Watling was one of hundreds of convicts sent to Australia from the UK, but as well as being an accomplished forger, producing counterfeit banknotes, Watling was a trained artist. This painting is of a man called Balloderree, and shows Watling's particular style and flair.

This and other paintings depict aboriginal people in a very positive light, reflecting the good relations between settlers and indigenous people during their first encounters. The first convicts left the UK on 13 May 1787. They travelled on 11 ships, known as the First Fleet, to establish a settlement in New South Wales, Australia. Convicts and sailors produced hundreds of artworks

of the animals and plants they saw in the new colony, 629 of which are kept at the Museum, collectively known as the First Fleet Collections. These are of huge historical importance and include drawings of people, plants, insects, birds and other animals. Watling signed 121 of them, and the rest are by George Raper and an unnamed artist known as the Port Jackson Painter.

CAPTAIN COOK'S *RESOLUTION*

This is the first ever record of
Antarctica's penguins, painted on the
legendary *Resolution* voyage by 18-year-old
artist Georg Forster. It was Forster's task
to record every plant and animal
encountered as they sailed around the
unknown territories of the South Pacific,
while also being an assistant to his father,
the naturalist on board. Many of the
plants and animals painted by Forster
were unknown to science and his
paintings are now among some of the
most studied collections in the Museum,
of immense value to scientists, artists
and cultural historians. This was the
second of Captain Cook's three epic
journeys and, with no maps to refer to, it
was potentially treacherous even though
the rewards were enormous. Forster had
seen king penguins in the waters leading
up to Antarctica, but nothing could
prepare him for what he witnessed on the
island of South Georgia. There were so
many penguins that the snow was a
carpet of black. Despite the excitement,
and not realising how close he was, Cook
was unconvinced he would find the
Antarctic continent and so turned back.

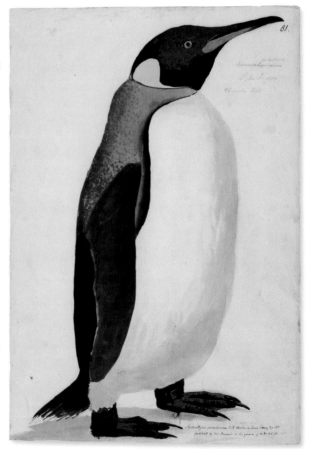

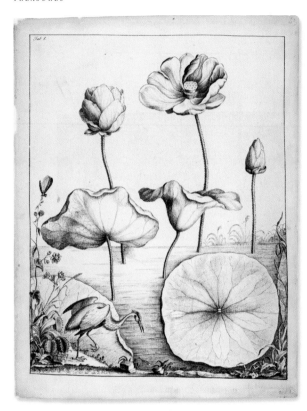

VENUS FLY-TRAP BY WILLIAM BARTRAM

In the bottom left-hand corner of this picture, beneath the American lotus and by the great blue heron, is the first ever drawing of a Venus fly-trap (*Dionaea muscipula*). It is the work of William Bartram (1739–1823), one of the first American-born natural scientists. Bartram thought the plant was both bizarre and beautiful, describing it as a 'sportive vegetable', in reference to its carnivorous habit of eating insects. His love of plants was inspired by his father's botanical garden in Philadelphia. As a child he joined his father on numerous collecting trips, and in later life he spent four years travelling in the Carolinas, Georgia and Florida, collecting and drawing plants and animals.

FLORIDA SANDHILL CRANE

The bird in this charming painting was both drawn and eaten by the great American naturalist William Bartram in 1774. Bartram was the first to officially record the bird, but with no body to bring back, the painting and his description stand in its place. The magnificent crane (*Grus canadensis pratensis*) measures more than one metre long in life, with an even wider wingspan. It was painted during Bartram's four years travelling in the southern American wilderness, including the wilds of Florida. The bird features several times in his remarkable book *Travels Through North and South Carolina, Georgia, East and West Florida*, which describes in beautiful poetic imagery the flora and fauna of the region as well as the lifestyle of the Native Americans. It is perhaps not surprising that during his years away, camping along riverbanks or savannahs in isolated spots, many animal subjects of his art became dinner at the end of a long day. On this particular occasion, having caught the 'stately bird,' Bartram described how 'we had this fowl dressed for supper and it made excellent soup'.

T. 11

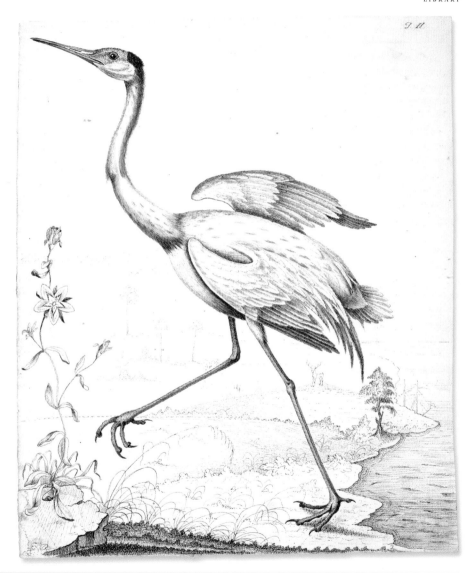

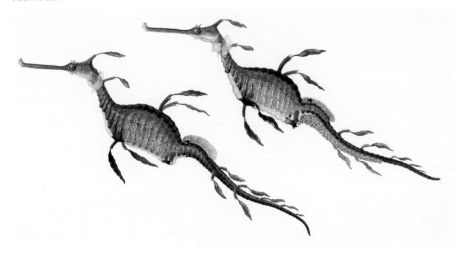

SEA DRAGONS BY FERDINAND BAUER

This is one of many delightful paintings by Ferdinand Bauer (1760–1826) held by the Museum. He was among the best natural history artists of all time, and the intense beauty of his work is not only due to the incredible attention to detail, but to his near obsession with colour. He went to extreme lengths to re-create the true colour of specimens, which he noticed began to fade soon after the animal or plant died. Rather than hurry his work or try to recall the colours from memory, Bauer assigned each shade a four-digit number and meticulously recorded the various codes for each specimen as soon after it died as possible. In his own time, Bauer could then paint in the different shades when he later turned his sketches into paintings. As a result, his paintings are a vibrant depiction of the animal in life.

Remarkably, Ferdinand's elder brother, Franz, was also a world-class natural history artist, but while Franz spent 40 years in England painting plants, Ferdinand travelled. One of his most significant voyages was to Australia in 1801 on HMS *Investigator*, when he accompanied the naturalist Robert Brown, later the first Keeper of Botany at the Museum, to survey the Australian coastline. It was misfortune, or rather luck, that kept them in Australia for three years as the ship's progress was delayed by endless repairs. It gave them the time to collect thousands of plants and animals, and Bauer the time to sketch wonderful records of Australia's wildlife.

ORCHID BY FRANZ BAUER

This exquisite orchid, *Ophrys apifera*, was painted around 1800 by the first botanical artist employed at the Royal Botanic Gardens at Kew. His name was Franz Bauer, and he produced some of the most detailed botanical watercolours ever seen, specialising in studying plants under the microscope, and then enlarging them on to paper. His paintings were a gift for scientists, allowing them to see and study the minute detail of plants without spending hours peering down a microscope.

Bauer was born in Feldsberg, Austria, and inherited his artistic flair from his father, who was court painter to the Prince of Liechtenstein. Bauer spent 40 years at the world-famous gardens of Kew in southwest London, quietly creating a vast number of paintings. There was never any shortage of inspiration for him. Botanical riches were delivered daily as voyages to different parts of the world returned to England. Seeds from around the globe were grown at Kew, and Bauer was there to document each stage of growth with dazzling attention to detail.

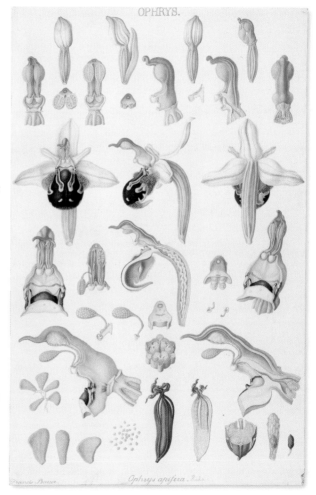

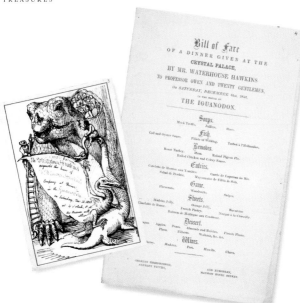

VICTORIAN MENU

This lavish menu is valued not for what it reveals about Victorian appetites, but the event it was created for: the opening of the world's first dinosaur attraction. On New Year's Eve 1853, scientist Richard Owen unveiled the three life-size dinosaur models – *Hylaeosaurus*, *Iguanodon* and *Megalosaurus* – in Crystal Palace Park, southeast London. An invitation to the event (left) was sent to the cream of Victorian society. They were to be seated in the unfinished model of the *Iguanodon*. They toasted not only the models but Owen's recent discovery of this new group of ancient reptiles. Few would have dared mention it was Owen's life-long rival Gideon Mantell who had first identified the group, Owen hijacking the glory by simply naming them Dinosauria. Owen's real skill lay in re-creating the dinosaurs, using fossil bones to estimate their size and his expertise in anatomy to predict what they may have looked like. The dinosaurs were brought to life by sculptor Benjamin Waterhouse Hawkins, who built other ancient reptiles and mammals to create the first prehistoric park. Ancient plants completed the scene, a landscape that depicted 350 million years of Britain's evolution. Thousands came to visit, including Queen Victoria and Prince Albert.

FIRST GEOLOGICAL MAP

This is the first map to show the geology of an entire country, and was devised by William Smith in 1815. It depicts the different rock types across England and Wales, each a different colour, and laid the foundation for geological surveying worldwide. Smith's love affair with geology began with fossils he collected in his native Oxfordshire. Studious and observant, he started work as a surveyor aged 18, prospecting for water, coal and minerals, draining land and building canals. His work took him all over the country and he noticed that wherever he was surveying, rocks were layered in the same order. What's more, the same fossils were found in corresponding layers, or strata, and so could be used to age the layers. He spent over a decade collecting yet more evidence and raising funds before finally publishing his map. Beautifully hand-painted and almost two metres square, it was magnificent. The establishment, however, was slow to accept Smith's work, probably because of his humble background and lowly profession. Today he is given more recognition, as the 'father of geology'.

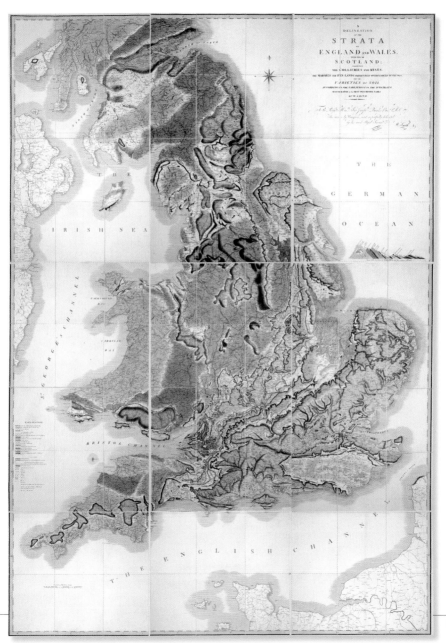

A DELINEATION OF THE STRATA OF ENGLAND AND WALES, WITH PART OF SCOTLAND; EXHIBITING THE COLLIERIES AND MINES, THE MARSHES AND FEN LANDS ORIGINALLY OVERFLOWED BY THE SEA, AND THE VARIETIES OF SOIL ACCORDING TO THE VARIATIONS IN THE SUBSTRATA, ILLUSTRATED BY THE MOST DESCRIPTIVE NAMES. BY W. SMITH.

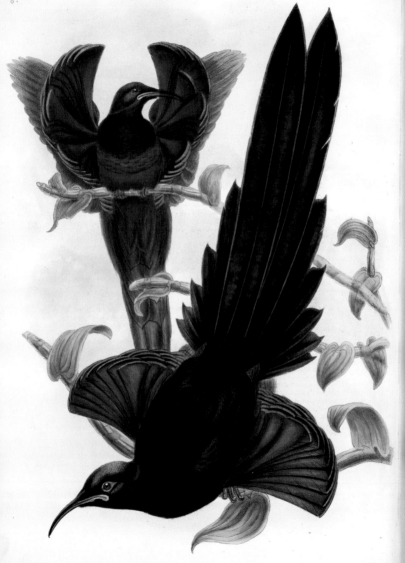

EPIMACHUS ELLIOTI, *Ward.*

GOULD'S *BIRDS OF NEW GUINEA*

This spectacular plate is from a first edition of *Birds of New Guinea* by John Gould, one of the most gifted bird illustrators of the nineteenth century. Gould was a prolific artist, producing a large number of works including multi-volume editions showcasing birds of Great Britain, Australia, Europe and Asia. The Museum looks after first editions of each.

Gould was not only an artist but was also an excellent ornithologist. He identified, for example, the birds Charles Darwin brought back from the Galapagos Islands, which Darwin had named wrongly. This mix of incredible artistry and a real understanding of birds made his drawings exquisitely accurate, so much so they are sometimes used as references in the same way as real specimens. Some even serve as type specimens, the specimen chosen as the most typical of that species against which all others in the species are compared.

Gould did not work alone to produce this magnificent book. After he drew the birds, they were transferred to lithographic stones from which prints were made. He then employed a team of colourists, most notably his wife, to bring the plates to life, painting them as spectacular watercolours. By using gold leaf underneath the paint and then adding gum Arabic to certain areas, they managed to re-create the birds' iridescence.

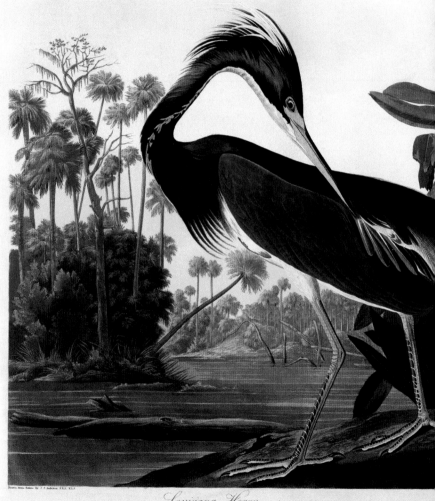

Drawn from Nature by J. J. Audubon, F.R.S. M.L.S

Louisiana Heron. ARDEA LUDOVICIANA: Wils. *Male adult.*

PLATE CCXVII

Engraved, Printed, & Coloured, by R. Havell, 1834

AUDUBON'S *THE BIRDS OF AMERICA*

If one book changed the way we look at birds, it is John James Audubon's *The Birds of America*, published between 1827 and 1838. The 435 pages, each one metre tall, are bursting with 1,065 life-size watercolours, regarded as some of the most life-like ever created. In contrast to other naturalists at the time, who worked from prepared bird skins or zoo specimens, Audubon roamed into the wild to draw. He was also the first to illustrate birds at life size and in natural poses, from small songbirds to soaring eagles and hawks. By wiring newly killed specimens in position, he could paint them as they would have looked in life.

Audubon was born in Santo Domingo (now Haiti) in 1785 and grew up in France, with little formal education. He quickly developed a passion for observing and drawing birds, and when he was aged 35 decided he wanted to draw

every bird species in America. He spent the next 20 years exploring every habitat he could, from mountains to valleys, from Canada to the Gulf of Mexico, drawing all the while and gathering material for this magnificent book.

Why Audubon could not find a printer and publisher in America is unclear, but his work was enthusiastically received when he took it to the UK. Robert Havell Jr, one of the finest engravers of the early nineteenth century, transformed Audubon's watercolours into 435 hand-coloured plates. Combining scientific accuracy with an almost romantic beauty, *The Birds of America* quickly achieved the status of an icon of American culture. There are thought to be 119 complete copies of the work still in existence, one of which sold at auction for a record-breaking US $8,802,500 (just over £4 million) in 2002.

MARGARET FOUNTAINE'S NOTEBOOKS

Four personal notebooks, each in a handmade protective sleeve, record the explorations of the irrepressible Margaret Fountaine, born in Norfolk in 1862. She lived a life very few Victorian women even dreamt of, travelling solo around the world in pursuit of butterflies. Each page is filled with her delicate watercolours and carefully painted notes, from parts of Europe and Africa, from India to the West Indies, China to Sri Lanka. She travelled almost continuously for 50 years, 27 of which were with Khalil Neimy, a male companion she met in Syria, who would eventually break her heart. Margaret Fountaine defied the social conventions of Victorian England, instead choosing a life of freedom. Her rebellion paid off as by the time she died she was a respected lepidopterist with close links to the Museum, the notebooks probably a gift to the keeper of entomology, whom she knew. She collected many wonderful adult specimens, but also reared them from larvae or pupae.

Fountaine was a wonderful romantic, a quality that stayed with her to the end, as when she died in 1940 she bequeathed a locked iron box to the Norwich Castle Museum with strict instructions it was not to be opened for 100 years. In it were her numerous butterfly collections, photographs and 12 additional journals.

Edward Lear's parrots

Bursting with personality, this charming painting is from a first edition of *Illustrations of the Family of Psittacidae or Parrots* by Edward Lear (1812–1888). It was published in 1832 when Lear was just 19. Lear wanted to capture more than the colour and form of parrots and so spent weeks watching them at the Zoological Gardens in London, later known as London Zoo. He observed how they moved and their different personalities, and then he translated that energy into his paintings. As a result, each of his paintings is a flurry of colour and activity, no doubt also influenced by Lear's vivid imagination as a storyteller.

Despite a life plagued by epilepsy and ill health, Lear painted furiously throughout his teens and twenties, though he is probably better known for his limericks as in *A Book of Nonsense* and his other children's poems and stories, such as *The Owl and the Pussycat*. He was widely compared with one of the greatest bird artists of all time, James Audubon, and even gave drawing lessons to Queen Victoria.

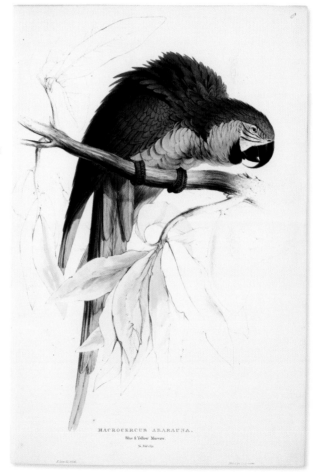

MACROCERCUS ARARAUNA.

Blue & Yellow Macaw.

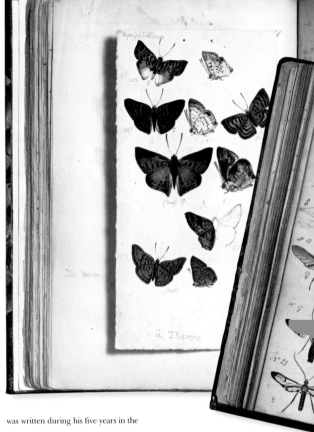

Henry Bates' Journal

The field journal of naturalist Henry
Bates (1825–1892) is extraordinary for
more than its scientific content. It shows
the formidable dedication Victorian
scientists had for learning about
the natural world, facing hardships
inconceivable in the modern age. Bates
is the best-celebrated Victorian naturalist
after Charles Darwin and Alfred Russel
Wallace, and his journal was one of
two bought by the Museum in 1933.
The scrawled handwriting is illegible
in parts, and Bates' thinking is hard to
follow from notes alone, but the journal
is treasured for the commitment and
passion it represents and is a humbling
piece of work to handle. The journal

was written during his five years in the
Amazon. It is full of notes and delicate,
beautiful watercolours of the butterflies
Bates saw. It was a dedication beyond
imagination if you consider what it must
have been like with the suffocating heat,
the intense isolation, flies and lack of
modern survival kit. Nevertheless, he
spent hours creating these beautiful

life-size watercolours,
or making notes on the structure,
diversity and lifestyle of the novel species
he was so obsessed with understanding.
This journal provided the basis for Bates'
bestseller, *The Naturalist on the River
Amazons*, which was published in 1863.

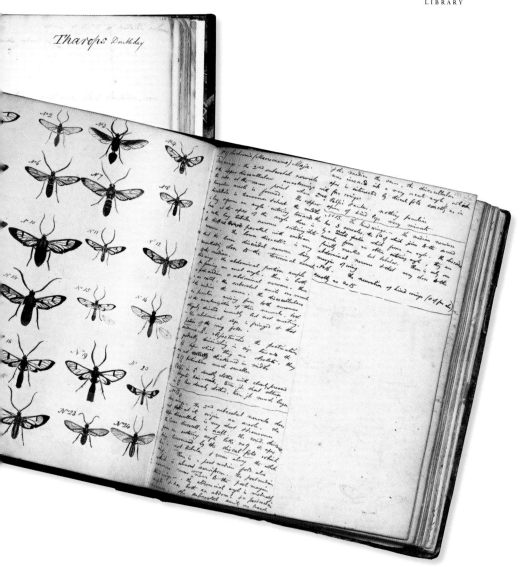

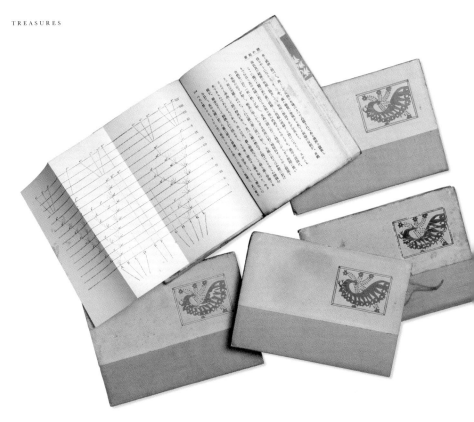

DARWIN'S *ON THE ORIGIN OF SPECIES*

Opposite is one of five pages of notes held by the Museum that were hand-written by Charles Darwin for his book *On the Origin of Species*, published in 1859. They were written for the chapter on instinct and are a precious legacy of one of the most influential books ever written, the crossings out and annotations a record of a great mind. In the book, Darwin revealed his theory of evolution through natural selection. He saw that all living things shared a common ancestry, but that over time organisms change, with those best suited to their environment being more likely to survive, thus helping to explain the great diversity of the natural world. It took him 20 years to refine and publish his ideas. When first published, the book had the title *On the Origin of Species by Means of Natural Selection, or the Preservation of Favoured Races in the Struggle for Life*, but it was renamed *Origin of Species* in 1872 with the sixth edition. It was an instant bestseller, although also a direct challenge to the widely held belief that God created, and still controlled, everything. The first Japanese edition (above), with a folding image of a speciation tree, was published in pocket size in 1914.

The possibility or even probability of inherited variation
of instinct in a state of nature will be
strengthened by briefly considering a few cases in the
domestic animals. We shall, also, then be enabled to
see the respective parts which _____ habit & the
selection [from] so-called accidental variation have
in modifying them mental qualities.
a number of [instances] authentic instances will be
given of the inheritance of all shades of disposition &c of
tastes & likewise of the inheritance
& of the oddest tricks associated with certain frames of
mind at periods of time. But let us look to the
of several breeds of
familiar case of Dogs: it cannot be doubted that
any pointer (I have myself seen a most striking
instance) with [skeleton] point & even back the [dog], the
very point terror than they are ... taken ...
retrieving is certainly in some degree inherited &
retrievers, & a tendency to run round, instead of
at a flock of sheep, by shepherd dogs.
I cannot see the these _____
action, performed without
experience by the young, & in ... to some mere
& each individual, performed with
& without the end ... being known to the animals,
for the young pointer can no more know that he
to aid
point _____ ... man, than does the
white butterfly know why it lays its eggs on the leaf

Drawings saved from a shipwreck

As he scrambled to escape a burning ship, naturalist Alfred Russel Wallace only had time to salvage a tin box, containing notes and these sketches. They were all he had left after four years' collecting along the Rio Negro in Brazil, South America. His return vessel, *Helen*, had caught fire and the young Wallace could only watch from the rescue boat as hundreds of plants, insects, bird skins, numerous notebooks and some live animals, including parrots and monkeys, went down with the ship. As a young man, Wallace was keen to explore the natural world and in 1848 left England for the Amazon in Brazil. Over the next four years, he paid his way by selling the specimens he collected, and followed a strict regime to make use of every day. He began with two hours at dawn looking for birds, then from mid-morning to mid-afternoon he trapped insects. He stopped for dinner at four, then wrote notes or prepared specimens in the evening. Wallace published an account of his Amazonian experience in 1889. By then he was well known as a naturalist, having also spent many years collecting in the Malay Archipelago. It was there he developed his ideas of evolution through natural selection. He didn't know that back home Darwin was developing exactly the same ideas.

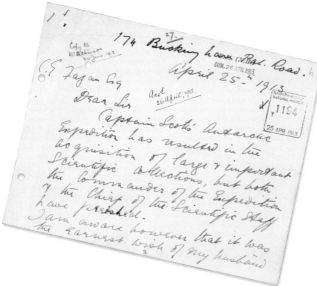

CAPTAIN SCOTT IN THE ANTARCTIC

Captain Robert Scott's wife Kathleen wrote this letter to the Museum in 1913, after her explorer husband failed to return from an expedition to the South Pole. She was looking for a home for the specimens his team had collected. Scott led two expeditions to the bleak terrain of Antarctica, recording what they found in notebooks, drawings and photographs, and collecting rocks, fossil fish, plants and animal specimens such as seal skulls, bird skins and sea spiders for study. The *Discovery* expedition (1901–1904) was a great success. But on the *Terra Nova* expedition (1910–1913) tragedy struck. Returning to base camp from the South

Pole, beaten there by the Norwegians, Scott and his four companions died of exposure and starvation. Kathleen took time from her grief to try to unite specimens from the first trip, already at the Museum, with those from *Terra Nova*, writing: 'both the Commander of this Expedition and the Chief of the Scientific Staff have perished… it was the earnest wish of my husband that some similar arrangement be made… as led to such excellent results regarding the geological and biological results of Captain Scott's former expedition.' They did come to the Museum, and this letter is held in the Museum Archives.

MARK RUSSELL

This super-realistic weevil painting, by entomologist and contemporary artist Mark Russell, is a wonderful piece of art, showing every hair and pore of the tiny insect. It was bought in 2000, and spearheads a concerted effort by the Museum to gather examples from the cutting edge of modern art. For the collection to be a comprehensive record for generations to come, we must continue to collect not only treasures from the past but the treasures of the future, and contemporary talent such as Russell is an excellent example. Russell worked in the Museum's Entomology Department from 1971 to 1975, curating the vast beetle collection. It was then that he decided to spread his wings to more exotic climes, travelling extensively around Europe, South America and Africa collecting along the way many weevils, the inspiration for his art. This *Baris cuprirostris* was drawn from acute observations under the microscope, where every tiny detail has been enlarged and then painted in brilliant acrylics.

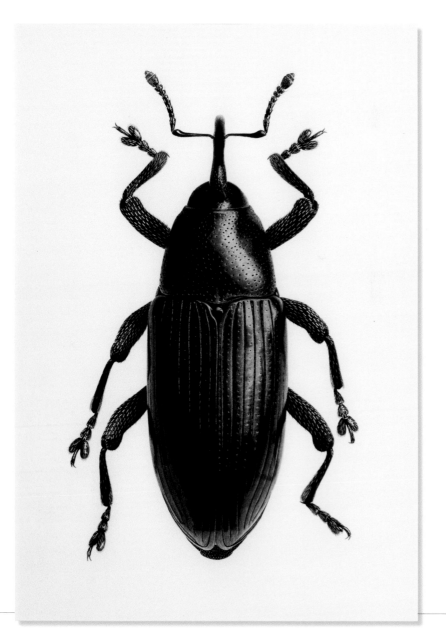

BOTANY

OLD MAN BANKSIA

This plant, with the scientific name
Banksia serrata, was named in honour of
the great eighteenth-century naturalist
Sir Joseph Banks. He was the first
European to see it growing in its native
Australia, while on the circumnavigation
voyage of *Endeavour* (1768–1771). Banks
brought it and specimens of other closely
related new species back to England,
where a new genus, *Banksia*, was named
after him. The artwork of *Banksia* (far
right) was prepared from a drawing by
Sydney Parkinson, a young and talented
artist on board who helped produce
18 volumes of plant drawings from the
voyage. In total Banks collected some
3,000 plants from the newly discovered
land, about 900 new to science.

Banks is probably best remembered
for his botanical legacy. He sponsored
numerous voyages, enabling young
naturalists and artists to record their
discoveries. As King George III's advisor
at Kew, he also introduced countless
plants to the UK and developed an
interest in the economic value of species,
for example identifying Assam as a prime
spot to cultivate tea for export home.

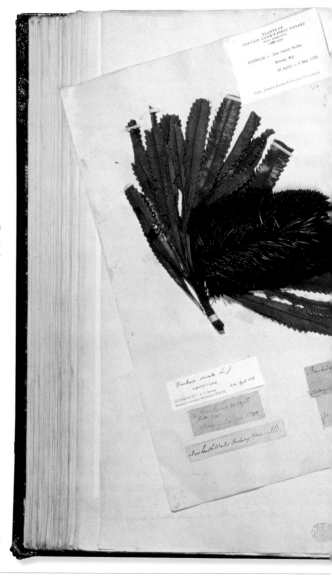

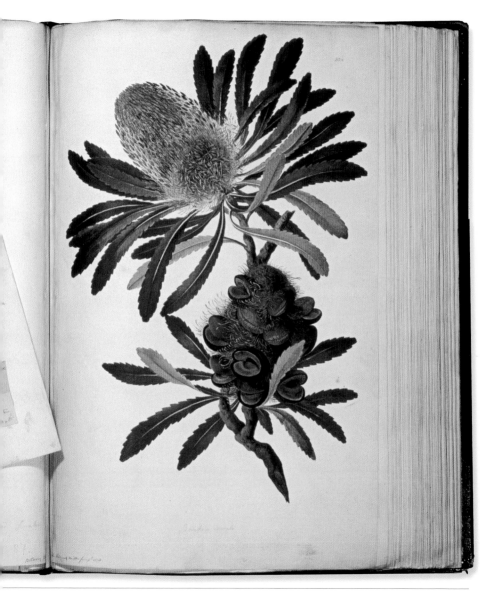

SIKKIM RHUBARB

The extraordinary noble or Sikkim rhubarb (*Rheum nobile*) has to be seen to be believed – a towering, two-metre-high flower spike. It grows about 4,000 metres above sea level in the remote Himalayas, from northeastern Afghanistan through northern Pakistan and India, Nepal, Bhutan and Tibet. This specimen was collected by Frank Ludlow, George Sherriff and N M Elliot. Ludlow was a well-known plant collector and naturalist who spent many years travelling in the Himalayas and Far East. In this photograph, taken in Tibet in 1947, you can see the size of the plant compared with Ludlow's pet dog Joker. The plant's roots are said to grow as thick as a man's arm; but it is not only a visual feast as local people consider its stems to make a pleasantly acidic snack.

Conditions get extremely cold where the noble rhubarb lives, and most other plants around survive only as low-lying shrubs. To help it survive, the noble rhubarb has its own central heating system, an outer curtain of translucent bracts that lets visible light in and traps the heat to create a greenhouse effect.

RESCUED FROM EXTINCTION

St Helena boxwood (*Mellissia begonifolia*) is the subject of a miraculous tale of survival. Endemic to the tiny Atlantic island of St Helena, it smells of tobacco, gooseberry and, at worst, sweaty feet. It was first described in 1813, but was believed extinct by the end of the 1800s due to overgrazing by goats introduced to the island, deforestation and soil erosion.

Then in 1998, a local man out walking one day found seven plants. Six were dead, but the seventh, though badly infested with insects, was in flower and had seeds. More plants have been found since and seeds successfully germinated, bringing the species back from the brink of extinction. It is still critically endangered on St Helena.

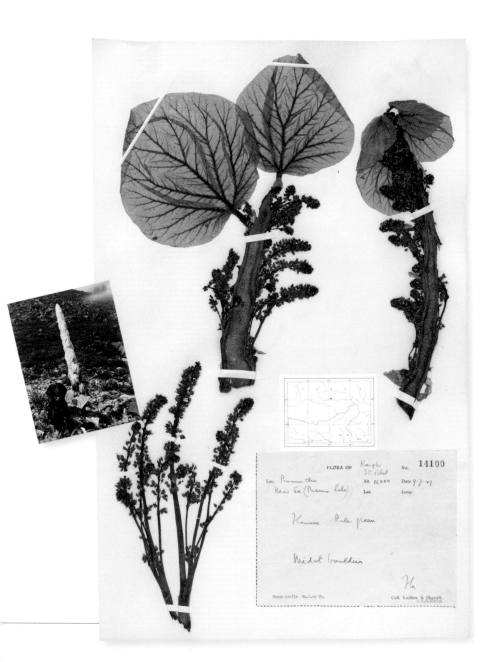

FLORA OF Kongbo
SE Tibet

No. 14100

Loc. Pinnan Chu
Near Tre (Pasum Lake)

Alt. 15,000 Date 9·7·47

Lat. Long.

Flowers Pale green

Midst boulders

Rheum nobile Hk.f. et Th.

Coll. Ludlow & Sherriff

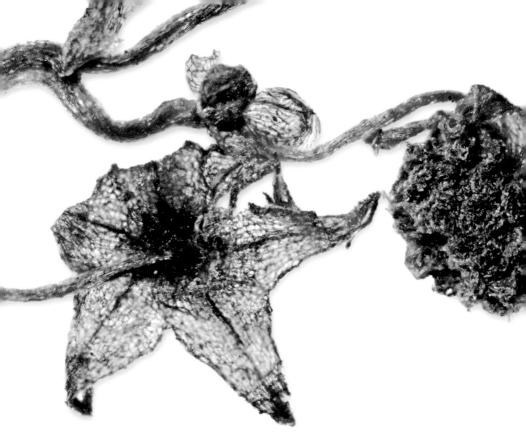

An unusual plant from Mexico

Unlike every other flower on the planet, *Lacandonia schismatica* has its male parts in the middle and female parts around the outside. All other flowers have the reverse structure. When scientists discovered it in 1985, they decided its highly unusual form meant it should be placed in its own, entirely new family. But DNA analysis has shown it is a member of the Triuridaceae, an existing family of saprophytes – plants that grow and feed on the decaying remains of other plants. *Lacandonia* is small and inconspicuous, found only in the Lacandon rainforest of southeast Mexico. Its thread-like stem grows to about 10 centimetres long, enough to poke through the moist leaf litter of the forest floor. Each stem is topped with one or more tiny flowers, about one-hundredth the size of a daisy, in which tiny clusters of ovaries (orange) surround the central

male anthers (yellow). It was first found during exploration for the Flora Mesoamericana project – a collaboration led by the Museum, the Universidad Nacional Autónoma de México and Missouri Botanical Garden to document all the vascular plants of Central America. Newly collected material, such as this *Lacandonia*, is sent to the Museum and added to the collections. The first volume of the *Flora* was published in 1995.

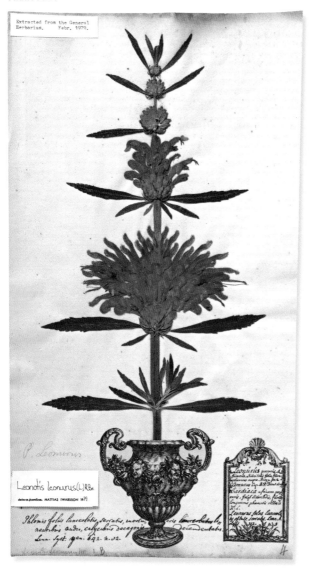

Extracted from the General
Herbarium. Febr. 1979.

P. Leonurus

Leonotis leonurus (L.)R.Br.
determinavit MATTIAS IWARSSON 1979

Phlomis folis lanceolatis serratis, inodus eris lanceolatis li,
nealibus aude, calycibus decagonis decemdentatis
Lin. Syst. gen. 692. n. 12.

CLIFFORD HERBARIUM

These examples of *Leonotis leonurus* (left)
and *Ipomoea quamoclit* (opposite) are from
an early collection of dried plants, or
herbarium. It was created in the 1730s
by the wealthy Dutch merchant George
Clifford and was studied by the young
Swede Carl Linnaeus (1707–1778), who
later became known as the father of
modern botany. Its 3,491 sheets reflect
the many plants growing in Clifford's
magnificent garden, including bananas
and cacti, cultivated from seeds gathered
in the early exploration of Asia, the
Americas and Europe, as well as gleaned
from other European gardens. Carefully
pressed examples were arranged as if
growing from a pretty vase, then named
on elaborately printed labels. These
names included a genus and a short
descriptive phrase in Latin and were
listed in Linnaeus' lavishly published
book, *Hortus Cliffortianus*. Linnaeus then
referred to these entries 15 years later,
when he published his seminal work
Species Plantarum. In it, he introduced
for the first time the binomial naming
system, with a genus and a single species
name, which is still used today.

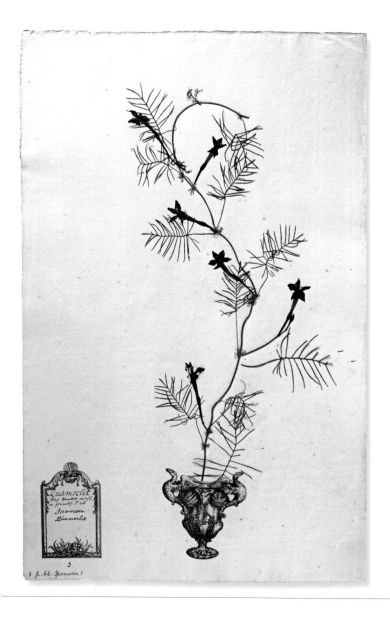

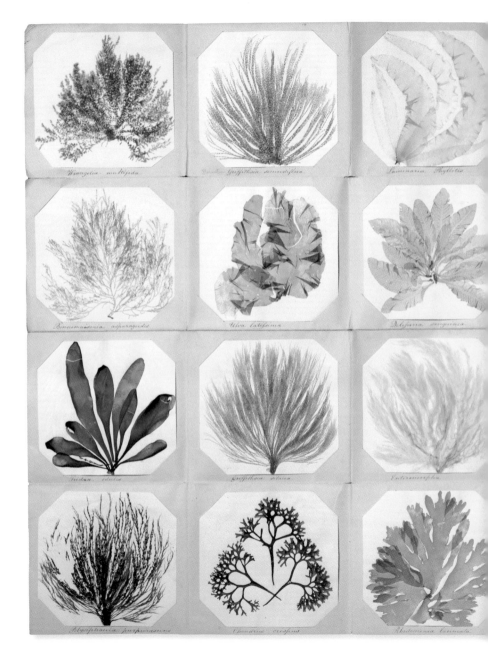

Wrangelia multifida.

Griffithia secundiflora.

Laminaria Phyllitis.

Bonnemaisonia asparagoides.

Ulva latissima.

Delepina sanguinea.

Iridæa edulis.

Griffithia setacea.

Ectocarpus.

Blanefilmia purpurascens.

Chenaria crispus.

Rhodomenia laciniata.

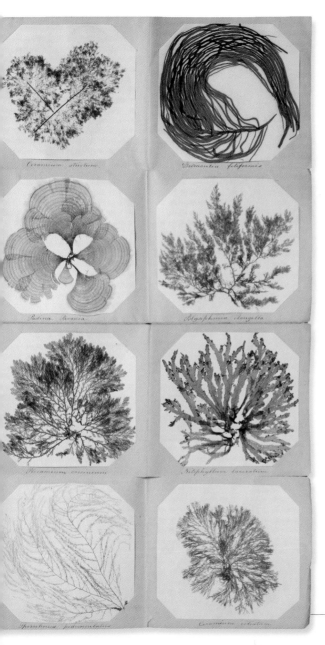

Ceramium strictum

Dudresnaia filiformis

Padina pavonia

Rhynphonia languetta

Rhodomenia ciliatum

Rhytiphloea laceratum

Sporochnus pedunculatus

Ceramium strictum

PRESSED SEAWEED BOOK

These mounted seaweeds, the handiwork of women living in Jersey during the 1850s and 1860s, are a charming souvenir from the beach. This one is labelled from La Chaire. The delicate sprays of plants are painstakingly flattened out on to postcard-sized pieces of card, which together fold neatly up into a little booklet. What stands out is the variation of form, the range of texture and the mix of colours – reds, browns and greens. Some of the booklets have names inscribed in them, others not, and they were probably made to be sold. It's likely they were made by the same group, as most bear excerpts of the same poem. This one reads:

> *You collect and admire us*
> *We amuse leisure hours*
> *Then call us not weeds*
> *We are ocean's gay flowers*

The Museum looks after about half a dozen little booklets, some received as gifts, others bought from booksellers. They contrast beautifully with the common image of seaweed as dead litter, piles of it thrown up by the sea like rubbish.

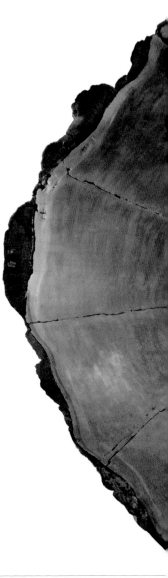

GIANT SEQUOIA

This enormous slice of tree is almost five metres wide and is from a giant sequoia that grew from a seedling in 557. In 1891, more than 1,300 years later, it was felled at the request of the American Museum of Natural History, in New York. At the time its height exceeded 90 metres and it took two men more than a week to cut it down in what is now Big Stump Grove, Kings Canyon National Park. One giant slice was sent to New York, another to the British Museum and the rest was chopped up for fence posts. Though giant sequoias don't grow quite as tall as coast redwoods, they are still the largest living things due to their tremendous girth. They can live for at least 3,000 years and the secret of their ability to live so long is manyfold. Found only in the Sierra Nevada mountains of California, where they thrive in the combination of wet winters and dry summers, their unusually thick, fire-resistant bark protects them from summer fires that conveniently wipe out the competition. Their seeds are then shed in greatest numbers after fire and germinate well in fire-mineralized soil. The trees also contain a natural wood preservative, making them very resistant to disease.

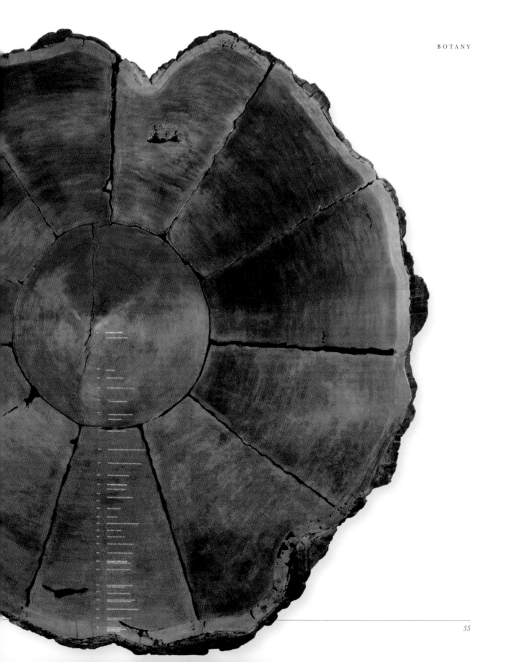

DUCHESS OF BEAUFORT'S AURICULAS AND TULIPS

The herbarium of Mary Somerset (the Duchess of Beaufort), 14 volumes of beautifully pressed plants, is more than the work of a lady of leisure. It's a tangible record of plants cultivated in England during the early 1700s, grown and pressed by the Duchess herself (1630–1714). She grew hundreds of plants in her two magnificent gardens at Badminton, near Bristol, and in London's Chelsea, many acquired from the New World and Europe. She is even credited with introducing more than 60 species into England. Pressed and dried specimens from her gardens were mounted in individual paper folders, on each of which the Duchess wrote the plant's name and, in the case of the tulips

(above), how much each bulb cost. Page after page of plants reflect changing fashions of her day and while the original colours have altered through preservation and time, her collection is a wonderful record of early cultivation. In London, the Duchess was a close neighbour of Sir Hans Sloane. He was very impressed by her garden, noting the many plants that 'flourished better there than in any garden of Europe I ever saw… her Grace having what she called an infirmary, to which she removed sickly or unthriving plants and with proper culture… brought them to greater perfection than at Hampton Court'. The volumes came to Sloane on her death in 1714 and so, eventually, to the Museum.

VEGETABLE LAMB OF TARTARY

No stranger plant could exist than one said to sprout live lambs. Known as the lamb of Tartary, it was once thought to be a plant that grew sheep as its fruit and was seen as a way of explaining the existence of cotton. The sheep were thought to be connected to the plant by an umbilical cord and to graze the land around the plant. When the sheep had grazed all the land around it, both the plant and sheep were thought to die.

This particular specimen from China was obtained in 1698 by Hans Sloane, a doctor and collector with an insatiable appetite for curiosities. In his lifetime he collected thousands of objects which, after his death in 1753, became the core of the British Museum's collections. A sceptic and scientist, Sloane correctly identified the 'lamb' as in fact being constructed out of the stems or rootlets of an arborescent fern which had cleverly been manipulated to look like a lamb, the so-called legs being nothing more than broken-off leaf bases. Despite this the legend of the lamb-plant continued to persist in the following centuries.

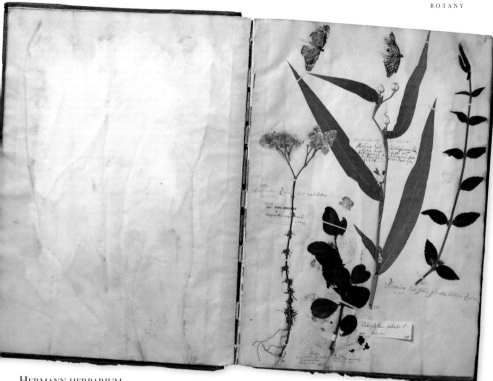

HERMANN HERBARIUM

This page of specimens, including butterflies, belongs to one of the earliest and most important collections of Sri Lankan plants, some 400 species picked, dried and named by the physician Paul Hermann (1646–1695). The collection contains mostly native plants but also early introduced species from the Americas such as cashew nuts, custard apples and cotton. Hermann spent five years in Sri Lanka (then Ceylon) as chief medical officer to the Dutch East Indies

Company, which managed the island under Dutch rule. Most medicines at the time were derived from plants, and Hermann's eye strayed from his patients to the local flora. The collection didn't achieve lasting importance until after Hermann's death in 1695. His widow sent the plants, as well as his drawings and manuscript notes, to William Sherard, Professor of Botany at Oxford University, who published a small catalogue based on them. The Swedish

scientist Carl Linnaeus later borrowed Hermann's specimens and used them as the basis for his book on Ceylon's plants, *Flora Zeylanica*, published in 1747. Six years later, Linnaeus gave the world his binomial, or two-name system for naming plants that is still used today, and Hermann's collections underpin Linnaeus' names for Sri Lankan plants. You can see Hermann's handwriting under each plant and, beneath that, a reference number written by Linnaeus.

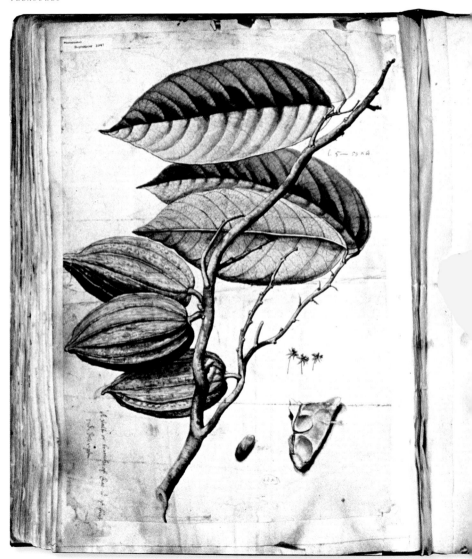

SLOANE'S HERBARIUM

This cocoa plant (left) was brought back to London from Jamaica in 1689 by the collector and doctor Hans Sloane and was one of the first cocoa specimens recorded by science. The plant's scientific name, *Theobroma cacao*, is from the Greek *theobroma*, meaning drink of the gods, and Sloane saw local people boiling its seeds up to make a drink. When he tasted it, he found it too bitter for his palate and so he added milk and sugar. After Sloane returned to England he sold the recipe and it was eventually reworked by Cadbury, initially as a drink and later as the now ubiquitous chocolate bar.

Eight of the 265 volumes of Sloane's collections came from Jamaica, each filled with carefully dried and mounted plants, and they are now kept in a special room at the Museum. Sloane employed a local artist, the Reverend Garret Moore, to illustrate many of the specimens, but those that were not, such as the cocoa leaf, were drawn by the talented artist Everhardus Kickius on Sloane's return to England (far left). The volumes are still often used by scientists, a powerful record of the biodiversity of the West Indies.

PALAEONTOLOGY

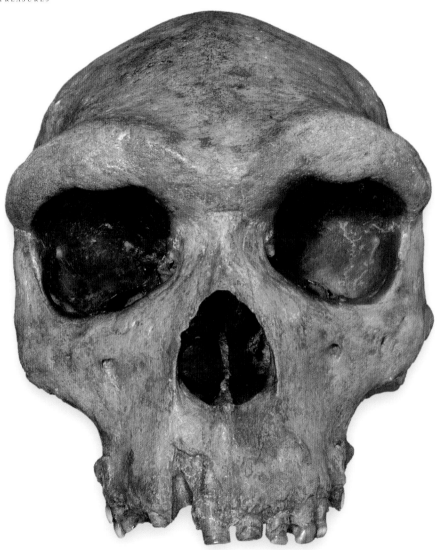

RHODESIAN MAN

The Broken Hill skull is the first human fossil ever recognised as such in Africa. Unearthed in 1921 in Broken Hill, northern Rhodesia (now Kabwe, Zambia), it was given the species name *Homo rhodesiensis*, but is often assigned to *Homo heidelbergensis*. Human evolution has been pieced together from various finds such as this. About five to eight million years ago a primate ancestor diverged into separate lineages. Gorillas and chimps went one way, and early human relatives called hominins went another. Several hominins came and went, then around two and a half million years ago the earliest humans evolved, including *Homo habilis*. The more advanced *Homo erectus* probably evolved into *H. heidelbergensis*, which may, in turn, have became *Homo neanderthalensis* and *Homo sapiens*. The Broken Hill skull has a long face like *H. neanderthalensis*, but the nose is smaller and the brow ridges are much larger. Once thought to be less than 40,000 years old, it was used to support the supposed backwardness of Africa in human evolution. But the skull is probably nearer 300,000 years old and could possibly belong to the African population from which all modern humans descended.

PILTDOWN CRICKET BAT

This bat-shaped fossil was used in one of the greatest scientific frauds of all time. It was found in a gravel pit in Piltdown, Sussex. Hailed as an early tool, it was part of the evidence used to prove a missing link between apes and humans. But it was a fake. The story starts in 1912 when Charles Dawson, a local lawyer and fossil hunter, showed part of a large skull apparently found at Piltdown to Arthur Smith Woodward, Keeper of Geology at the Museum. The following summer, they searched the site and also found an ape-like jawbone (right). They claimed the bones proved humans were evolved from apes, via a missing link known as Piltdown Man. Two years later, Dawson found this bat-shaped elephant bone, hailed as a Piltdown Man tool. It wasn't until 1953 that new dating and analytical techniques began to reveal that the

skull and jaw were probably less than 1,000 years old. The jaw belonged to an orang-utan and the bones and teeth had been stained to look older. The bat had obvious cut-marks from a modern steel tool. At least 20 names have been put forward as suspects. Dawson is the most obvious, having been present at all the finds, but cut and stained bones and teeth found in a box at the Museum may point the finger at more than one hoaxer. Scientists now know there is no single missing link between humans and apes, but that we share a common ancestor.

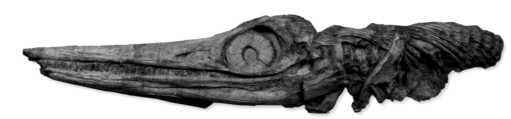

First ichthyosaur fossil

This specimen (now identified as belonging to the species *Temnodontosaurus platyodon*) was the first ichthyosaur fossil ever discovered. Ichthyosaurs are a group of extinct sea-living reptiles that lived between 240 and 100 million years ago. The specimen was found in 1811 and, unusually for science at the time, by a woman. Her name was Mary Anning (1799–1847) and she was the world's first professional fossil hunter. She made her living selling her finds to museums, wealthy individuals and other fossil collectors. Anning found the metre-long skull and several neck bones when she was just 11 years old, while walking along the cliffs around her home in Lyme Regis,

on England's south coast. She hired some men to excavate it and sold it to Mr Henley, the Lord of the Manor, for £23, who in turn gave it to Bullock's Museum in London's Piccadilly. At the time, no one could identify what it was, its long snout and teeth a strange mix of fish and reptile, hence its original scientific name *Ichthyosaurus*, which means fish lizard. When Bullock's Museum closed down in 1819, the collection was auctioned off and the British Museum bought Anning's remarkable find. Rumours surfaced that it was then lost, but it has been on display in South Kensington ever since the Natural History Museum opened its doors in 1881.

ANTARCTIC FOSSIL LEAF AND WOOD

This fragment of fossilised leaf is a poignant reminder that natural objects of all sizes are treasured. It was collected by explorer Captain Robert Falcon Scott's last expedition to Antarctica. This leaf, called *Glossopteris indica*, is one of the earliest pieces of evidence that forests once covered the now icy continent. It was found on the Beardmore Glacier, central Antarctica, and proves the climate there was once much warmer than today. The leaf was one of many specimens collected by the team as they raced to the South Pole on the *Terra Nova* expedition. But when Scott finally reached the pole in 1912, he found the Norwegian Roald Amundsen had beaten him to it by one month. Disappointment soon turned to tragedy when Scott and his team died of extreme cold and starvation on the way back home. Many of the objects collected during Scott's expeditions to Antarctica are now in the Museum's collections, including fossil wood (right), which also proved Antarctica's warmer past.

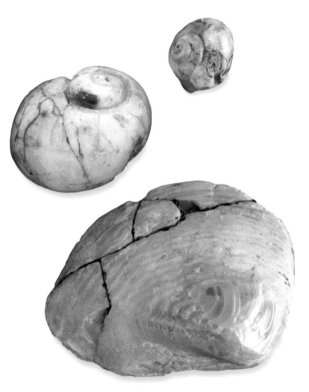

OPALISED SNAILS AND CLAM

While many fossils are a rather dull shade of grey or brown, these ancient snail and clam shells twinkle rainbow colours because they have been preserved in semi-precious opal. They were found in the South Australian town of Coober Pedy, the opal capital of the world. The town's name comes from the aboriginal Kupa Pita, which means white man in a hole, no doubt inspired by the fact that opal miners and their families used to, and sometimes still do, live underground to escape the intolerable heat of the desert. Australia produces most of the world's opal. Sea covered about a third of the continent 110 million years ago during the Cretaceous period, and the semi-precious stone is found all around the margins of where the water once stood. Very occasionally, opal has replaced the calcium carbonate of the shell of animals such as snails and clams that lived at the bottom of this sea. Such specimens are seen at their best when polished.

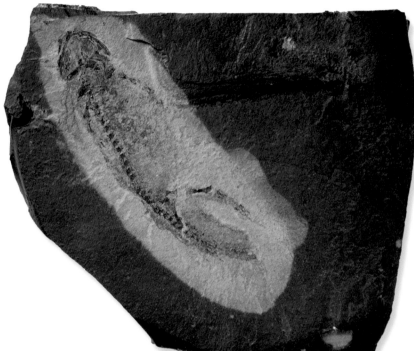

ANCIENT AMPHIBIAN LARVA

This seven-centimetre-long larval amphibian is so well preserved it shows us almost exactly what the ancestors of modern frogs and newts looked like 300 million years ago. It also indicates that they lived in water. Soft tissue is very rarely preserved in fossils, but here almost all of it has survived. As well as the skeleton, you can see the entire outline of the body, the shape of the long tail, the eyeballs and even the faint impression of gills just behind the skull on either side.

The swollen body suggests that after this animal died the internal organs decayed and produced gas that inflated the body cavity. Hundreds of these animals were found as mass deaths, dying when the ponds and lakes in which they lived became deoxygenated. The very first example of this species, *Apateon pedestris*, was identified in the late 1800s and in 1925 this spectacular example was bought by the Museum from Germany. Unlike frogs, which undergo huge changes from tadpoles to adults, early amphibian larvae looked similar to the larvae of modern newts and salamanders. We know it is a larva because of the wonderfully preserved external gills, used to breathe underwater but lost in the land-living adults. It also has gaps where the wrist and ankle bone should be, showing that these bones had not yet ossified and so the larva would not have been able to support its weight on land.

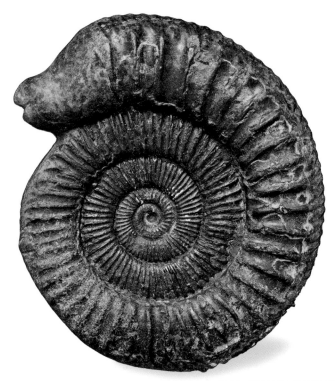

WHITBY SNAKESTONE

Ammonite fossils such as this one from
Whitby in Yorkshire were once thought
to be snakes that had turned to stone.
A snake's head was sometimes carved
onto the fossils, which were known as
snakestones. The fossil is in fact the coiled
shell of a mollusc related to squids and,
more distantly, to clams and snails.
Ammonites were important predators
in the world's oceans 200 to 65 million
years ago. Whitby is so famous for its
ammonites that they became the town's
symbol some time in the sixteenth or
seventeenth century and still feature on
the town's coat-of-arms. Even the current
Whitby football team, Whitby Town FC,
has the ammonite design on its crest.

The name ammonite comes from the
similarity in shape between the fossil shell
and the coiled horns of the Egyptian
Ram-god Ammon. In China, coiled shells
were also compared with horns and
known as Jiao-shih, or horn stones.
During Roman times it was believed that
sleeping with an ammonite under your
pillow guaranteed pleasant dreams.

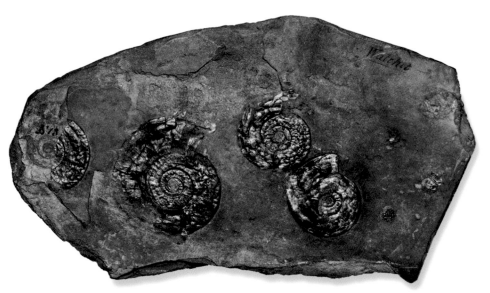

NACREOUS AMMONITE

These specimens of *Psiloceras planorbis* are Britain's earliest ammonites and, even after 200 million years, you can still see the mother-of-pearl on their shells. It is unusual to see mother-of-pearl preserved so well in an ammonite shell. Usually the cavity enclosed by the shell is filled with sediment that hardens with time, while the shell itself may dissolve away to leave an internal cast or be replaced by another mineral. As well as being attractive, these ammonites also have the distinction of being part of the William Smith Collection, arguably one of the most important historical collections held at the Museum. It was compiled by the civil engineer turned geologist William Smith (1769–1839), who famously produced the first geological map of England and Wales. Whether Smith collected these fossils himself is hard to tell. Scientists frequently swapped, borrowed and bought fossils to complete their personal collections. However, the label 'Watchet', the place in Somerset where the fossil was found, is in Smith's handwriting.

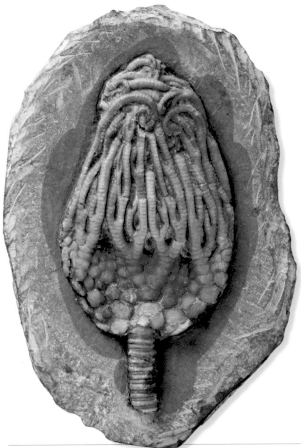

SEA LILIES

Sea lilies as well preserved as these are rare. Looking like rock art from ancient times, you can see the details of the sturdy stems, built up like a stack of coins, and the cones of branching arms at the top. Despite appearances, sea lilies are not lilies at all. They're not even plants, but animals belonging to a group called crinoids, related to sea urchins. Some of the best examples of sea lilies are found in the UK, America and Sweden. There are hundreds at the Museum, few as enchanting as the one to the left, collected during the 1800s at Wren's Nest, Dudley, the West Midlands, one of the most fossil-rich sites in the UK. About 420 million years ago, during the Silurian period, Dudley was covered by a tropical sea. Where limestone hills now stand, there were coral reefs teaming with trilobites, sea lilies, brachiopods and other creatures. More than 700 species of fossils have been found there, 86 found nowhere else on Earth. Crinoids from a much younger geological period cover the beautiful slab of rock to the right. These examples of *Pentacrinus* date from the Jurassic and are about 190 million years old.

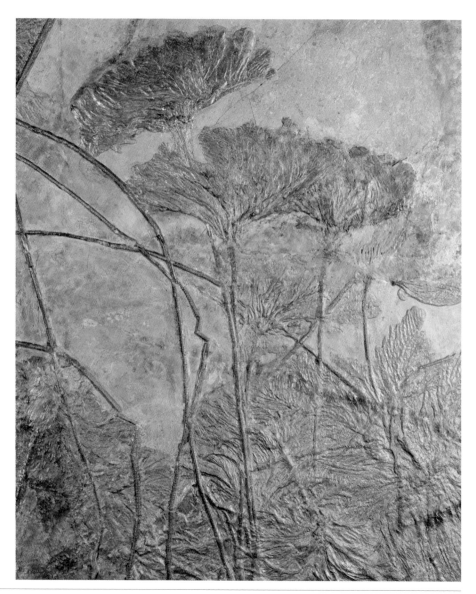

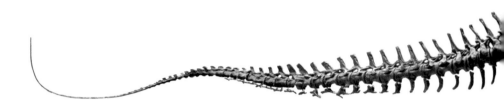

Dinosaur teeth

These teeth inspired one of the biggest ideas in evolutionary history, that giant reptiles (later named dinosaurs) used to walk the Earth. Each tooth is about the size of a peach stone and while they are of monumental significance, they were found quite by accident on the side of the road near Lewes in southeast England, in 1822. Mary Ann Mantell, wife of the doctor and palaeontologist Gideon Mantell, discovered them in a pile of gravel while accompanying her husband on one of his rounds, but Mantell was at a loss to identify them. He eventually took the teeth to the Royal College of Surgeons and showed them to an expert, Samuel Stutchbury. He thought they most resembled the teeth of a modern reptile, an iguana, though they were 10 times bigger. This information gave Mantell all the encouragement he needed and during the next three years he refined his theory that giant reptiles once existed. He finally named the teeth *Iguanodon* and published his idea in 1825. But it is Richard Owen, the Museum's first Superintendent, who is credited with 'inventing' the dinosaurs. Although Mantell was the first to identify these giant reptiles, it was Owen, in 1842, who coined the name Dinosauria for three particular species – including *Iguanodon* – effectively cashing in on Mantell's breakthrough.

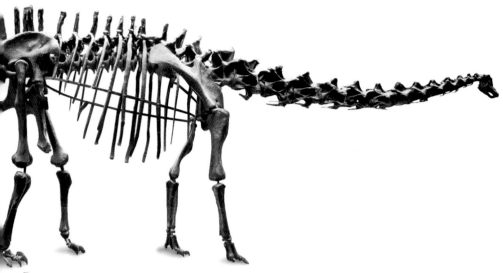

DIPLODOCUS SKELETON

The 26-metre *Diplodocus* skeleton, affectionately known as Dippy, was on display for more than 100 years until 2016. The first bone of this giant long-necked dinosaur, a sauropod, was found in 1898 in Wyoming, USA. The thigh bone, more than two metres long, caught the attention of Scottish-born millionaire Andrew Carnegie, who wanted the skeleton for his new museum, the Carnegie Museum in Pittsburgh, USA. More than three years and $10,000 later, Carnegie's team of palaeontologists uncovered enough fossil bones to build a complete skeleton. It was named *Diplodocus carnegii* in his honour. Carnegie showed illustrations of it to the Prince of Wales, soon to be King Edward VII, when he was visiting the United States in 1903 and told him about the complete skeleton in his museum. The Prince immediately suggested that a cast would make a very welcome addition to the Natural History Museum and Carnegie agreed to have a replica built at his own expense. It took 18 long months to make, was shipped over in 36 crates and was unveiled in the Reptile Hall to huge acclaim in 1905. At that time the tail used to rest on the ground, but later research revealed it would have been raised high to balance the neck, so in 1993 Dippy was remounted with its tail aloft.

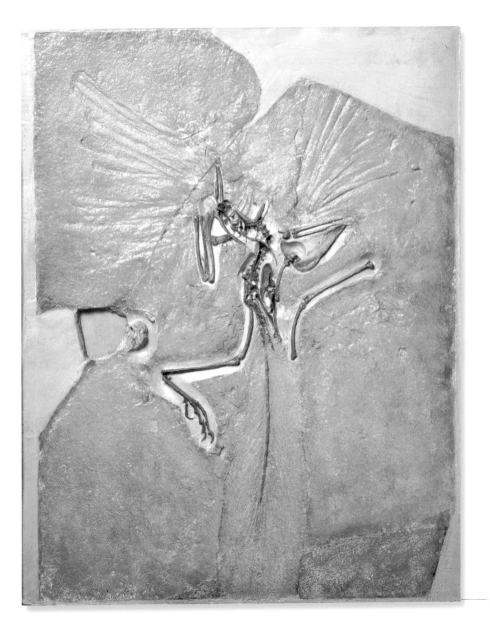

ARCHAEOPTERYX

Archaeopteryx lithographica is the most valuable single fossil in the entire collection. The oldest known bird, it kick-started the debate that birds evolved from dinosaurs. Only 10 have ever been found, all from limestone quarries in a small area of southern Germany. The small meat-eating creature has wings and feathers like a modern bird, but also the teeth, bony tail and hand claws of a dinosaur. Its outstretched wings and delicate body convinced the quarryman who discovered it that he had found the remains of an angel, preserved 147 million years ago in the fine mud of a lagoon. The Museum's first Superintendent, Richard Owen, realised it was something special but didn't know then what it signified. Luckily, he decided to buy it for the Museum from a German doctor, Dr Karl Häberlein, who sold his collection of 2,000 fossils to raise a dowry for his daughter's wedding.

Further evidence that dinosaurs evolved into birds was discovered in the 1990s, when several small meat-eating dinosaurs known as dino-birds were found in China, some covered in a downy coat of primitive feathers.

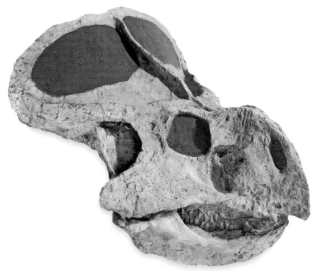

PROTOCERATOPS SKULL FROM MONGOLIA

Of the many dinosaur skulls in the collection, probably the most attractive, with its wonderful beaked mouth and elegant head frill, belongs to *Protoceratops*. This dinosaur lived during the Cretaceous period about 80 million years ago and this skull, roughly the size of a bear's, was found in Mongolia, the only place apart from China where this dinosaur is known. The first palaeontologists to venture into Mongolia's Gobi Desert were from the American Museum of Natural History, led by Roy Chapman Andrews in the 1920s. In those days the area was ruled by warlords, so it was with some trepidation they began their search. They must have made quite a sight, their line of cars choking across the dried earth, stopping occasionally to explore a rocky outcrop or refuel at the various camel caravans that met them with petrol and food. They had set out to look for human remains, but it wasn't long before they noticed *Protoceratops* skulls sticking out of the ground. They also found the first dinosaur eggs and the first *Velociraptor*.

TRICERATOPS

This was one of the last dinosaur species
to evolve, only two million years before
the great Cretaceous–Tertiary extinction
about 65 million years ago. It was a plant-
eater that lived in herds and roamed
across the plains of North America.
Tyrannosaurus rex may be famous for its
teeth, but *Triceratops* is loved for its frilled
skull and horns both of which no doubt
provided it with much needed protection
from predators. Despite their fearsome
appearance, however, they were probably
used more for courtship and dominance
displays than fighting.

The name *Triceratops* means three-
horned face, and the large pair of horns
above the eyes are each a metre or so
long. No complete skeleton has been
found, but numerous partial specimens
have helped piece together this
formidable animal, which probably grew
to a length of nine metres, with a skull
taking up at least one-quarter of that
length. The first *Triceratops* bones were
found in Colorado in 1887, and at first
the pair of brow horns attached to a piece
of skull were mistakenly thought to
belong to a large and unusual bison.

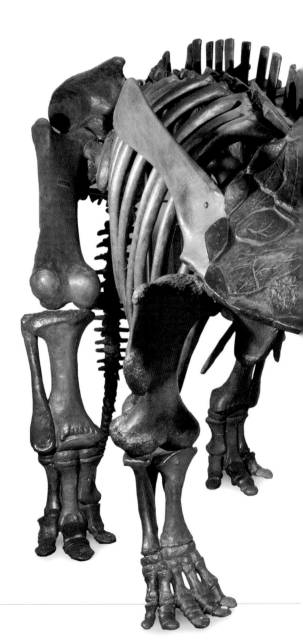

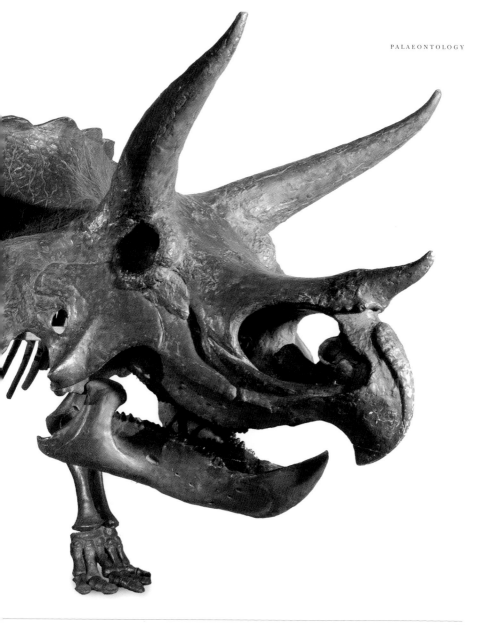

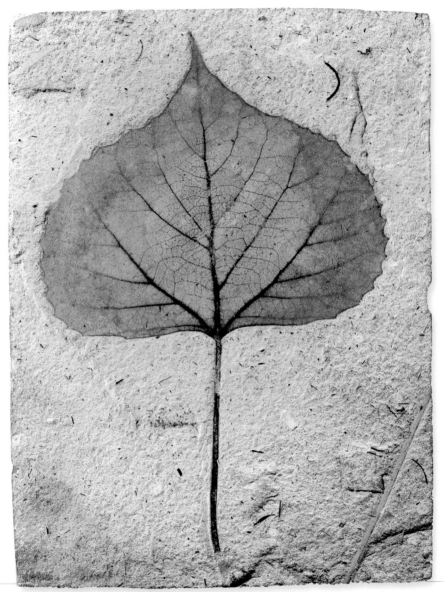

FOSSIL LEAF

Like a cut of lace pressed into limestone, this perfect poplar leaf from Öhningen, Germany, was preserved around 14 million years ago during the Miocene epoch. It is one of 200,000 fossil plants in the Museum's collections, all beautiful examples of how even the most fragile objects can survive if the conditions are right. The heart-shaped leaf probably fell from the tree and drifted down onto the surface of a lake and sank to the bottom, where it was covered in sediment. The water must have been very calm as the leaf is virtually intact. The only part of the original leaf that remains is its waxy cuticle, much more resilient than the soft tissues inside, which would have quickly decayed. But the specimen is valued for much more than beauty. Climate change scientists can obtain clues to earlier climatic conditions by looking at fossil leaf structures. Toothed edges are more common in leaves growing in cooler climates for example, and the more stomata (small pores through which the leaf breathes) there are on its surface, the less carbon dioxide there was in the atmosphere.

THE WORLD'S OLDEST FOSSILS

This wafer-thin slice of rock from Western Australia contains arguably the world's oldest fossils, preserved a staggering 3.5 billion years ago. They are cyanobacteria, one of the first forms of life on Earth. At about five micrometres across they are incredibly hard to see even under the microscope. The tiny microbes were discovered by the scientist Bill Schopf in 1993, while he was studying rocks from a deposit known as the Apex Chert. Schopf sliced the rock into sections thinner than human hairs and after examining them under the microscope was amazed to find the minute fossils. Whether they constitute life as such is still being argued by some scientists, but there is no doubt about their age. Lava deposits below and above the Apex Chert have been dated, confirming that the fossils were formed when the Earth was only one billion years old.

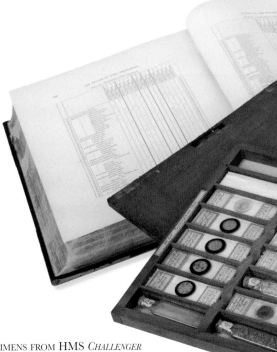

Specimens from HMS *Challenger*

These jars and slides are from HMS *Challenger*, the first major expedition to investigate every physical and biological aspect of the oceans. It left British shores in 1872 for a three-and-a-half-year voyage around the world, and experts on board brought back thousands of jars, bottles, tins and tubes of samples from the ocean floor. The dried and cleaned sediment looked like sand, but sand made up of billions of microfossils, tiny shells of single-celled organisms. At the time little was known about the deep ocean. Some scientists even argued life could not exist deeper than 550 metres. So when telegraphic cables, trailed along the ocean floor, were raised for repair and found covered in tiny crustaceans, it sparked a quest to find out more. *Challenger* criss-crossed the oceans, from South America to the Cape of Good Hope, Antarctica to Australia, the Fiji Islands and Japan and back round, recording temperatures, currents and depths of more than eight kilometres. Fifty volumes of research were produced, some by the Museum, and they are a unique legacy still in use today.

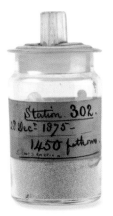

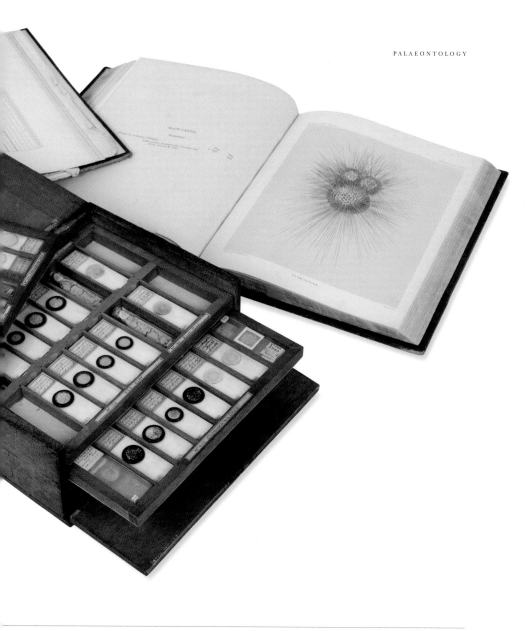

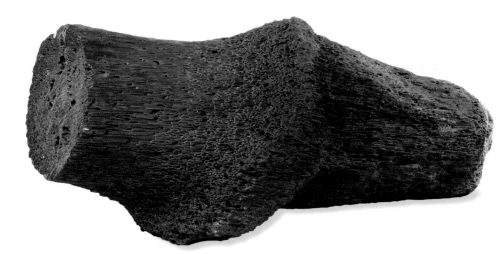

FOSSIL WOOD WITH VOODOO DOLL

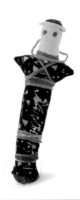

There are cupboards full of fossilised wood in the collection, but this specimen is unique in that it supposedly carries a curse. When the crate it came in was opened in 2001, the words 'bunga bunga gonnagetya' and a skull and crossbones were found scrawled on the inside. The curse was put on by a man in South Carolina to stop the wood being stolen, but as he had met and liked the scientist it was being sent to, he also included a protective voodoo doll. The wood itself is not that unusual, a fossilised palm from the North African desert. Fossils like this are remnants of a forest that grew there perhaps as much as 15 million years ago. This specimen came with a note explaining that the doll is the voodoo god of Loco, a patron of healers and plants, especially trees. To refresh the spirits of the doll it needs to be buried with the head of a dead dog once a year, but in the meantime it is kept alongside the wood.

Peas in a Pod

The fossil plant collections of
palaeontologist Professor T D A Cockerell
(1866–1948) are full of irresistible gems
such as this humble pod and its clutch of
peas, etched into rock 34 million years old
in Colorado, North America. But this
specimen has a 'twin'. Fossils often occur
as two halves, known as a part and a
counterpart. When a fossil hunter cracks
open a rock it often breaks along a line
of weakness, usually where the fossil is
embedded, and imprints of the fossil then
sometimes appear on each half. Cockerell
owned both halves of many fossil plants,
as well as some insects. He generously
distributed half of these specimens to this
Museum and others to the American
Museum of Natural History in New York
and the University of Colorado. Should
anything happen to the material in
London, scientists can still study the
counterpart specimens in America.

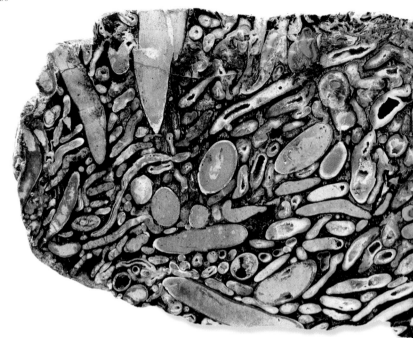

Shipworm borings

The shipworm, though small, is a formidably destructive force, whose insatiable appetite for wood has brought down piers, bridges and even battleships. This block of wood was attacked by shipworm (*Teredo* sp.) about 50 million years ago, when England was covered in tropical woodland. It floated out into the surrounding shallow seas where the worm struck, and eventually the wood sank to the bottom to be buried in mud and preserved. Shipworms are in fact clams, with tiny shells smaller than a little fingernail on the end of a very long worm-like body up to half a metre long. The shipworm eats into the wood and secretes a hardened shelly tube around itself as it goes. In heavily infested material, the wood can be replaced almost entirely by an intergrown mass of these tubes.

To give an idea of their impact, the Spanish Armada might have been successful in invading England in 1588 if it wasn't for the shipworm. As it happened, the Spanish boats were so riddled with borings they couldn't survive the British attacks or the bad weather.

Slipper limpets

Charles Darwin collected this stack of slipper limpets in Chile, and they are treasured among the many other plants and animals he brought back from his *Beagle* voyage (1831–1836). What Darwin didn't know then was that 50 years later a species of slipper limpet would invade the UK, becoming one of the most commonly seen shells along the south coast and contributing to the decline in native oyster populations. Slipper limpets (*Crepidula*) may look like limpets, but they are in fact snails of a different type. Intriguingly they live and grow in chains

of up to 12 animals, with younger, smaller shells at the top and older, larger shells towards the bottom. The oldest one at the very bottom eventually dies and falls off. Why they form chains is uncertain. Individuals at the top are male, those in the middle hermaphrodite, and the ones at the bottom are female – each male passes through a hermaphrodite stage, before becoming female. It's possible that living in a chain ensures there are several mates nearby, with the males at the top providing sperm for the females at the bottom to fertilise their eggs.

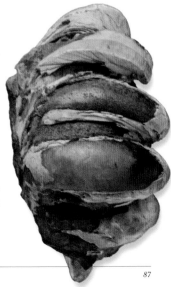

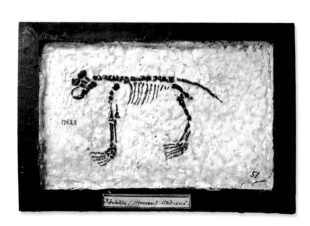

Fake rodent skeleton

This curious little rodent skeleton, on a slab roughly the size of a slice of bread, tricked one of the most respected scientists of the nineteenth century, Richard Owen. It was one of several sent in by an enthusiastic amateur palaeontologist called Reverend C Green, in 1843. Green said he had found the skeletons while digging along the Norfolk coast, the fragile little bodies preserved in mud. Owen was quick to suggest they came from a very ancient group of rodents, many millions of years old, and chose four for the national collection. But

SPIRAL MYSTERY

the skeletons had not been dug out of the ground whole. The Reverend had stuck the bones on separately and from different individuals. They were also much younger than Owen supposed. It might have been a trick, but quite possibly the Reverend just assembled displays of the bones he had lovingly excavated in order to show his friends the fruits of his labours, digging around in the mud on the windy cliffs. Owen realised his mistake eventually and furiously tagged the Reverend's work 'a wicked deception', probably to try and salvage some pride.

This almost three-metre-long spiral of rock that looks like a giant snail is called *Dinocochlea*. But no one knows what this bizarre object is. It, and a few others like it, have been found in East Sussex in southern England, in rocks that are about 135 million years old and also contain bones of the dinosaur *Iguanodon*. One thing we can be sure of is that *Dinocochlea* is definitely not a snail. There is no trace of shell and there are no growth lines. It's just solid rock. Usually if snail shells become filled with sediment and the shell erodes away on the outside, a cast of the

shell is left inside, imprinted with the shell's ridged contours. This one is smooth. Unlike snails, the coils are rather uneven and spiral in one direction in one specimen, but the opposite direction in another. Is it a coprolite, fossilised dung from a dinosaur perhaps, or is it too uniform a shape for that? Is it a spiral burrow, infilled by sediment millions of years ago? If it is, it would have taken a large animal, certainly a vertebrate, to make it. For now it will remain one of the many mysteries of the natural world, awaiting further scientific study.

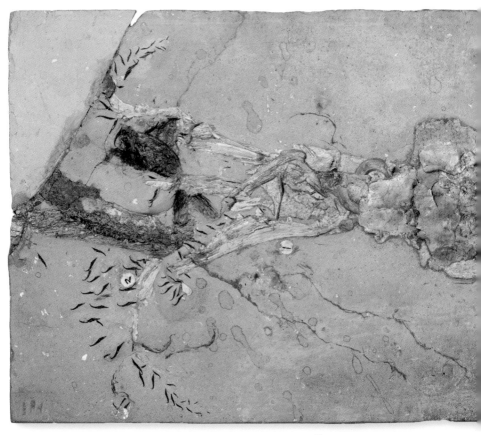

Fossilised squid

It is incredibly rare to see a whole fossilised squid like this one. Usually the soft parts decay very quickly, leaving only the tiny, tentacle hooklets as evidence a squid was ever there at all. But this beautiful example of *Belemnotheutis antiquus* has both the body and tentacles intact. It comes from the famous Oxford Clay deposits in Wiltshire, southern England, and is 160 million

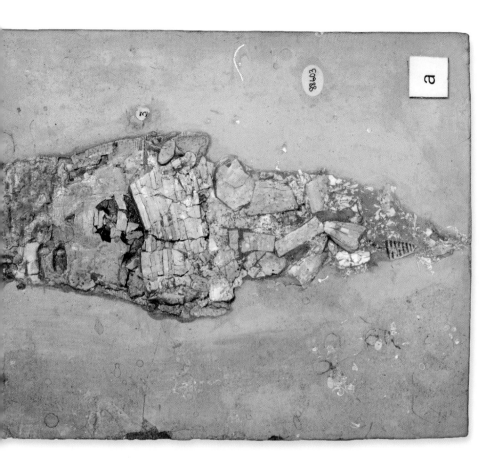

years old. Its label is missing but the squid was probably found in the mid-1800s, a time when digging was carried out by hand and eagle-eyed workers would pick out gems such as this. Unfortunately, now that heavy machinery does the work, fossils often go unnoticed. At the time when the Oxford Clay was laid down, the sea floor was covered in fine sediment into which dead organisms gently fell, and the ocean bottom was a realm of calm with little oxygen and few predators to feast on the remains. The soft parts of the animals were converted to a phosphate mineral, probably derived from phosphorus produced by the decaying carcasses, and so the soft organs, tentacles and sometimes even ink sacs were preserved.

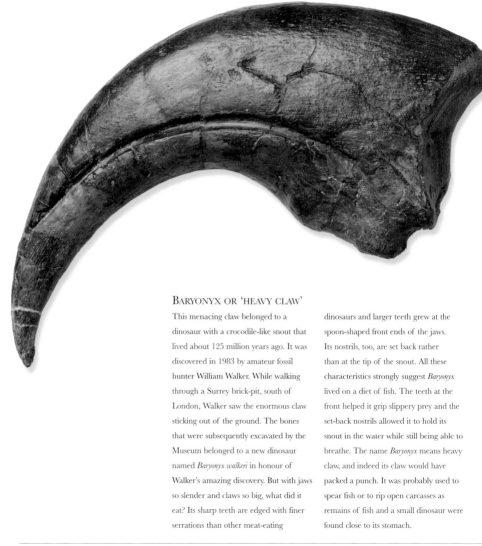

Baryonyx or 'heavy claw'

This menacing claw belonged to a dinosaur with a crocodile-like snout that lived about 125 million years ago. It was discovered in 1983 by amateur fossil hunter William Walker. While walking through a Surrey brick-pit, south of London, Walker saw the enormous claw sticking out of the ground. The bones that were subsequently excavated by the Museum belonged to a new dinosaur named *Baryonyx walkeri* in honour of Walker's amazing discovery. But with jaws so slender and claws so big, what did it eat? Its sharp teeth are edged with finer serrations than other meat-eating dinosaurs and larger teeth grew at the spoon-shaped front ends of the jaws. Its nostrils, too, are set back rather than at the tip of the snout. All these characteristics strongly suggest *Baryonyx* lived on a diet of fish. The teeth at the front helped it grip slippery prey and the set-back nostrils allowed it to hold its snout in the water while still being able to breathe. The name *Baryonyx* means heavy claw, and indeed its claw would have packed a punch. It was probably used to spear fish or to rip open carcasses as remains of fish and a small dinosaur were found close to its stomach.

Mammal-like reptile from South Africa

We know mammals evolved from ancient reptiles because of skulls like this *Cynognathus crateronotus*, which shows the gradual transformation between the two. It lived during the Triassic period, about 240 million years ago, 20 million years or so before the dinosaurs appeared. All modern mammals are descended from animals like it, and the clues lie in its mouth. While other reptile groups at the time had one type of tooth, *Cynognathus* had three, just like modern mammals. Each tooth type had a different role. The large incisors at the front were for cutting, the paired canines ripped and stabbed into flesh, and shearing cheek teeth lined the back of the jaws. These specialised teeth, and the fact that *Cynognathus* had forward-facing eyes, are both strong evidence that this was a line of evolution leading to modern mammals. Animals such as *Cynognathus*, still reptiles but with mammal features, dominated the land until their reign was cut short by another even more successful group of reptiles, the dinosaurs. With the dinosaurs around, the mammals remained a group of small and probably nocturnal animals. But when the dinosaurs died out 65 million years ago, mammals were able to flourish and diversified into the hugely varied group we see today.

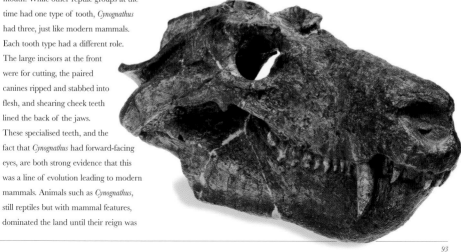

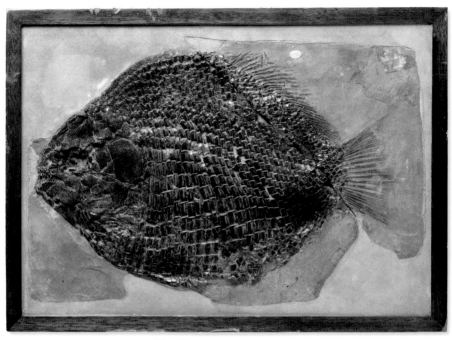

FISH DAPEDIUM

This *Dapedium* fish from the Jurassic period is exceptional because it is so exquisitely preserved, still with all of its scales and skull bones perfectly in life-positions. The Museum has no record of where this particular specimen came from, but similar ones are found in rocks dating back 200 million years and exposed along the south coast of England around Lyme Regis in Dorset.

The deep body, long fin along the back and fan-shaped tail all suggest that *Dapedium* was a slow but manoeuvrable swimmer able to move among narrow crevices in the shallow seas of the time. The small mouth and short jaws are equipped with many small peg-like teeth. These are believed to have been used for nibbling seaweed and coral heads. *Dapedium* was one of the first fishes to adopt this type of feeding called browsing. This demonstrates to scientists that the habit of browsing, as opposed to snapping at prey or crushing shells, is very ancient.

Dapedium gets its name from the Greek word meaning 'pavement'. This is an allusion to the pattern of thick, rhomboid scales that closely interlock with one another and form a tough protective cover to the body. The head bones are also very thick and provided further protection against predators.

Gogo fish

The Gogo fish (*Eastmanosteus*) was one of the first ever fossils extracted using acid, a simple yet groundbreaking method pioneered by Harry Toombs at the Museum in 1948. Instead of painstakingly chipping away at the limestone that encased the fish skeleton, Toombs immersed it in dilute acetic acid (vinegar) for several weeks. Slowly, the skeleton began to emerge as the rock disintegrated, and once all the bones were freed they were glued back together to reconstruct this extraordinary fish. Extracting fossils with acid is now widespread, not only because it is easy to do but because the freed bones are virtually unscathed by the process, so the quality of preservation is extremely high. *Eastmanosteus* belonged to a strange group of fish known as placoderms, primitive creatures with bony shields covering the head and front of the body. They once lived all over the world, but became extinct around 355 million years ago for reasons scientists still do not fully understand. This fossil came from an area in Australia known as Gogo, which was a coral reef some 370 million years ago.

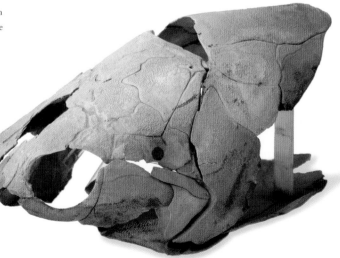

WOOLLY RHINO TOOTH

This woolly rhino tooth, together with two others, was among the earliest finds in the fossil mammal collection. They were found in 1668 at Chartham, near Canterbury in Kent, by natural historian John Somner, who thought they belonged to some kind of sea monster. It was a fair guess, given they were each the size of a small child's fist. Indeed, fossil rhino skulls, with their elongated snout, enlarged nostrils and high crest, may have inspired the legend of the dragon. Somner died of the plague before he could publish his conclusions and so it was left to his brother, William, to print the article, 'A Brief Relation of Some

Strange Bones There Lately Digged Up In Some Grounds of Mr John Somner'. As soon as Nehemiah Grew, a formidable character at the Royal Society, saw the teeth in 1681 he realised they belonged to a rhino, with their raised edges good for slicing leaves from plants and their flattened surfaces for grinding them. However, it was not until 1846 that Richard Owen, the Museum's first Superintendent, correctly identified the teeth as from the upper jaw of a woolly rhino, similar to a black rhino today but covered in thick hair. It lived around 35,000 years ago, when temperatures were much colder.

PORTRAIT OF RICHARD OWEN

As well as being the main driving force behind the building of the Natural History Museum, Richard Owen had an extraordinary gift for interpreting fossils. His deduction that the bone in this painting once belonged to a moa, an extinct and giant flightless bird, is a brilliant example of his talents. Because of his ability to read bones, Owen was sent many samples from explorers and scientists around the world. In 1839, Owen was sent what looked like a leg bone with the ends cut off by a colleague in New Zealand. The bone was only about 15 centimetres long, but Owen quickly deduced it belonged to a spectacular creature that no longer existed. The honeycomb matrix and the fact it was hollow made him think it must be from a bird, but its size suggested the bird would have been too big to fly. Owen concluded, 'as far as my skill in interpreting an osseous fragment may be credited, I am willing to risk the reputation that there has existed, if there does not now exist, in New Zealand, a struthious bird nearly, if not quite equal in size to the Ostrich'.

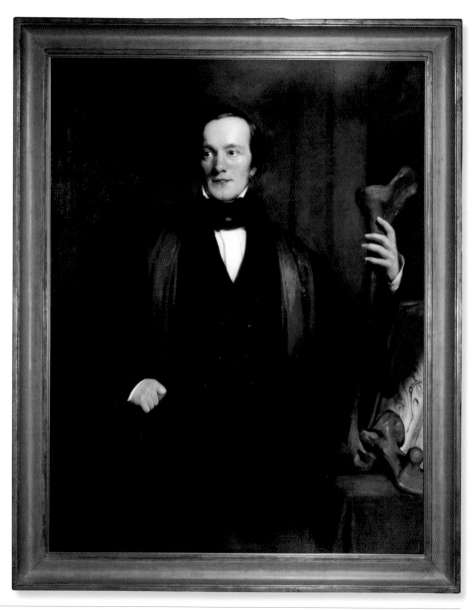

HERON-ALLEN MICROSCOPE SLIDES OF FORAMINIFERA

These two charming Christmas greetings are spelt out in minute shells, celebrating not only the artistry required to make them but the diversity of the often elaborate shells. Each shell is made by tiny, one-celled organisms called foraminifera, and the smallest are no bigger than grains of sand. The shells come in all shapes – fine strands, coiled spikes, rounded spheres, stars. Yet each has a name. Edward Heron-Allen exchanged his Christmas slides with other scientists as the one above bears the initials A E for Arthur Earland, his one time scientific collaborator. The one below contains his own initials and the year it was made: E H A, 1909. Heron-Allen spent many hours at the Museum, studying the foraminifera and curating the collections. He also bought from other collections to add to it and there are now hundreds of thousands of slides in the collection, some with single foraminifera, others hundreds. Heron-Allen was accomplished in other ways too; he spoke Turkish, translated Persian, practised palmistry, was a proficient musician and even made two violins.

WOODWARD TABLECLOTH

Far more impressive than a visitor book, this metre-square of tablecloth is covered in the embroidered signatures of every scientist who dined at the house of Sir Arthur Smith Woodward. He was an eminent British palaeontologist and Keeper of Geology at the Museum between 1901 and 1923, and his wife Maud created the poignant reminder of their hospitality through 50 years of marriage. In 1986, their daughter Margaret Hodgson paid for the cloth to be mounted as a tribute to her father. There are almost 350 signatures, from all over the world. In the days before aircraft, some visitors would have travelled weeks by ship to reach London, rewarded by long dinners steeped in debate on science or world affairs. Among them were C C Young, known as the father of vertebrate palaeontology in China, and Alfred Romer, author of several famous anatomy textbooks still used by students. And what did Othniel C Marsh discuss over dessert? Perhaps the infamous 'bone wars', a bitter career-long struggle he had with Edward Cope to see who could discover the most dinosaur bones in North America.

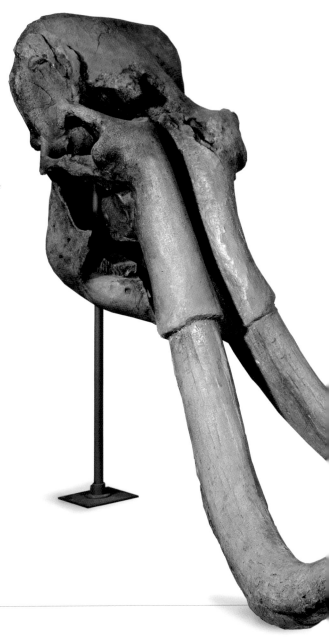

MAMMOTH SKULL

This is the only complete skull of a steppe mammoth ever found in Britain – and what a skull. It belonged to a creature as big as a large elephant, its awesome tusks stretching for two metres. It is without doubt one of the most visually impressive specimens in the Museum. In 1864 the Museum's curator of fossil vertebrates was called out to Ilford, Essex, to help excavate it. The huge skull lay buried five metres or so down in a clay and gravel pit, most unusually still intact. Like elephants today, mammoths tended to move the bones of their dead. This one must have died and been quickly buried naturally, possibly by falling into a river. It was originally thought to be a woolly mammoth, but by looking at its teeth in particular we now know it isn't. Woolly mammoths had teeth to suit their ice age environment, with numerous enamelled ridges to grind up the tough, grassy plants. But the teeth of this creature have fewer ridges because its food included trees and shrubs. It lived during a warm, interglacial period, about 200,000 years ago, and it may also have had less fur than its woolly ice age cousin.

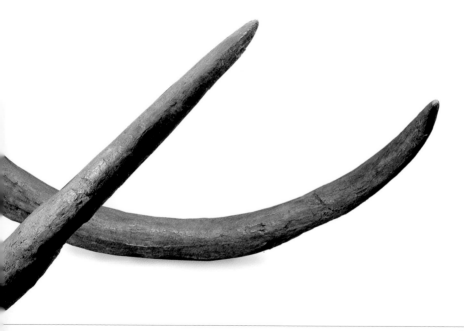

PYGMY ELEPHANT TOOTH

This pygmy elephant tooth, shown
here next to one of normal size, was
discovered around 1901 by Dorothea
Bate (1878–1951), a fearless and
incredibly accomplished palaeontologist
who contributed many specimens to
the collections. Sexism in science was
rampant at the time – women were not
even allowed to apply for jobs at the
Museum until 1928 – but in hat and
skirt, and with no escort, Bate became
the first person to excavate the remote
limestone caves of Cyprus, Crete, Malta
and Sicily. Her efforts were rewarded
when exploration of the caves revealed
the remains of unique pygmy versions
of elephants, hippos and deer that
lived there up to 500,000 years earlier.
Scientists already knew about island
dwarfism, where large species evolve
into smaller varieties through food
shortage and lack of predators, but her
finds greatly increased the evidence for
it. The animal this tooth came from was
the size of a big dog, but its ancestor was
a 10-tonne giant. Note the remarkable
similarity in shape between the two,
despite one being so much smaller.

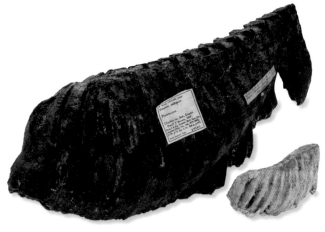

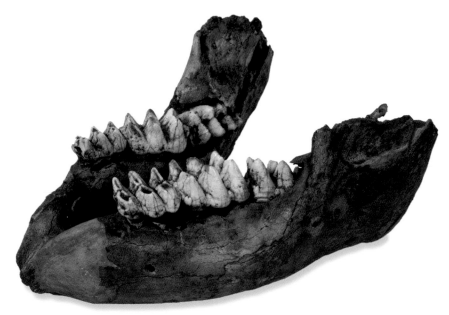

KOCH MASTODON'S JAW

In 1841, London flocked to see this and other gigantic bones in a stunning travelling exhibition from America. The enormous skulls, jaws and bones all belonged to an extinct relative of the elephant. They had been unearthed the year before on the shore of the Pomme de Terre River in Missouri by Albert Koch from St Louis Museum. Koch knew a crowd pleaser when he saw it. After excavating the bones, he took them to Louisville, where they formed the centrepiece of a full skeleton that stood more than four metres high. Dubbed *Missourium theristrocaulodon*, it was bigger than it should have been and was compiled from several individuals, but the crowds came in their thousands. When the exhibition came to London, the timing was perfect. Just months before Richard Owen had coined the word 'dinosaur', following the discovery of huge fossil bones, and so big bones were in vogue. The exhibition ran in Piccadilly for 18 months, from 9 in the morning to 10 at night. It was due to tour Europe, but the British Museum was so keen on the bones it bought the entire show for US$ 2,000, and the bones now fill several cupboards in South Kensington.

OLDEST FOSSIL INSECT

These jaws belong to the oldest insect ever found, preserved in rock about 400 million years old. They were overlooked in the collection for years, but reveal that winged insects may have been flying 80 million years earlier than previously thought.

Only by chance does an animal die in the right place and at the right time to be fossilised. But even preserved fragments can reveal much to the trained eye. These jaws were identified as belonging to *Rhyniognatha hirsti* in 1928, but the partial specimen was then largely ignored. It wasn't until more than 70 years later in 2002, when two American scientists came to study the insect fossil collections, that their true value was appreciated. They discovered that the jaws are very advanced, like those only seen in winged insects. Previously, the oldest flying insect fossils known were about 320 million years old. But even though this specimen wasn't preserved with any wings, this jaw evidence was still enough to rewrite insect evolutionary history.

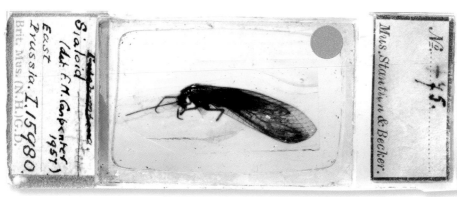

INSECT IN BALTIC AMBER

This insect, which is more than two centimetres long, is not only the largest insect preserved in amber in the collections but also the only known example of its species. What's more, it took more than 100 years and intense study to work out exactly what it was. The insect came to the Museum in 1892, from the amber mining company Stantien and Becker, which was based on the shore of the Baltic Sea. The company sold amber and amber oil to various industries (for varnishing boats, cosmetics, soldering etc) and also built up its own amber museum. It wasn't until 1957 that this insect was studied and identified as some

kind of alderfly. There are only two families of alderfly, and in 2000 it was assigned to one of them. But a few years later, when a student chose to study it, the picture changed. After a year of examining every detail of the insect, from the pattern of veins on its wings to the structure of its tiny feet, the student realised it was very different to any insects living today. Scientists agreed that while it shared many features with the two living alderfly families, there were enough differences to suggest that this insect, which was given the scientific name *Corydasialis inexpectatus*, belonged to a third and entirely separate family.

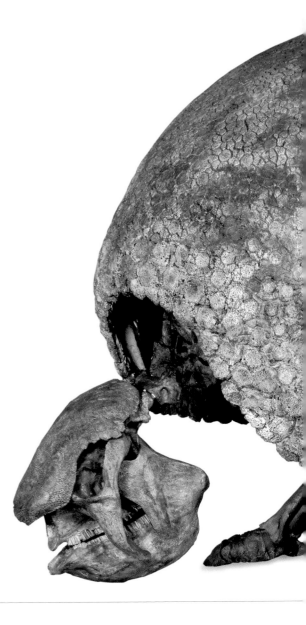

Glyptodon

Bigger than a baby elephant, *Glyptodon clavipes* was the most armoured of all the ice age mammals, with a huge dome of bony shell. This giant relative of the modern armadillo grew to about three metres from head to tail. It roamed – slowly – around the humid swamps of southern USA and Mexico, wallowing in the mud and feeding on plants, until it died out 10,000 years ago. Its most distinctive feature was its shell, made up of about 2,000 small plates of bone, each about three centimetres thick and fused together to form a spectacularly off-putting defence. If the shell was not enough to deter predators, a swing from *Glyptodon*'s clubbed tail would probably see them off. And although it couldn't roll up like its armadillo relative, *Glyptodon* merely had to tuck its small head into its shell to become completely invulnerable to attack.

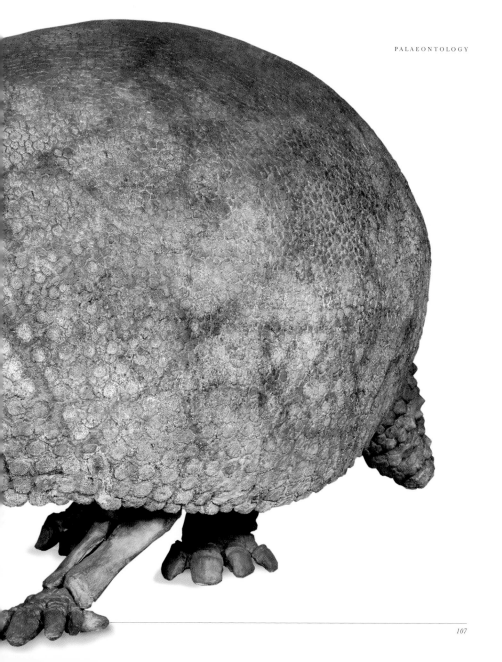

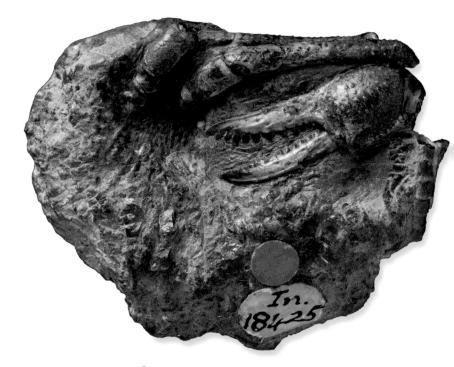

Oldest fossil crab

Three centimetres long, and only a little larger than a thumbnail, this is the oldest crab fossil (*Eocarcinus* sp.) ever found. It was unearthed in Gloucestershire in the nineteenth century, but lived 180 million years ago, when this area of southern England was covered by a shallow sea. Although 180 million years may seem old, crabs appeared relatively recently in the fossil record when compared with many other animals. They belong to the phylum Arthropoda, an enormous group that includes the insects, arachnids and crustaceans, all with segmented bodies. Arthropod fossils have been found in rocks as old as 550 million years, and crabs evolved about 350 million years later from prawn-like creatures. While the very first crabs were small, the largest living today is the Japanese spider crab, with a body big enough to cover a dinner plate and legs nearly two metres long.

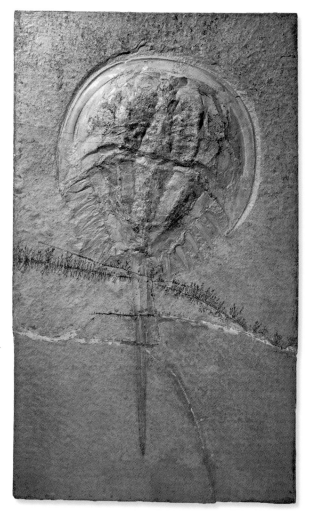

FOSSIL HORSESHOE CRAB

This fossil *Mesolimulus*, a horseshoe crab, is an impressive 40 centimetres or so long, about as big as a cat. It is beautifully preserved, every detail of its armoured body captured in the fine mud of a lagoon in Solenhofen, Germany, about 150 million years ago. The Solenhofen area has produced some of the world's most famous fossils, including *Archaeopteryx*, the oldest known bird and most valuable single fossil in the Museum's collections. Fossils from this area are immediately recognisable because they are preserved in exquisite detail on very smooth, pale yellow slabs of limestone. Horseshoe crabs have existed for 470 million years, long before the dinosaurs, and the earliest species were only one to five centimetres long. Because of their conservative body form and long evolutionary history, modern horseshoe crabs have been dubbed 'living fossils'. Four species are found today, off the coasts of Japan, Southeast Asia, and eastern and central America.

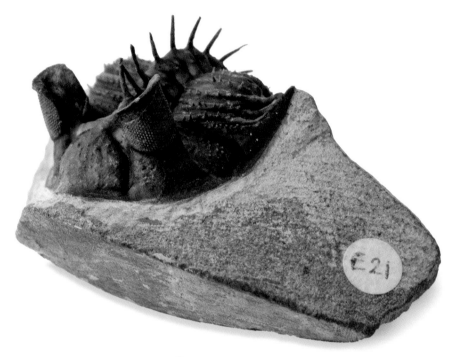

TOWER-EYED TRILOBITE

Only a few complete specimens of this spectacular *Erbenochile* trilobite have ever been found, the best coming from Morocco's Atlas Mountains. This one is about the size of a walnut and was bought from a dealer in 2002. Excavating this specimen from the surrounding rock took incredible skill and patience, using air abrasives and drills under a microscope. Many of the spines had to be cut through one by one and then carefully glued back on once the rock had been removed from around them. Trilobites were successful predators that existed 300 million years ago in ancient oceans. They were one of the first animals to develop complex eye systems, and *Erbenochile* is an exceptional example. What look like towers either side of its head are huge eyes, composed of hundreds of tiny lenses, which gave it a 360-degree view. The ridge at the top of the eyes probably acted as some kind of sun-shield, suggesting it was active during the day.

'DUDLEY LOCUST' BROOCH

This unusual Victorian brooch, a family heirloom given to the Museum by a Miss E Begg in 1960, is a polished trilobite mounted in gold. Fossil jewellery is an acquired taste, but was very much in vogue in the mid nineteenth century. It's likely the 425-million-year-old extinct arthropod attracted more attention than the usual diamonds and pearls. While there are hundreds of trilobite specimens in the Museum's collection, this is the only example in jewellery. Trilobites have, however, been found in native North American jewellery. Legend has it that these trilobites helped cure diphtheria, sore throats and other sicknesses and also protected the wearer from being shot. Trilobites, like arthropods today, were encased in a hard external skeleton which they had to shed from time to time in order to grow. Related distantly to today's horseshoe crabs, most crawled along the seabed but others floated among the plankton or were active swimmers. There were thousands of different species and this one is *Calymene blumenbachii* from the limestone reef deposits of Dudley, in the West Midlands.

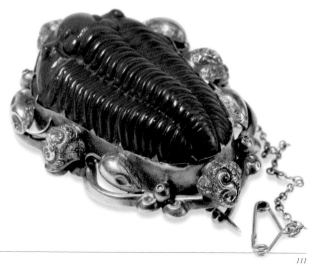

Giant deer antlers

These magnificent antlers are from the largest deer that ever lived, the extinct *Megaloceros*. They weigh a crushing 40 kilogrammes and have a span of three and a half metres. Also known as the Irish elk, *Megaloceros* lived across Europe and western Asia until it became extinct about 8,000 years ago. Growing up to two metres tall, the impressive animal was a target for hunters but the climatic changes at the end of the ice age also contributed to its demise. Like modern deer, only the males grew antlers, which were bone extensions of their skull that they shed each year to grow bigger ones the next. These tools of battle took vast amounts of energy to grow, so the deer fed on calcium-rich plants on chalk downlands to build up the bone. Most *Megaloceros* fossils have been found beneath Ireland's peat bogs, stained black from the peat like these ones. Recent research has allowed us to extract tiny amounts of residual DNA from the fossils and prove *Megaloceros* was related to the modern fallow deer.

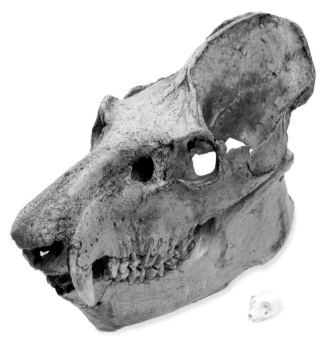

Lemurs from Madagascar

The lemurs of Madagascar are celebrated for their incredible diversity but also for their tragic recent demise. At least 17 species have become extinct during the last couple of thousand years, including the sloth lemur, which was as big as a chimpanzee, and the koala lemur, which was the size of a gorilla. There are still 50 living species of this remarkable group of primates, some as small as a mouse, others as large as a one-year-old human, but all are threatened by hunting and extensive loss of habitat. Lemurs first arrived on Madagascar, off the east coast of Africa, about 60 million years ago. It was too far to swim from the mainland, so they probably drifted over on natural rafts, purely by chance. These first arrivals would have been small and uncommon, but once on Madagascar, with limited competition and few predators, they increased in size and numbers to fill every available ecological niche. That all changed when humans arrived 2,000 years ago. The large species were the first to go, as big animals are more vulnerable to habitat loss, more attractive targets for hunters and slower to reproduce.

SLOTH SKIN AND JAW BONE

This rare sloth skin, one of the best examples of its kind, was found in a cave in Chile in the early 1900s. It looks like it was collected yesterday, so much so it even sparked a hunt to find the living animal. But the creature it came from died 13,000 years ago, when cold dry winds quickly turned it from soft, vulnerable tissue to a leathery relic. Fossil skin makes up only a tiny percentage of fossils, as most skin and other soft tissues decay, leaving only the bones and teeth behind. The lower jaw (right) of a similar extinct ground sloth was collected by Darwin when he stepped off the *Beagle* in Argentina. Like so many fossils in this book, it was first officially recorded by the great scientist Richard Owen, the first Superintendent of the Museum. He named it *Mylodon darwinii*, in honour of Darwin. It is one of the few survivors from a bomb that destroyed the basement stores of the Royal College of Surgeons during the Second World War. In life, the giant sloth was bigger than a gorilla and weighed about a tonne. It was too big to live in the trees, like its smaller and living relatives, and so foraged for plants on the ground. The sloth is known from many fossils, mostly bones, but also from fossilised dung.

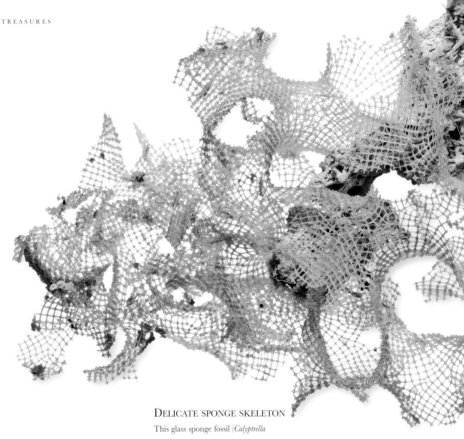

DELICATE SPONGE SKELETON

This glass sponge fossil (*Calyptrella tenuissima*), from near Hanover in Germany, is so delicate curators hardly dare touch it. It died on the seabed about 80 million years ago and somehow managed to keep its shape after being buried in sediment. Usually when these delicate animals die, their needle-like skeletons of silica disintegrate to become part of the sea-floor sediment or are dissolved and then re-precipitated as flint nodules in the chalk. This particular fossil, however, escaped both disintegration and dissolution and was preserved with its delicate meshwork skeleton intact. Sponges are very common fossils in Late Cretaceous marine deposits, which include the chalk forming the White Cliffs of Dover.

COCCOLITHS

This stunning photograph, taken with a scanning electron microscope, exposes the rarely seen complexity of a coccolithophore, a tiny marine alga made up of just one cell. It has been coloured to show the different features, including the chalky armour of plates (or coccoliths) that surrounds each one. When the algae are eaten, the coccoliths are not digested and pass out in the animal's faecal pellets, sinking to the ocean floor to form chalk and limestone deposits.

The chalk of the White Cliffs of Dover on the south coast of England is almost entirely composed of coccoliths, deposited during the Late Cretaceous, between 100 and 65 million years ago. There are a few thousand coccolithophores floating in every litre of the ocean's surface waters, forming one of the main groups of phytoplankton. Phytoplankton may be small, but they are at the base of the marine food chain, and everything else in the sea depends on them. They also play a huge role in helping to combat climate change (caused by the build up of carbon dioxide in the atmosphere) by absorbing carbon dioxide from the air as they photosynthesise.

ENTOMOLOGY

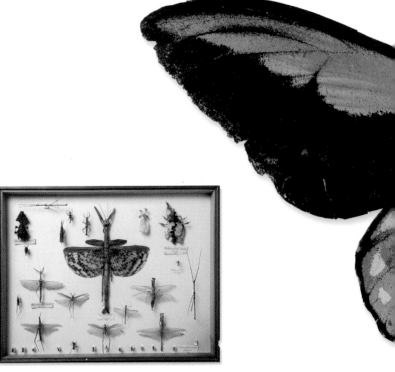

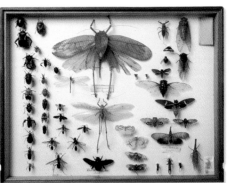

GOLDEN BIRDWING BUTTERFLY

This magnificent butterfly is treasured
not only for its glorious fiery wings,
but also for the man who collected it,
Alfred Russel Wallace, best known for
developing his own theory of evolution by
natural selection independently of Charles
Darwin. Part of Wallace's inspiration for
the theory came from the huge variation
he witnessed among the insects, birds
and other animals he collected on his
travels. Many of the thousands of animals

he collected are now in the Museum, including the recent addition of 850 butterflies, beetles, stick insects, earwigs, bees, ants and more, kept in 28 drawers and left exactly as Wallace arranged them (left). The magnificent golden birdwing butterfly (*Ornithoptera croesus*) is one of the most famous insects in the collection. Wallace caught it on the Indonesian island of Batchian (Bacan) in 1859, during eight years travelling around the Malay Archipelago. Far from being a cold observer of their habitats and variety, Wallace was entranced by insects. In his book *The Malay Archipelago*, he described what it was like catching the male birdwing: '... on taking it out of my net and opening the glorious wings, my heart began to beat violently, the blood rushed to my head… I had a headache the rest of the day, so great was the excitement...'

ORCHID BEES

Orchid bees are among the most spectacular insects in the collection, many species of which have a striking green iridescence. Despite the name, they feed on nectar and pollen from a range of different flowers in the tropics of South and Central America, and their two distinct forms have two very distinct lifestyles. One group is hairy, like bumblebees, and builds nest cells of resin, bark or mud in which they store food. They lay eggs in the cells, and when the small larvae hatch they feed on the stores. The second group is more sinister. Having lost the hairs of their close relatives, they are covered in hard armour. They have also lost the habit of building nests, instead stealing into the nests of other orchid bees and leaving their eggs to hatch and feed. The armour protects them from the stings of any host bees if caught in the act of parasitising their nest. Like other bees, orchid bees are important pollinators, and one species is the main pollinator of the Brazil nut tree.

REINDEER BEETLE

The spectacular male 'flying deer' beetle (*Chiasognathus granti*) earns its name from its antler-like jaws, which are almost as long as its body. It lives fairly widely in Chile and Argentina and is one of 45,000 stag beetles currently being looked after by the Museum, each carefully pinned and then grouped in drawer upon drawer, cabinet after cabinet. Charles Darwin collected 12 of them in South America and describes them as 'strong insects' in his book *Descent of Man*. But while the jaws look as if they could give a nasty bite, they make poor teeth. The males use them instead for display and as powerful weapons in jousts, pushing male opponents away or even lifting them off the ground and flipping them over. While the adults are well studied, little is known of the large, cream, C-shaped larvae that feed on semi-rotten wood.

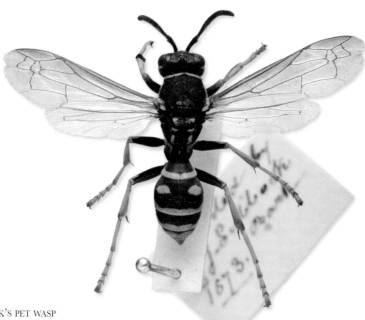

SIR JOHN LUBBOCK'S PET WASP

The treasure behind this wasp is the delightful tale of its owner, Sir John Lubbock (1834–1913), who presented it to the British Association's annual meeting in 1872, describing how he had learned to feed and stroke it without being stung. Lubbock caught the wasp in the Pyrenees and kept it as a pet until its death 10 months later. His account of its demise is touching. 'One day, I observed she had nearly lost the use of her antennae, though the rest of the body was as usual. She would take no food. Next day I tried again to feed her; but the head seemed dead, though she could still move her legs, wings, and abdomen. The following day I offered her food for the last time; for both head and thorax were dead or paralysed; she could but move her tail, a last token, as I could almost fancy, of gratitude and affection. As far as I could judge, her death was quite painless; and she now occupies a place in the Museum.' Despite this rather eccentric tale, Lubbock was a respected scientist, author, banker and Liberal politician. He improved labour laws and introduced the Bank Holiday Act, Wild Birds Protection Act and Public Libraries Act among others.

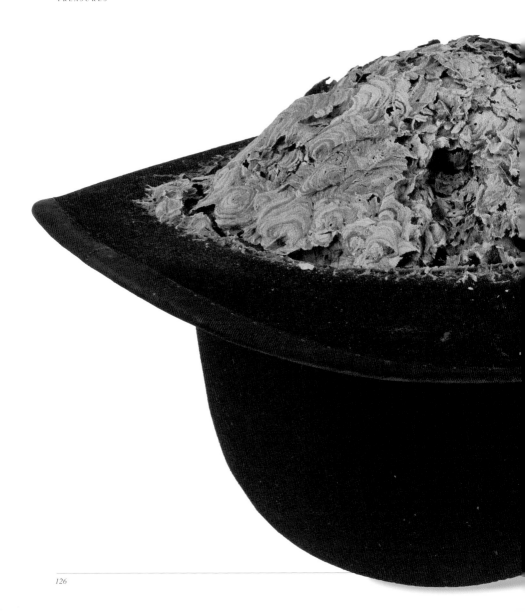

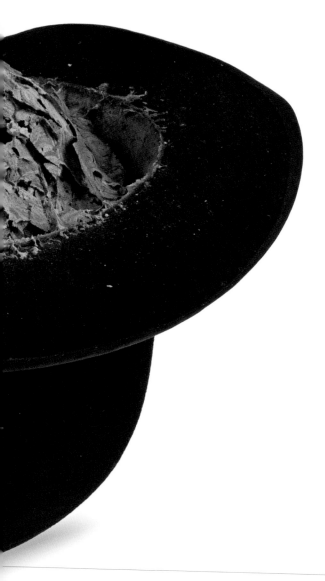

WASP NEST IN A BOWLER HAT

What finer place to build a wasp nest than in a bowler hat. It was found in an outhouse on the estate of Walter Rothschild in Tring, perhaps left by a gardener over the winter, and is now part of the collection. Rothschild would have welcomed the new inhabitant, being a lover of all wildlife. His extensive collections became part of the Natural History Museum in 1937.

The nest was built by the common wasp (*Vespula vulgaris*), the queens of which seek out protected hollows to start their building. They usually choose underground homes, deserted mouse holes or hollows at the base of trees, but some time in March a queen must have flown into the outhouse and seen the upturned bowler hat. She would have begun by chewing up some wood, using the pulp to build a few individual cells, layer by layer. After laying eggs in the cells, she waited for them to hatch in June, feeding the first offspring on insects. They then took over building the nest, leaving her to lay yet more eggs. Work continued until the weather turned cold, when the nest was abandoned.

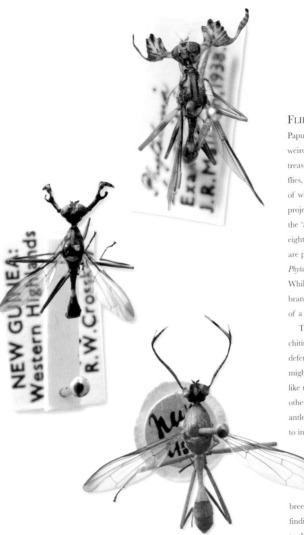

FLIES WITH ANTLERS

Papua New Guinea is renowned for its weird and wonderful wildlife, and its treasures include this group of fruit flies, known as antlered flies, the males of which have a variety of fantastic projections on their heads. The shape of the 'antlers' is different for each of the eight species in the group, three of which are pictured here: *Phytalmia cervicornis*, *Phytalmia alcicornis* and *Phytalmia biarmata*. While some antlers are slender and branched, others are wide like those of a moose.

The antlers are extensions of the chitinous exoskeleton and help the males defend their territory, but not as you might imagine. Instead of locking horns like rutting stags, males posture to each other, slowly twisting and turning their antlers into different and distracting poses to intimidate would-be attackers. Only if that approach fails will they actually launch a physical attack. The victorious male is able to secure the best spots for breeding and so has the best chance of finding a mate and passing on his genes to the next generation.

STALK-EYED FLIES

This fly, with the scientific name
Achias rothschildi, takes the expression
'eyes out on stalks' to a whole new level.
Its eyes are indeed at the end of stalks,
earning it the name the stalk-eyed fly.
Only the males have long stalks, which
vary in size, with a distance of two to
five centimetres between each eye (the
eyes on this specimen are about five
centimetres apart). Like all strange
physical modifications, these stalks have
probably evolved for a reason. The most
likely is to indicate a hierarchy among
males, where those with longer stalks
are dominant over those with shorter
stalks and are then more successful at
establishing territory and attracting
mates. This species was described in
1910 by Ernest Edward Austen, an
entomologist at the British Museum,
from specimens in Lord Rothschild's
collection, hence the Latin name. It and
several other closely related species of
stalk-eyed fly live in Papua New Guinea,
a treasure chest of the bizarre and
beautiful. Isolated from the Australian
and Asian continents, the region is full of
endemic species.

DRESSED FLEAS

Among the most popular oddities to
come out of the 1800s were dressed fleas,
like this man and woman. Scraps of cloth
and paper make up the clothes while the
flea, probably the human flea *Pulex
irritans*, only makes up the head, glued
on top. No one knows where the
phenomenon began, but dressed fleas
were made and sold as unusual souvenirs.
It's possible they came to life in convents,
as nuns were well known for making
miniatures of all sorts. At less than half
a centimetre tall they are impressive
constructions, particularly as the makers
probably had no magnifying equipment
and either worked in daylight or, if at
night, by lamps or candlelight. These
particular dressed fleas were probably
made in Mexico and are among 12 given
in 1910 to the Honourable Charles
Rothschild, a world expert on fleas. He
was the brother of Walter Rothschild,
whose natural history collection is now
the Natural History Museum at Tring,
the Hertfordshire town just north of
London. Also in the collection at South
Kensington is a wedding party, complete
with mariachi band.

CAPE STAG BEETLES

This rare beetle only lives on the high mountain tops of the Western Cape Province in South Africa. All 17 species of Cape stag beetle are endangered, and this *Colophon primosi* critically so. Slow-moving and flightless, Cape stag beetles are particularly vulnerable to habitat destruction and climate change because they are unable to disperse as other insects might. Indiscriminate collecting has also taken its toll, and anyone now found collecting them illegally faces heavy penalties.

All the species belong to the group known as *Colophon*, derived from the Greek word kolophon meaning summit or peak. Remarkably, each species is restricted to its own mountain range or peak, and they are so isolated that only a few entomologists have seen them alive in their habitat. Almost nothing is known of the larvae or what they feed on. In the past, specimens of Cape stag beetles have attracted very high prices among dealers. One European seller listed a specimen of *Colophon primosi* at almost £3,000, making it one of the most expensive insects in the world.

BOMANS' STAG BEETLE COLLECTION

The 32,000 stag beetles in this astounding collection were gathered by the French entomologist Hughes Bomans, and it is probably the most comprehensive stag beetle collection ever created by an amateur. Bomans bought and exchanged stag beetles over a period of 40 years, collecting specimens smaller than a fingernail and as big as your hand. He mounted them carefully in glass-topped boxes, then labelled and grouped them, even naming many of the new species himself. Because of his age and declining eyesight, Bomans auctioned the collection in 1999, hoping it would be purchased by a national museum and made available to stag beetle researchers worldwide. And it was, as the Natural History Museum beat off stiff competition from other European museums and private collectors to secure it for tens of thousands of pounds.

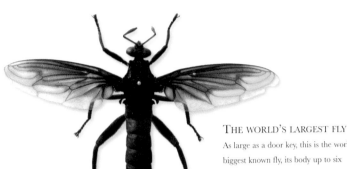

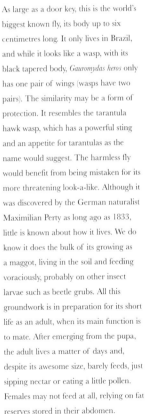

THE WORLD'S LARGEST FLY

As large as a door key, this is the world's biggest known fly, its body up to six centimetres long. It only lives in Brazil, and while it looks like a wasp, with its black tapered body, *Gauromydas heros* only has one pair of wings (wasps have two pairs). The similarity may be a form of protection. It resembles the tarantula hawk wasp, which has a powerful sting and an appetite for tarantulas as the name would suggest. The harmless fly would benefit from being mistaken for its more threatening look-a-like. Although it was discovered by the German naturalist Maximilian Perty as long ago as 1833, little is known about how it lives. We do know it does the bulk of its growing as a maggot, living in the soil and feeding voraciously, probably on other insect larvae such as beetle grubs. All this groundwork is in preparation for its short life as an adult, when its main function is to mate. After emerging from the pupa, the adult lives a matter of days and, despite its awesome size, barely feeds, just sipping nectar or eating a little pollen. Females may not feed at all, relying on fat reserves stored in their abdomen.

A WINGLESS FLY

It may look like a spider at first glance, but this is the sole member of a family of wingless flies, Mormotomyiidae, known only from one cave in Kenya. There are other wingless flies, many of which live their adult life on a single host as a parasite, but this is the only species in its family. It is about one centimetre long and covered in fine hairs. *Mormotomyia hirsuta* was first described in 1936 by Edward Ernest Austen, after specimens were collected from a cave on Ukazi Hill in eastern Kenya. It is completely dependent on the bats that roost in the cave, laying its eggs on the bat dung, on which the larvae that hatch will feed. The adult flies are thought to feed on body secretions from the bats, spending their entire short life in this remote spot, unable to fly out but with little cause to.

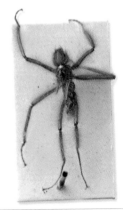

Sphinx moth

Extreme nature at its best, this Morgan's sphinx moth (*Xanthopan morganii praedicta*) has one of the longest tongues ever recorded for a moth. At 30 to 35 centimetres it is a little longer than a piece of spaghetti. But it was not its tongue that first attracted scientists, rather the flower it pollinates. In 1862, naturalist Charles Darwin examined a comet orchid (*Angraecum sesquipedale*) from the forest canopy of Madagascar. It had incredibly deep, tube-like flowers, about 30 centimetres from end to end. The large waxy flowers were indeed beautiful, but what intrigued Darwin was what kind of insect could pollinate it and how it could reach down the deep flowers to dip into the nectar. Darwin suggested it was a moth with a very long tongue, one as yet undiscovered. His idea was confirmed in 1903 when this moth was found. It took a further 80 years for scientists to witness the moth pollinating the orchid under controlled conditions and until this century to see it doing so in the wild. In 1986, a closely related orchid, *Angraecum longicalcar*, with an even longer flower was discovered. Its pollinator is yet to be identified.

INDONESIAN BUTTERFLY FIND

Bedford-Russell's tree-nymph (*Idea tambusisiana*) is probably the most spectacular butterfly find of the past 50 years. It was discovered in 1981, more than 100 years since the last species in its genus (*Idea*) was found. To appreciate its true splendour you must see it in flight, its large white wings floating softly in the breeze like a lost piece of paper, earning it another common name: the letter butterfly. This butterfly is only found in Indonesia and was discovered on the slopes of Gunung Tambusisi on the island of Sulawesi by Anthony Bedford-Russell. He was leading an expedition of school leavers on Operation Drake, a forerunner to Operation Raleigh. After a few days of hard climbing and heavy rain, the group had set up camp and were enjoying a dry spell while cooking up some bats for supper. Suddenly, Bedford-Russell spotted the large white butterfly in a clearing and, suspecting it was something unusual, scrambled for his net. After a short chase he caught it, and it later proved to be a new species.

CEROGLOSSUS BEETLES

Charles Darwin himself caught many stunning ground beetles in the Andes of Chile, while on his five-year *Beagle* voyage (1831–1836). Although birds are most often credited with inspiring his theory of evolution by natural selection, Darwin's first real passion was beetles and he collected them as a student in Cambridge. Wherever the *Beagle* docked, Darwin took the chance to explore and collect. Joined by a team of young and eager assistants, he collected 30 or more of these metallic specimens, in the *Ceroglossus* genus, to bring back and study. They would have had to work hard to find these voracious predators, stooping down to turn over stones and rocks to find them hiding from the daytime heat and predators. The beetles join the precious legacy of more than 10,000 insects collected by Darwin in the Museum's collections.

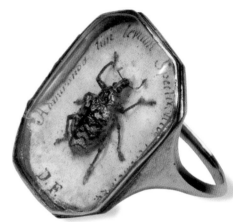

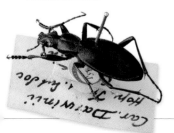

RING WITH A WEEVIL SET IN

Someone somewhere loved weevils so much they had one set in a gold ring, about 200 years ago. There is no record of how it came to the Museum; its label may have been lost or the ring never formally recorded. But, despite its glamorous casing, it is treasured in the beetle collection, among the other, more traditionally pinned specimens. The initials D F are engraved on it with the charming Latin inscription *admiranda tibi levium spectacula rerum*, from the poet Virgil: 'I'll tell of tiny things that make

a show well worth your admiration.' Perhaps it was made as a gift.

The weevil chosen as the centrepiece, *Tetrasothynus regalis*, is only one centimetre or so long and was a perfect choice, its glittering bands of copper and gold catching the light like jewels. The colour comes from minute scales on its surface, which under the microscope look like tiny balls of glitter. They interfere with the light, much like the scales on a butterfly's wing. This species lives in Hispaniola, an island in the West Indies.

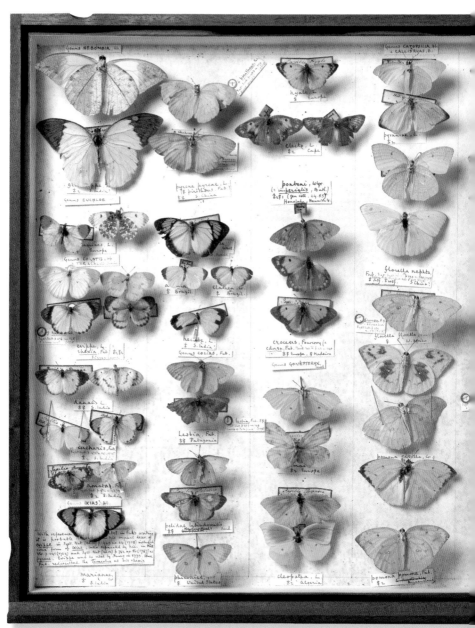

BANKS' INSECT COLLECTION

This is one of the first ever scientific collections. With more than 4,000 insects, including butterflies, flies, bugs and moths, it was compiled by Joseph Banks, once the president of the Royal Society and one of the most influential supporters of science of his time. Before collections like this most people simply gathered what took their interest or what looked beautiful, creating cabinets of curiosity that were a jumble of various objects. Only during the age of enlightenment did the hunger for knowledge about the natural world and how different species relate to each other lead to a more professional approach. In Banks' collection, each specimen is carefully pinned, named and set in well-ordered drawers, easy to navigate around and study. Much of the collection was gathered on board Captain Cook's voyage to explore the South Pacific (1768–1771), when Banks became one of the first Europeans to set foot on Australia. It was his only large-scale collecting trip, and he gathered specimens from Madeira, Tahiti, New Zealand, Australia, South America and parts of Africa. With the help of his assistants, Banks collected as many new species as he could to take back home to the UK. The collection is still being researched to this day, with new species continuing to be identified or renamed.

Tailed wax bug

The tailed wax bug (*Alaruasa violacea*) does not actually have a tail at all, because the extraordinary growth behind it is pure wax, secreted from the abdomen in tiny amounts throughout its life. As the bug matures, wax is slowly added and the 'tail' becomes longer and heavier. This one has the longest tail of all the specimens in the collection, about eight centimetres. No one knows why these bugs produce wax tails, but there are theories. One proposed idea is that the wax is a way for the bugs to get rid of lipid waste. Another suggests the tail might give the bugs a fighting chance if attacked from behind, the predator getting a mouthful of distasteful wax for its trouble. Tailed wax bugs live in tropical parts of South America, using their piercing mouthparts to feed on plant sap. They belong to the family Fulgoridae, most of which exude wax, often as what looks like a fine covering of cobwebs over the abdomen.

Peanut head bug

How the peanut head bug got its common name is self-evident. Its spectacular head is shaped like a peanut and, at six centimetres or so, is almost as long as its body. Why it has this shape is less obvious. One theory is that, if you look at it from the side, the bug looks like a lizard, and the dark markings could also be mistaken for teeth, both of which may ward off attackers. An insect might be easy pickings for a bird, but the bird might not attack so readily if it mistook it for a lizard. Because parts of the bug's gut extend into the head, another theory suggests the shape has something to do with digestion. Like other bugs in the family Fulgoridae, the peanut head bug secretes wax over its body from glands in the abdomen and thorax, giving it a fine white coat. It was described in 1767, by the great Swedish scientist Carl Linnaeus, who devised the system of assigning a two-part scientific name to every species. Its name, *Fulgora laternaria*, may have been inspired by a legend that the head glows like a lantern.

SILVER CHAFER BEETLE

While several groups of scarab beetles
have a beautiful shine, the silver
chafer beetle (*Chrysina limbata*) looks
as if it really is made of silver. It is a
perfect example of nature's variety and
extremes and is the jewel in the crown
for beetle collectors. This specimen is
the only one in the Museum. Despite
their startling appearance, these beetles
are not often seen in the wild, but
the few people who have seen them
say they sparkle as they fly through
the dappled light of the rainforests in
Costa Rica and West Panama. Far from
attracting other animals, their highly
reflective wing cases confuse predators
such as birds, reptiles and monkeys,
giving them time to make their escape.
How they achieve their metallic sheen
is not well understood. They have
a base pigment covered by several
colourless, microscopically thin layers
called laminae. These layers cause the
optical interference, in much the same
way as thin layers of aluminium do on
the playing surface of a CD.

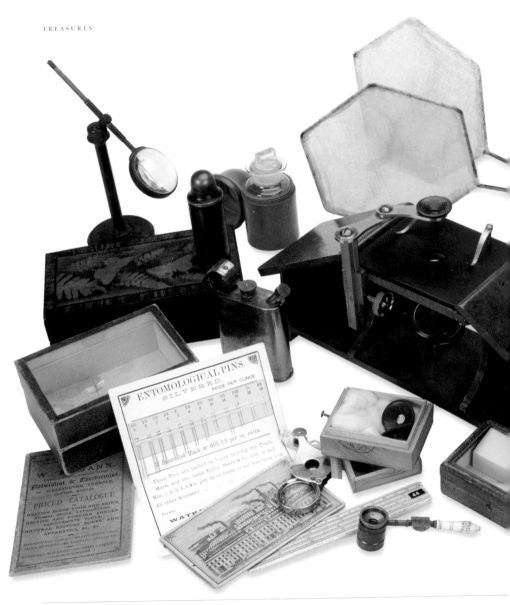

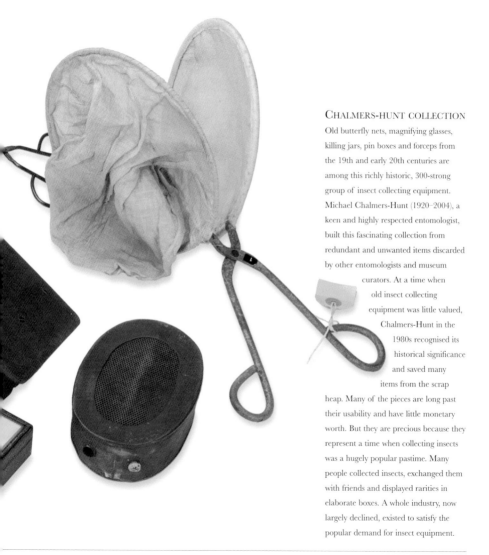

CHALMERS-HUNT COLLECTION

Old butterfly nets, magnifying glasses, killing jars, pin boxes and forceps from the 19th and early 20th centuries are among this richly historic, 300-strong group of insect collecting equipment. Michael Chalmers-Hunt (1920–2004), a keen and highly respected entomologist, built this fascinating collection from redundant and unwanted items discarded by other entomologists and museum curators. At a time when old insect collecting equipment was little valued, Chalmers-Hunt in the 1980s recognised its historical significance and saved many items from the scrap heap. Many of the pieces are long past their usability and have little monetary worth. But they are precious because they represent a time when collecting insects was a hugely popular pastime. Many people collected insects, exchanged them with friends and displayed rarities in elaborate boxes. A whole industry, now largely declined, existed to satisfy the popular demand for insect equipment.

ZOOLOGY

Sloane's nautilus shell

This elaborately engraved shell is
treasured for its beauty, not for science. It
was once home to a *Nautilus*, a squid-like
creature, but in the hands of Dutch
craftsman Johannes Belkien it became
a piece of art.

Belkien was born in 1636 and his
father was the famous Dutch mother-of-
pearl inlayer Jean Belkien. Very little is
known of Belkien's life or when he died,
but the style of the engraving suggests
this shell was produced in the last
quarter of the seventeenth century.
Following in his father's footsteps,
Belkien carefully exposed the mother-
of-pearl lining of the shell's chambered
interior, then engraved a sophisticated
scrolling leaf pattern and three densely
crowded figure scenes on to it. He has
signed it on one of the three roundels
at the front.

Sir Hans Sloane probably procured
the shell sometime at the end of the
seventeenth or beginning of the
eighteenth century and, after his death,
it became part of the founding collection
of the British Museum along with
everything else he had amassed.

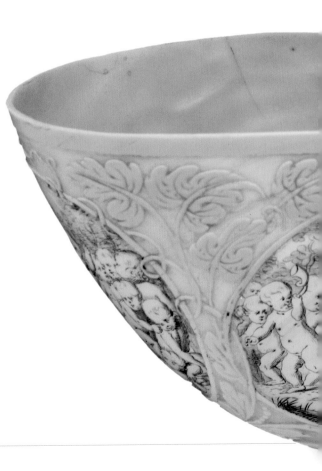

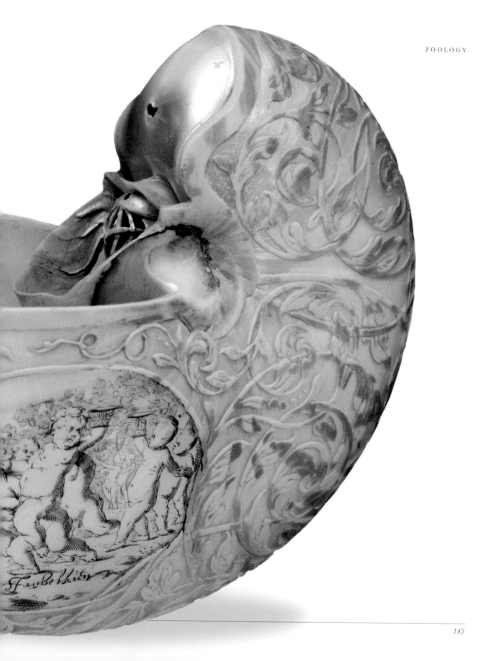

RACEHORSES

Not every bone in the collection
is important because of what it
reveals to science. This is the
skeleton of Brown Jack, one of 11
legends of the horseracing world
donated to the Museum. Each of the
horses has a file with data on all the
races it won and a chart tracing its
pedigree; but their main function now
is research. Vets, for example, come to
study the bones to look at injuries
developed as a result of the horses'
lifestyles, such as compacted spines from
being ridden so much when young, or to
look at how the bones move together.
Brown Jack is one of the most famous of
the articulated skeletons, together with
St Simon and Persimmon. St Simon was
foaled in 1881, the year the Museum
opened in South Kensington. He was
unbeaten in nine races and won the Ascot
Gold Cup by an impressive 50 metres.
Persimmon, born in 1893, gave his owner
King Edward VII much to celebrate,
winning not only the Gold Cup, but also
the Derby and St Leger. Brown Jack won
the Ascot Gold Cup an unprecedented
six times (1929–1934).

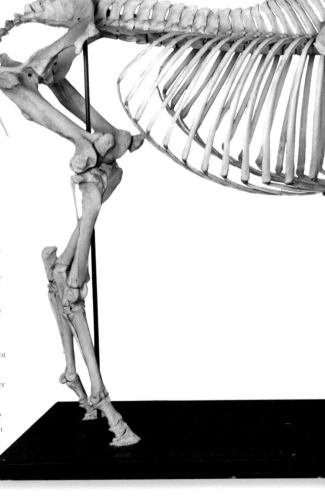

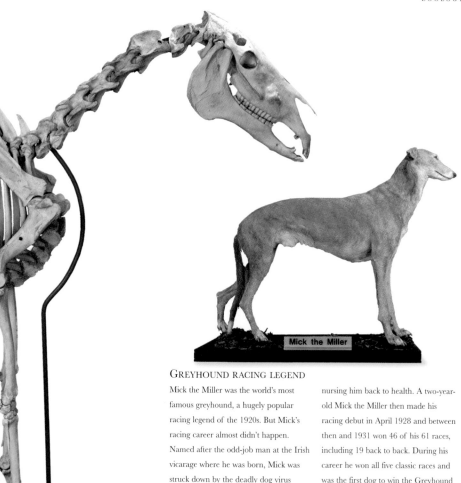

Mick the Miller

GREYHOUND RACING LEGEND

Mick the Miller was the world's most famous greyhound, a hugely popular racing legend of the 1920s. But Mick's racing career almost didn't happen. Named after the odd-job man at the Irish vicarage where he was born, Mick was struck down by the deadly dog virus distemper at 12 months old and almost died. His owner Father Brophy took him to the manager of a local racing ground, who was also a vet and who looked after Mick day and night, nursing him back to health. A two-year-old Mick the Miller then made his racing debut in April 1928 and between then and 1931 won 46 of his 61 races, including 19 back to back. During his career he won all five classic races and was the first dog to win the Greyhound Derby twice. He scooped not only headlines but thousands in prize money. When after years of fame Mick died in his sleep in May 1939, his owner, A H Kempton, donated him to the Museum.

BARBARY LION SKULL FROM THE TOWER OF LONDON

The lion whose skull this once was lived at the Tower of London in the Royal Menagerie, the monarch's personal collection of wild and exotic animals. The skull was excavated from the moat. It was no doubt well looked after while alive but when it died its body was probably thrown into the water, its quick burial a possible explanation for why it is so well preserved.

The Royal Menagerie was established in the twelfth and thirteenth centuries by King John, in Woodstock near Oxford, but soon after was relocated to the Tower. Over the centuries many animals, often gifts from foreign monarchs, lived there particularly lions which were the symbol of the British throne. The skull was one of two excavated in 1937, and recent carbon dating confirms one of the lions lived between 1280 and 1385, the other between 1420 and 1480. Both were males, as shown by their long skulls and large canines, and genetic research on material from the jawbones revealed they share unique genes with the north African Barbary lion, now extinct in the wild. Western north Africa was the nearest region to Europe to sustain lion populations until the early twentieth century, making it an obvious and practical source for Mediaeval merchants. Apart from a tiny population in north-west India, lions had been practically exterminated outside sub-Saharan Africa by the beginning of the 1900s.

CAPE LION

The Cape lion was hunted to extinction so quickly in the 1800s that for years scientists could not find any evidence of it to study. Then, in 1954, this mounted skin was sent to the Museum. It had been hanging on the wall of a gentleman's club in a glass case for 60 years. Six others have been found since, but this is probably the best example of the magnificent creature.

The Cape lion once lived along the southern tip of South Africa. It was distinguished from other lions by the thick black mane that hung over its shoulders, its fringe of black belly hair and its large skull. This male was shot near South Africa's Orange River in about 1830, by Captain Copland-Crawford of the Royal Artillery. It was so striking it was eventually given as a gift to the Junior United Services Club in London in 1895, mounted in a glass box in amongst savannah grass. The specimen, still in its original box, has been used by scientists to investigate if the Cape lion is a separate subspecies of lion or not. They are still unsure.

LAST JAPANESE WOLF

When the young American mammologist Malcolm Anderson shot this wild Japanese wolf on 23 January 1905 he could not have known it would be the last one ever seen. The wolf had lived on the southern Japanese island of Honshu, one of the stops on Anderson's major collecting trip around eastern Asia, with his brother Robert. All the material they gathered was given to the Natural History Museum, but none of the other specimens were nearly as significant. Also known as the Honshu wolf, it inhabited the rugged, forested mountains of Japan's Honshu, Shikoku and Kyushu islands. It was the smallest wolf in the world, but despite its size was still a menace to livestock and was hunted or caught in traps which, together with rabies, probably led to its extinction. Although never displayed, the skin and skull have been studied, photographed, written about in numerous magazines and guidebooks and even filmed for Japanese television. Among the many people who have visited the skin are descendants of Kiyoshi Kanai, the Japanese guide who accompanied the Anderson brothers.

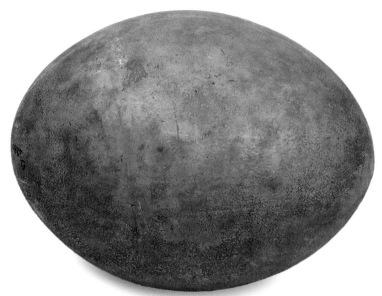

ELEPHANT BIRD EGG

The largest known bird eggs ever laid were by the appropriately named elephant bird (*Aepyornis maximus*), from Madagascar. The eggs are estimated to have had a volume of 8–10 litres, the equivalent of 150 to 200 domestic chicken eggs. One egg might have fed a whole family for many days, and the empty shells were probably used by humans to store things.

Elephant birds grew more than three metres tall and, at more than 400 kilogrammes, were the heaviest birds that ever lived, about four times the weight of the largest living bird, the ostrich. Like their relatives the ostriches, emus, cassowaries and moa, elephant birds could not fly and their remains have been found from almost two million years ago, in the Pleistocene. They probably became extinct during the seventeenth century after the arrival of humans in Madagascar as they had few natural predators except for crocodiles and eagles. Their giant eggs still emerge from beaches or lake shores, mostly as fragments but occasionally whole. Some contain bones of embryos, which can now be studied using high resolution X-rays and new computer techniques.

THE OLDEST GIANT TORTOISE

This is the oldest known giant tortoise and was probably considerably more than 200 years old when it died. Not only that, it has the best-documented history, with written and photographic evidence to prove its age. Most of its history is certain because it lived a large part of its life in one place: the artillery barracks at Port Louis in Mauritius. It was one of five giant tortoises brought to Mauritius in 1766 by the French explorer Marion de Fresne. Why he brought them there no one knows, but they were almost certainly from the Seychelles over 1,500 kilometres to the north. The next record of this particular giant was in 1810, when the British captured the island. They found the tortoise in the barracks, and pictures of it show a large scar in its side. It matches the scar on this specimen, possibly a gunshot

from a drunk officer wanting to test the thickness of the shell. With failing eyesight, the tortoise eventually died in 1918 after falling down a well. It had been on the island for 150 years. Local accounts suggest it had not changed in size in living memory and so was already an adult when it arrived, probably making it 200 to 250 years old.

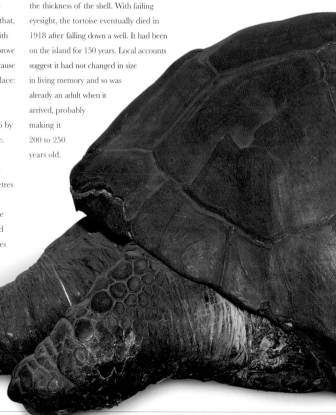

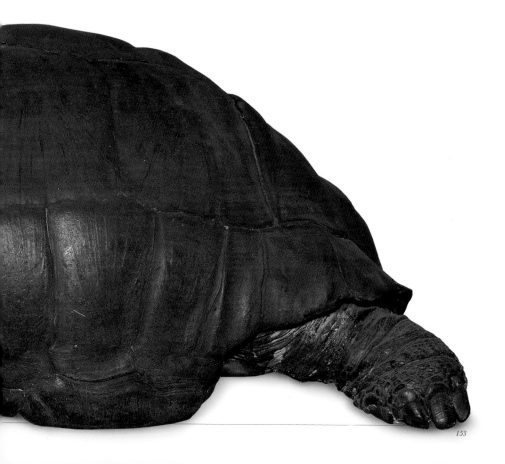

PASSENGER PIGEONS

Passenger pigeon skins are not rare in museums, but the story that specimens such as this represent is quite extraordinary. Passenger pigeons went from being one of the most common birds alive, with a population numbering hundreds of millions, to extinction in less than 100 years. It was a phenomenally unlikely event, much as if someone predicted the extinction of bluebottles. Passenger pigeons (*Ectopistes migratorius*) lived in eastern North America, in flocks so big they turned the sky black as they flew. Professional hunters caught them to sell as food, sometimes merely holding long sticks in the air to knock them down, other times tethering blinded live birds to concealed nets, as a lure. A single trapper could gather more than 2,000 birds a day. Over the years, as forests were also being cut down north and south of where they lived, populations declined, but a more subtle effect pushed them beyond the point of no return. There seemed to be a critical mass below which flocks could not survive. If numbers dropped below a certain point, the whole group disappeared very quickly. Whether this was to do with looking after young or finding food is unknown, but something about living in a big group gave them stability. The exact moment the passenger pigeon eventually ceased to exist was 13.00 on 1 September 1914, when Martha, the last female in captivity, died in Cincinnati Zoo, USA.

POLAR BEAR

The smile on this polar bear's face reveals a lot about Victorian taxidermists, who possibly mistook the bear's white fur as being the sign of a gentle giant. Polar bears are actually ferocious animals and the largest land predators. Their favourite prey is ringed seals, but they eat anything they can kill in their Arctic home, including birds, eggs, rodents, shellfish, crabs, beluga whales, walrus calves, musk ox, reindeer and even vegetation in the summer. They have a highly developed sense of smell and have been tracked walking in a straight line over the ice to reach seals that they had apparently detected from up to 64 kilometres away. They are also powerful swimmers, capable of swimming more than 100 kilometres without rest, and have been known to stay underwater for up to two minutes while stalking a seal.

This particular polar bear forms part of the collection amassed by Walter Rothschild in the late nineteenth and early twentieth century. It is on display today at the Natural History Museum at Tring and was used by Raymond Briggs as the model for his book *The Bear*.

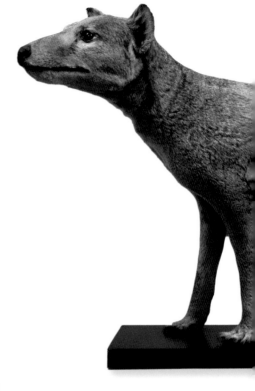

OKAPI HIDE

This belt is the first official record of the okapi, with its unmistakable plum-coloured, striped skin. It was sent to the Museum in a flurry of excitement in 1900 by the explorer Sir Harry Johnston. Johnston, who was working in Africa in various roles for the British colonial service, had heard about an elusive, long-legged and striped animal living in Congo, but had never seen it. His chance to look for it came while he was in Uganda and a group of rescued pygmies needed to be returned to their Congo home. They had been kidnapped for an exhibition in Europe, a popular attraction at the time. On the way there Johnson's search proved fruitless but, while staying at an army base on his way back, he discovered a soldier wearing an okapi belt and bought it from him there and then. It was as near as he was going to get. Such was the rush to record this new and unusual animal, rather than wait to find the animal itself, the belt was scientifically recorded as the first example of the animal and named *Okapia johnstoni*.

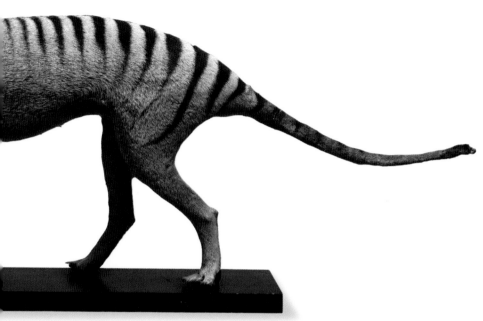

TASMANIAN TIGER

The thylacine, or Tasmanian tiger, is famous for being the largest meat-eating marsupial in living memory, and also for its swift extinction. It has all the ingredients of legend, a dog-shaped creature with tiger stripes found far away in Tasmania. But despite its name, the Tasmanian tiger was a quiet and shy animal, as big as a large dog. However, quite unlike a dog, it gave birth to undeveloped young, which spent the next three months maturing in a pouch on the mother's underside. Rock art

featuring thylacines has been found in northwest Australia and is thought to be at least 3,000 years old. Due to pressures of hunting and possibly competition by dingoes they were gradually eradicated from the mainland of Australia, although there are reports of some still surviving in the eighteenth century and even more recently. In Tasmania, the arrival of humans in the early 1800s, and more importantly their sheep, also spelt the beginning of the end for the remaining thylacines. What risk they actually posed

to livestock isn't clear, but by 1880 they had a bounty on their head, one pound for every one killed. In 1936 numbers had dropped so far the government outlawed killing thylacines and made them a protected species. But it was too late. Fifty-nine days later, the last captive one died in Hobart Zoo and in 1986 they were officially declared extinct. Despite this many people believe the animal still exists in the wild and there have been a number of sightings over the years but no conclusive evidence.

BUFFALO HORNS

These magnificent horns were given to the doctor and collector Hans Sloane as payment for a medical bill. They have been in the collection since before the South Kensington building opened in 1881, and are the largest Indian water buffalo (*Bubalus bubalis*) horns ever recorded, each almost two metres long. Now more than 250 years old, the horns need to be kept in stable environmental conditions, around 50 per cent relative humidity and a temperature of between 16 and 18°C, for optimum storage and preservation.

Given to any other doctor, the bulky payment might have been turned away. But Sloane was no ordinary doctor. He was obsessed with collecting and, being a wealthy man, spent a great deal of money buying anything that caught his eye. By the time he died in 1753, every room, corridor and surface in his house was stacked with books, shells, coins, engravings, paintings and more. His collections were used to found the British Museum, the natural history sections of which were later moved out to form the Natural History Museum.

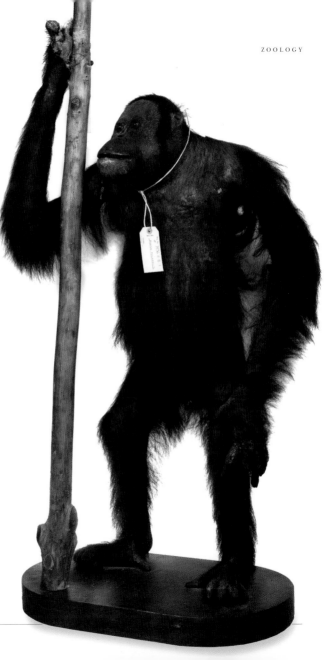

WALLACE'S ORANG-UTAN

This glorious orang-utan was shot by
the naturalist Alfred Russel Wallace
in the mid-1800s. It is a reminder of
a time when specimens like this, that
we would not contemplate killing (or
'collecting') now, opened Western
eyes to places and animals beyond
imagination. Credited for being the
co-discoverer of the theory of evolution
by natural selection with Charles
Darwin, Wallace spent eight years
travelling around the Indonesian
Archipelago, investigating any living
thing he could find. He collected
hundreds of specimens and shot a
number of orang-utan (*Pongo
pygmaeus*) on the island of Borneo.
Wallace wrote about it in his book
The Malay Archipelago. Far from being
a bloodthirsty hunter, he was in awe
of these apes and wrote movingly about
caring for an orphaned infant, 'I fitted
up a little box for a cradle, with a
soft mat for it to lie upon... When I
brushed its hair it seemed to be
perfectly happy, lying quite still ... For
the first few days it clung desperately
with all four hands to whatever it could
lay hold of, and I had to be careful to
keep my beard out of its way.'

Tapeworm

In 1978, a 3.8-metre-long killer whale washed up on a beach in Cornwall, UK, carrying this rare worm in its intestine. The worm, known as *Diphyllobothrium polyrugosum*, had only been seen once before and was longer than the whale. This worm's host was one of hundreds that are washed up on to British shores every year. The Museum is responsible for monitoring these strandings, trying to save any that are still alive but also studying their remains to learn more about why strandings happen, to which species and where. Tapeworms such as this are fantastically adapted to their hosts. Rather than grow a mouth or a digestive tract, they just lie in the intestine and wait for the whale to digest its food, after which they can absorb it. Reproduction is also fairly simple as the adults are made almost entirely of reproductive segments, each of which has the ability to produce eggs. The eggs pass out in the whale's faeces and are then eaten by shrimps where they begin to grow. The shrimps are then eaten by fish which are in turn eaten by whales and so the cycle continues. Rarely does the worm put itself out of a home and kill its host.

THAMES BOTTLENOSE WHALE

In January 2006, this six-metre-long northern bottlenose whale swam up the River Thames into central London as far as Albert Bridge. A major rescue operation was launched to save it, catching the attention of newspapers and television crews. Thousands of people came to watch, but the whale died just three days later, not far from open sea, from dehydration, muscle damage and kidney failure. Museum scientists were called in to dissect the whale and spent a whole day cutting the blubber and flesh away and then removing the bones, bagging and labelling them ready to be washed. Such was the public interest, the whale bones were stored at the Museum, joining one of the best cetacean research collections in the world.

Northern bottlenose whales often swim through UK waters, but their usual home is the deep-sea of the North Atlantic Ocean up towards the Arctic Circle. Why this juvenile female, less than 10 years old, swam up the Thames isn't known, but studying the bones and tissues will help scientists learn more about these animals, what they eat and where they are at different times of the year.

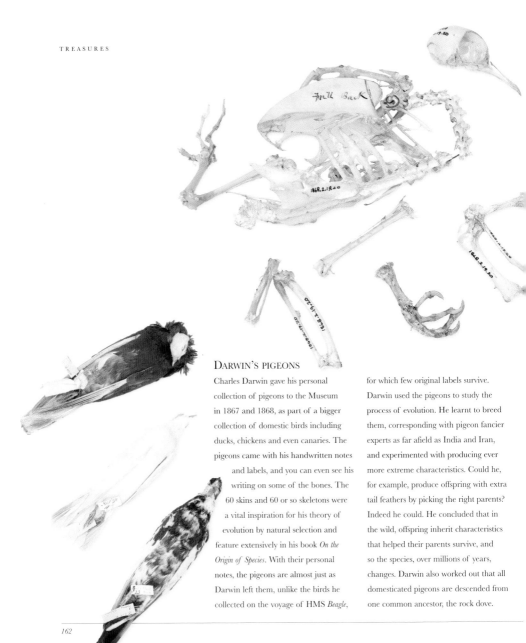

Frill Back

1868.2.19.20

Darwin's Pigeons

Charles Darwin gave his personal collection of pigeons to the Museum in 1867 and 1868, as part of a bigger collection of domestic birds including ducks, chickens and even canaries. The pigeons came with his handwritten notes and labels, and you can even see his writing on some of the bones. The 60 skins and 60 or so skeletons were a vital inspiration for his theory of evolution by natural selection and feature extensively in his book *On the Origin of Species*. With their personal notes, the pigeons are almost just as Darwin left them, unlike the birds he collected on the voyage of HMS *Beagle*, for which few original labels survive. Darwin used the pigeons to study the process of evolution. He learnt to breed them, corresponding with pigeon fancier experts as far afield as India and Iran, and experimented with producing ever more extreme characteristics. Could he, for example, produce offspring with extra tail feathers by picking the right parents? Indeed he could. He concluded that in the wild, offspring inherit characteristics that helped their parents survive, and so the species, over millions of years, changes. Darwin also worked out that all domesticated pigeons are descended from one common ancestor, the rock dove.

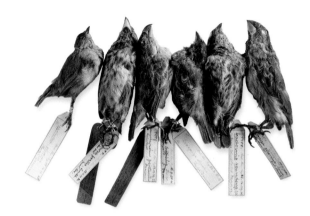

DARWIN'S MOCKINGBIRD

Many people believe it was the diversity of finches that first drew Charles Darwin's attention in the Galapagos, but in fact it was this scruffy songbird, the Floreana mockingbird (*Nesomimus trifasciatus*). It was the seed for his theory of evolution by natural selection, an idea that took him 20 years to develop. This is the very first Floreana mockingbird described by science and is known as a type specimen. When Darwin arrived in the Galapagos in 1835, he noticed the Floreana mockingbird on Floreana Island, but also spotted other related species on different islands. In his *Journal of Researches* he wrote, 'My attention was first thoroughly aroused by comparing together the numerous specimens ... of the mocking thrushes, when, to my astonishment, I discovered that all those from Charles Island belonged to one species (*Mimus trifasciatus*), all from Albemarle Island to *M. parvulus* and all from James and Chatham Islands ... to *M. melanotis*.'

DARWIN'S FINCHES

These are possibly the most famous birds of all time: Darwin's finches from the Galapagos Islands. They are the perfect model of evolution in action, where beak shape has adapted to food. The 13 species all look roughly the same, brown or black and sparrow-sized, but their beaks are very different, brilliantly adapted to what they eat. Those feeding on hard-to-crack seeds have big, strong beaks and those targeting tiny insects have smaller, pointed beaks. Many people think the birds ignited Darwin's ideas about natural selection. But he had no idea of their significance at first. In fact, he didn't even know they were all finches. He collected the birds while on the five-year *Beagle* voyage, the journey that inspired him to consider how the diversity of life came to be and which helped him write *On the Origin of Species*, published in 1859. But he thought they were a mix of wrens, blackbirds, finches and warblers and didn't care too much to label which island they came from. John Gould, the famous English ornithologist, identified all the birds as closely related finches. The pieces then started to fit together. More crucial to Darwin's theory, however, was the humble pigeon (*see* opposite), the selective breeding of which showed how different characteristics can be exaggerated through generations.

DODO

The dodo (*Raphus cucullatus*) is the icon of extinction. No mounted skins of this world-famous bird have survived – we only have a skeleton and a model reconstruction to depict what it may have looked like in life. The model shows it as being a rather fat bird, but recent evidence suggests it wasn't as comically round as we thought. The dodo was a relative of the pigeon and lived on the island of Mauritius, off the east coast of Africa. With no predators, it prospered, searching for fruit and nuts from the ground, its breastbone too small to support the strong muscles needed for flight. Its peaceful existence was shattered, however, in the early 1600s when humans arrived. They brought with them rats, cats and pigs, for all of which the dodo's ground nests were easy pickings. As forests were cut down, the dodo's food supply dwindled, and so by the end of the seventeenth century the last one had died. One of the first scientific investigations of the dodo was made by the Museum's first Superintendent, Richard Owen, almost 200 years later in 1865. Since 2005 Museum scientists have helped excavate over 10,000 fossil bones and bone fragments from the marshy coastal site of the Mare aux Songes, southeastern Mauritius, amongst them numerous beautifully preserved dodo remains, including chicks. Along with the bones, the muddy matrix trapped branches, seeds, leaves, snails, insects, pollen and even fungi. The site, once just famous for dodo, has now given researchers a detailed record of an entire lost world.

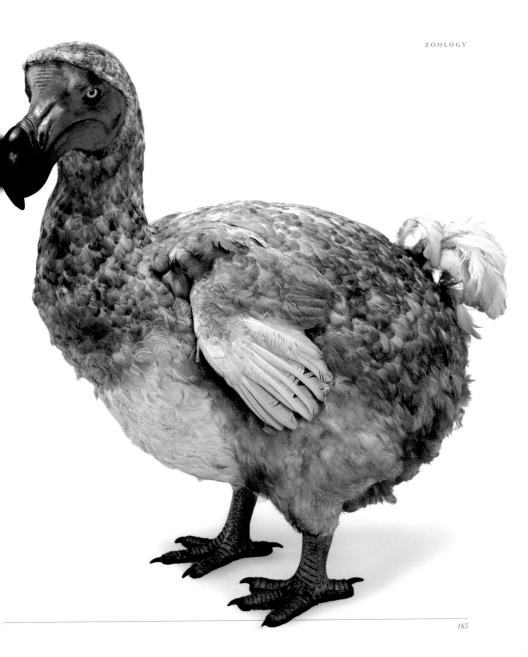

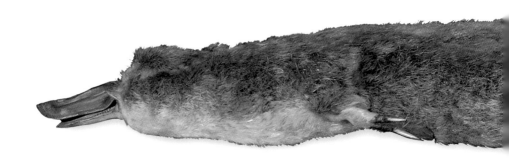

DUCK-BILLED PLATYPUS

Nothing has confused the science world as much as the duck-billed platypus (*Ornithorhynchus anatinus*). This is the first specimen brought to Europe from Australia in 1798, and when it arrived scientists were convinced it was a fake. How could an animal covered in fur also have a bird's beak? China was well known for producing fakes at the time, where leftover bits of animals were stitched together and sold. Such fakes included the eastern monkey, with the body of a monkey and the tail of a fish. But the platypus not only looked odd from the outside; its insides were strange, too. If it was a mammal, as the fur would suggest, where were the uterus and milk glands, the other typical mammalian features? The platypus did not have them. It took a year of careful study before scientists felt reassured the platypus was not a joke, but a new and remarkable animal to science. The monotremes – the platypus and the echidnas – are thought to be the most primitive of living mammals and are the only ones that lay eggs rather than give birth to live young. The platypus is also unique in being the only mammal known to be able to detect electric fields (which it uses to find its prey) and one of the few mammals able to produce venom.

Owlet forgery

This very rare forest owlet, *Athene blewitti*, is a treasure from a tragedy. It had not been seen in the wild for more than 100 years, but in 1954 avid bird collector Colonel Richard Meinertzhagen donated this specimen, having apparently caught it himself only 40 years earlier. In fact Meinertzhagen had stolen it from the Museum, removed bits of skull, twisted its legs and washed it, then changed its label, adding fake information about where it had been collected. In the process, he had destroyed one of only seven specimens known, all of which had in fact been collected in the 1870s and

1880s. Once scientists had realised the true origin of the specimen, they were inspired to travel to its genuine home region in India in 1997 to search for it. In an extraordinary twist of fate, they found it. The fake was a scandal in the press, but it was not the only one. Meinertzhagen donated 20,000 birds to

the Museum, some reliable but others forgeries. Many had false labels, such as two rare kingfishers labelled as collected in Burma but in fact from China. Meinertzhagen had long been suspected of stealing at the Museum, was twice almost taken to court and even banned from visiting for 18 months.

55 Series
Emperor Penguin

74. Series
Emperor Penguin

64. Series
Emperor Penguin

EMPEROR PENGUIN EGG COLLECTED BY WILSON

This penguin egg, collected on the British *Terra Nova* expedition to the Antarctic (1910–1913) along with two others and their embryos (above), is not unique or from an endangered species, but it represents an inspiring though tragic story. During Captain Scott's first expedition to Antarctica on the ship *Discovery* (1901–1904) the team's zoologist Edward Wilson examined three emperor chicks. He pledged to come back to collect some eggs, desperate to study the embryos to test a theory that birds were evolved from reptiles. And so he returned in 1911 on Scott's second journey to the South Pole, in the ship *Terra Nova*. Accompanied by his close friends and colleagues Henry Robertson Bowers and Apsley Cherry-Gerrard,

he left the main camp in search of the colony. They faced torturous conditions of freezing winds and huge ice ridges, their sledges pulling heavy on their backs. But 19 days later they collected five precious eggs, two of which broke. Back at camp, Wilson and Bowers were selected to join Scott on his final push to the pole. They never returned. It was left to Cherry-Gerrard, heavy with grief after losing his team mates, to deliver the embryos and the eggshells to the Museum in person. Two of the three embryos were prepared as hundreds of slides, and one was kept preserved in alcohol. By the time the final report was published, the theory that suggested the embryos could prove a link between birds and their reptilian ancestors had largely been dismissed.

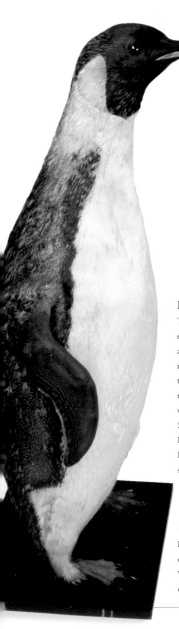

EMPEROR PENGUIN

This is one of the first emperor penguins ever collected, sometime between 1839 and 1843. Penguins are so familiar to us now it's hard to imagine people seeing them for the first time, but the excitement must have been intense. The specimen was collected in Antarctic waters by a 22-year-old naturalist, Joseph Dalton Hooker, part of a team travelling on the British naval ships *Erebus* and *Terror*, in search of the magnetic south pole.

Hooker was kept busy collecting and recording all sorts of new specimens, while also doubling up as the assistant surgeon, and probably needed help hauling the one metre-tall (and probably over 40 kilogrammes) bird on board. When Hooker returned to the UK, everything he collected was examined

and named by other naturalists and experts, and the large bird was officially called *Aptenodytes forsteri*, named in honour of the father and son naturalists Johann Reinhold Forster (1729–1798) and Georg Adam Forster (1754–1794), who had been on James Cook's second circumnavigation of the globe in the *Resolution*. Hooker sold a small part of his collections, including this penguin, to Walter Rothschild in 1897. Walter was an insatiable collector who created his own museum at Tring, in Hertfordshire. Following Walter's death in 1937 the museum was handed over to the Natural History Museum and today it is still open to the public, with many of the same specimens still on display in their original display cases.

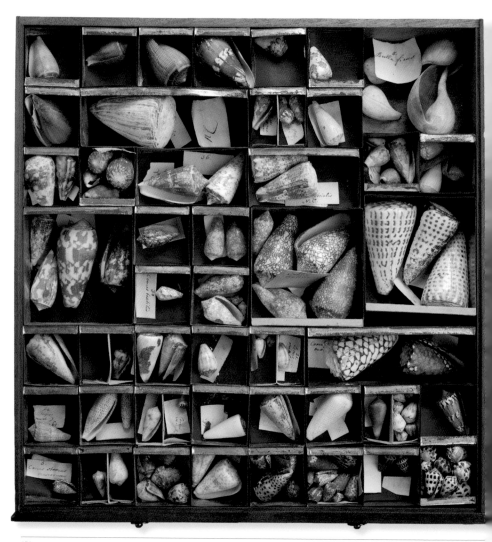

TRAY OF SHELLS

This tray of shells belonged to Sir Joseph Banks, one of the most influential scientists of his time. He dedicated his life to the pursuit of learning, a legacy that gives collections such as this a profound value, both scientifically and historically. The shells came to the Museum in 1863 in a small mahogany cabinet, and each of its seven drawers was filled with metal tins packed with shells. At the time, the Museum was being flooded with specimen donations, so the cabinet was set aside. As curators slowly began to sift through the backlog, naming and ordering, and as Banks' legacy of inspiring and encouraging knowledge of the natural world grew, so his collections became more significant and valued. There are shells collected from the beaches of Brazil, Tahiti, New Zealand and Australia on James Cook's first voyage around the world aboard the *Endeavour* (1768–1771). There are others from Africa, the Bahamas, North America and the Mediterranean. Many still have their original labels, written by the botanist Daniel Solander, who was for a time Banks' secretary.

FIRST SHELL BOOK

This was the first ever book to be dedicated solely to shells, and it was written and illustrated by an Italian priest Philippo Buonanni in 1684. While some of his drawings, such as his garden snail, show a wonderful familiarity with the subject, others, where he has had to imagine the creatures that might inhabit more exotic marine shells, are delightful flights of fancy.

The book is a wonderful first step towards exploring the natural world and laid the foundations for others to build on or correct. Unfortunately, all the drawings are back to front, showing the shells as left-handed or sinistral, which is rare in nature. This is because Buonanni drew the shells as he saw them, not as mirror images, and so when the drawings were then engraved onto printing plates and turned over to print from, the image was reversed. It's a mistake illustrators have often made over the centuries and although modern printing processes should have removed the problem it is still all too easy for an image to be flipped by mistake and printed the wrong way round.

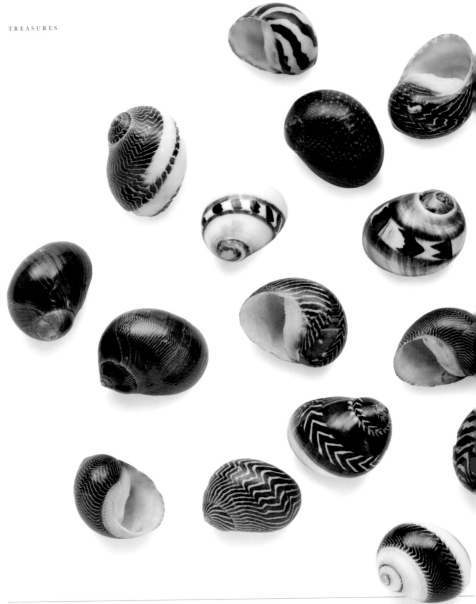

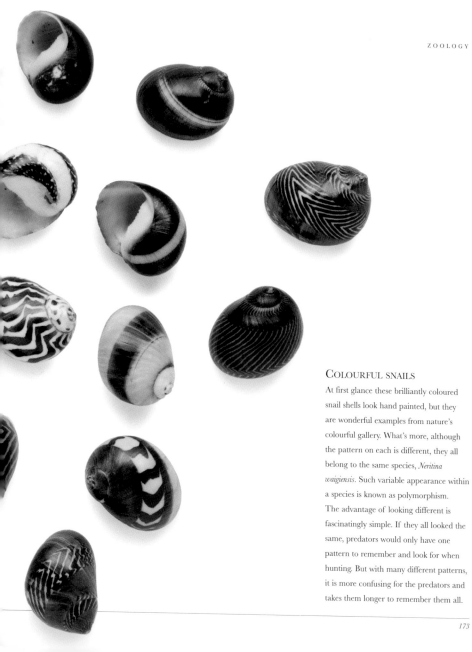

COLOURFUL SNAILS

At first glance these brilliantly coloured snail shells look hand painted, but they are wonderful examples from nature's colourful gallery. What's more, although the pattern on each is different, they all belong to the same species, *Neritina waigiensis*. Such variable appearance within a species is known as polymorphism. The advantage of looking different is fascinatingly simple. If they all looked the same, predators would only have one pattern to remember and look for when hunting. But with many different patterns, it is more confusing for the predators and takes them longer to remember them all.

NEW ZEALAND STORM PETREL

This skin was crucial in proving that the New Zealand storm petrel, believed to have been extinct since 1850, is a living species. *Oceanites maorianus* was known from only three Museum specimens collected in the 1800s and some fossils, until a small black-and-white bird flew past a group of birdwatchers at sea off New Zealand's North Island in 2003. It was only in view for a few seconds, so it was only when the group looked at their photos that they realised the closest match to the markings on its underwing and belly was the extinct New Zealand storm petrel. Expert opinion was originally divided, but subsequent trips successfully found more individuals, with scientists even able to catch some birds alive. Comparisons of their DNA with the original Museum specimens proved that the New Zealand storm petrel had indeed been rediscovered, with the analysis showing that it is a genetically highly distinctive species. Now reclassified as *Fregetta maoriana* and believed to be critically endangered, conservationists are urgently trying to discover more about its population and lifecycle. A great milestone was achieved in 2013 by radio-tracking birds to their elusive breeding locality. Remarkably, for a bird not seen for over 150 years, they were found breeding on a small island only 50 km from the city of Auckland!

HAMILTON'S FROG

Hamilton's frog (*Leiopelma hamiltoni*) is probably one of the rarest frogs in the world. The entire population, each no longer than 5 centimetres, lives in a single pile of rocks on New Zealand's Stephen Island. The Museum is lucky to have a specimen, which was donated in 1922 by the Dominion Museum in New Zealand. The moss-covered rocks where the frogs live, known as Frog Bank, stretch the area of two tennis courts. The frogs live hidden among the rocks and are unlikely to be seen exposed on the rocky fortress. They were first discovered in 1915 by Mr H Hamilton from the Dominion Museum, but so few have been seen they were thought extinct at one point. Some collectors in search of the frog come away having only heard its calls from deep within the rocks, others don't even hear that. It is not possible to guess how many there are without digging up the rocks to count them. Thousands more frogs were discovered on the nearby Maud Island in 1958. But DNA analysis in 1998 showed they were a related but different species, making *L. hamiltoni* a very isolated species again.

SILK FROM THE SEA

This delicate glove was knitted from the long, golden 'beard' threads of the noble pen shell (*Pinna nobilis*) in the 1700s. For hundreds of years the threads of this large Mediterranean mollusc were harvested as 'cashmere of the sea', creating quite an industry in southern Italy and Sicily, which was centred on Taranto in Puglia. The mollusc produces a brush of threads, known as a byssus, from a gland in its foot, which anchors the shell to the seabed. Once collected, the threads were washed and combed, then spun into fine yarn to make expensive gloves, shawls and even entire gowns. Both Pope Benedict XV and Queen Victoria apparently owned a pair of warm byssus stockings. Each shell only produces one gramme of yarn, so by the nineteenth century byssus had been replaced by conventional silk production in Europe, and its use finally died out just after the First World War. This glove is one of six (three pairs) in the collection, each of which is still beautifully soft.

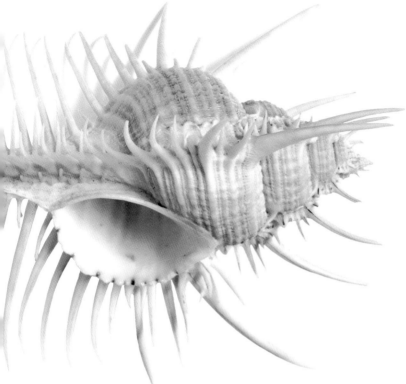

Venus comb snail

Although not rare, this marine snail (*Murex pecten*) is remarkable for its shell, which is covered in needle-sharp and curiously evenly spaced spines. The spines of this hand-sized shell are beautifully intact, but why and what they are for is not really known. Several ideas have been put forward. One suggests the spines might be defensive, to deter predators such as crabs or fish, put off by a mouthful of sharp spikes. Another idea is that they prevent the *Murex* sinking or overturning into soft mud, acting as a sort of snowshoe. The regular spacing has also led some to suggest the spines act like a cage, trapping mobile prey such as cockles underneath. This carnivorous marine snail lives in shallow waters of the Indian Ocean and eastwards into the Pacific as far as Fiji. It crawls on the muddy seabed, channelling water through the thin end of its shell, the siphonal canal. The siphon helps the snail 'smell' the water around it, constantly picking up chemical signals from nearby predators or prey.

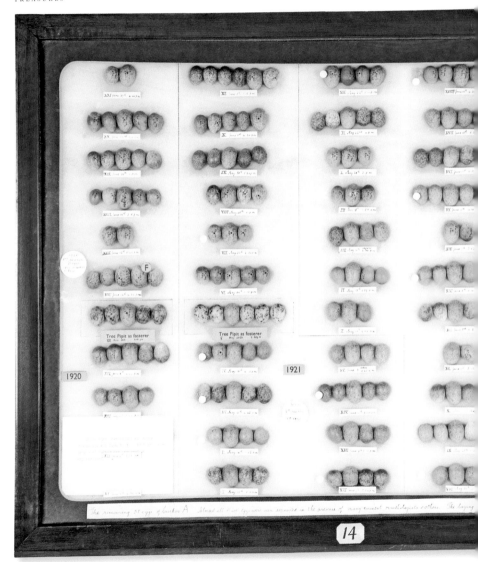

CUCKOO AND HOST EGGS

The 25,000 eggs in the collection of ornithologist Edgar Percival Chance (1881–1955) reveal more about the secret and devious life of the common cuckoo than any other single egg collection. Chance dedicated years to exposing exactly how the female lays her egg in the nests of other birds, and he was also the first to catch the act on film. He began his work, in earnest, in the summer of 1918 on a Worcestershire common, watching the nests of pipits, skylarks, yellowhammers and stonechats, all favourite cuckoo victims. He noticed the cuckoo laid its egg during the host bird's laying period, and concluded it must watch the host nest to know when to approach. And so he returned the next year to watch the cuckoo instead. The collection fills 37 drawers, with both cuckoo eggs and the eggs of the hosts they parasitise, all collected by Chance and his friends. The similarity of colour and pattern between some cuckoo and host eggs is striking, an incredible evolutionary feat. Chance's film revealed the details of the cuckoo's ruthless nesting methods. The female first removes a host's egg then lays its own in its place. The cuckoo egg usually hatches before any other, ensuring it is the first to be fed by the unknowing host parents. The cuckoo chick will then even push the host's eggs or chicks out of the nest.

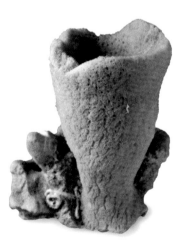

Discodermid sponge

The sea sponge *Discodermia* is a good example of how marine invertebrates are used for drug analysis. Laboratory tests have shown that it produces chemicals with an incredible ability to stop cells dividing, and it is the ability to rapidly divide that makes cancer cells so dangerous. *Discodermia* lives a sessile life on the seabed around North America and the Caribbean. It cannot move if danger approaches or if something grows on top of it, so it secretes chemicals to produce a hostile environment around it. Even if it buds, the new individuals only grow if wafted far enough away by the sea's currents. The search for natural therapies began with land plants, but the sea was soon explored for life-saving medicines. The Museum has a bank of plants and marine vertebrates that have been researched and trialled as remedies, known as chemical vouchers.

GIANT SQUID

So little is known about the giant squid (*Architeuthis dux*) that when this 8.62-metre animal was caught off the coast of the Falkland Islands in 2004 it hit the headlines. Nicknamed Archie, it was immediately put on ice and then given to the Museum to display. Defrosting this precious specimen was complicated and took three days of intense monitoring. The challenge was to make sure the dense body and head defrosted at the same time as the delicate tentacles,

without any part starting to decompose. Once defrosted the squid was placed in a specially constructed case and put on display in the Museum's Darwin Centre.

Most of what we know about the giant squid comes from the remains of dead squid recovered from the stomachs of sperm whales, which feed on them. Scientists have tried to estimate how long they live for and how quickly they grow by examining structures such as the gladius (the pen), the eye lens and the

statolith (a sensory organ). They can probably grow up to 14 metres long, have eyes the size of footballs, teeth-filled suckers and a strong beak. But exactly how they grow and develop, how they find a mate, and if they are solitary or shoaling animals are still mysteries. Still less is known about colossal squid which may be even bigger and, having a large mantle (body), are potentially far heavier. Below is the squid in its entirety.

Tuatara

The tuatara is a classic living fossil, fantastically unchanged since it first evolved 225 million years ago. The lizard-like creature, about 50 centimetres long, was thought extinct until this single specimen was re-examined in 1867. It had been identified as a lizard, but only by looking very carefully at the structure was its true identity revealed: it was a tuatara. The tuatara has very rarely been seen in the wild, not surprising when you consider it lives on 30 or so formidably rugged uninhabited islands, in a treacherous part of the sea, off the coast of New Zealand. Even if explorers did venture there, the ancient reptiles are active only at night and even then not to any great degree. They disappeared from the rest of the world around 60 million years ago. Like some other reptiles the tuatara has no earhole, but it is so primitive that males have no penis either. While the majority of reptiles alive today replace teeth as they wear out, the tuatara cannot. They are also the slowest growing reptiles, not gaining sexual maturity until about 20 years old, and living up to 100 years.

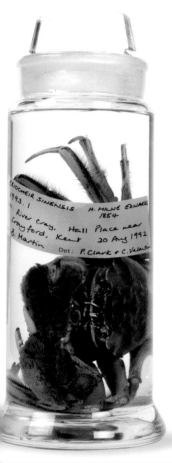

ERIOCHEIR SINENSIS H. MILNE EDWARDS
1993. 1 1854
: River Cray, Hall Place near
Crayford, Kent 20 Aug 1992
B. Martin
 Det: P. Clark + C. Valentine

CHINESE MITTEN CRAB

Adult Chinese mitten crabs can grow
as large as dinner plates and have
distinctive setal tufts on their claws.
These tufts look like woollen gloves
hence the crab's scientific name, *Eriocheir
sinensis*, from the Greek meaning 'wool
hand of the Chinese'. The precise
function of these tufts is unknown, but
scientists are currently more focused
on working out how to control the vast
numbers of crabs in the River Thames,
London, where they have been causing
problems as an invasive species since
the late 1980s. They arrived as larvae or
juveniles sucked up in the ballast water
tanks of ships, possibly from countries
in northeast Europe where the crab is
present in pest proportions. When the
ship pumps the ballast water out they are
transferred to local waterways and rivers.
In the Thames the population is now
thriving, and the crab causes damage by
digging burrows in the
side of riverbanks
which, in
high enough
densities, cause
them to collapse.

HUMMINGBIRD CASE

This delightful case of hummingbirds is the best of nineteenth-century extravagance, packed with hundreds of tiny individuals. It is a celebration of the diversity and iridescence of these charming creatures, most no longer than a finger. No one has found any written record of where it came from or who bought it, but a case fitting its description was auctioned from William Bullock's Museum in Piccadilly, London, in 1819. These kinds of displays were hugely popular at the time, the splendid plumage of the birds ultimately their downfall. The wooden case stands head height and the many lichen-covered branches within it are heavy with birds, each posed as if alive, busy tending nests or ready to take flight. Hummingbirds are extremely small, most between 6 and 12 centimetres long – the tiny bee hummingbird of Cuba weighs little more than a tea bag. The males are by far the more colourful sex, their glistening feathers a lure to mates and a sign of strength to would-be opponents. They live all around the Americas, from the high Andes to the rainforests, and it is likely new species will be found the more these areas are explored.

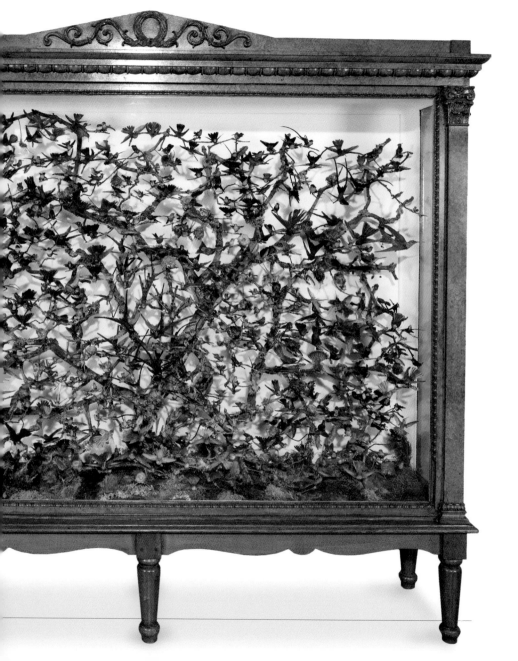

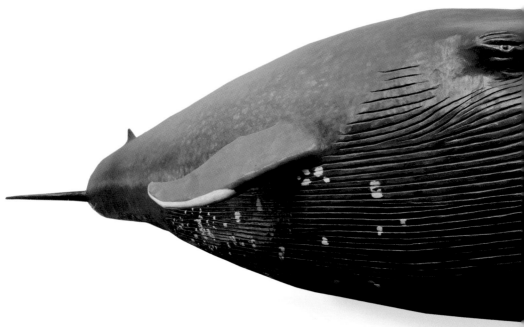

Blue whale model

The Museum's model of a blue whale was built to impress in 1937 and it has done its job ever since. At 27 metres long, it was at the time the world's largest whale model, so big it had to be built in the gallery from scratch. So how do you start making the biggest animal on Earth? Model-makers Percy and Stuart Stammwitz began by making a two-metre model in 1936, using records and photographs of whales that had been caught or stranded on beaches. Work on the full-size model began in mid-1937. Rather than making the parts of the body separately from casts, they built the model in one piece, applying plaster directly onto a wooden and wire-mesh frame. It was then painted.

Seventy years on and the whale is still a favourite among visitors. But with the development of underwater photography, we now know the shape of the model is

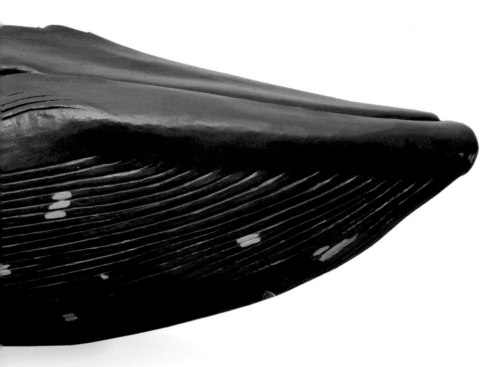

distorted – living whales are far more
streamlined and torpedo-like.

The model is hollow and originally
there was a trapdoor allowing access to
the stomach, though this has long been
sealed over. Stuart Stammwitz allegedly
kept an illicit still inside it before the
Second World War, and there have
also been rumours that it houses a
time capsule though these have never
been proved.

BLASCHKA GLASS MODELS

Among the thousands of works of art in the Museum are 182 exquisite glass models of marine invertebrate animals, made mainly during the second half of the nineteenth century. They were commissioned by the Museum from the skilled father and son glass model makers Leopold and Rudolf Blaschka, who originated from northern Bohemia, now the Czech Republic. The Blaschkas are best known for their glass flowers, made from 1886 to 1936, but the Museum collection consists mainly of marine invertebrates such as sea anemones, jellyfish, octopuses and squid. Many of the models were based on illustrations in scientific books of the day, but some were based on animals kept in their saltwater

aquarium, and some inspired from sketches made by Leopold Blaschka while marooned off the Azores. Each is an incredible study of anatomy, but with the flair and charm of a true art piece, showing aspects of these delicate creatures sometimes lost when preserving them in alcohol. The models were made in various ways. Some are wire structures with glass fused across them; others were enamelled by mixing ground glass with oil or gum Arabic and applying this to a clear glass base. The internal structures were made from painted paper or shells. More than 100 years on nearly all have needed attention, because of failing glues and lacquers, broken needle-fine glass structures and dusty surface pollutants.

COELACANTH

The coelacanth is probably the most
famous fish of the twentieth century.
It was widely accepted to have died out
with the dinosaurs and was only known
from fossils, its odd-shaped tail, thick
scales and the bony plates covering its
head all signs of a very ancient creature.
But in 1938 one swam into a fisherman's
net off the coast of South Africa. Since
then, a living colony of more than 300
of these metre-long fish has been found
in deep water near the Comoros Islands,
northwest of Madagascar, and two
individuals from another species found
thousands of kilometres away in Indonesia.
This specimen was caught in the 1960s
and it would have been deep blue in
colour when alive. Its large-lobed fins
have earned it the name 'old four legs',
which does in fact have scientific basis
as some scientists believe the coelacanth
is distantly related to four-legged land
vertebrates. Reports that it is the missing
link between fish and these land animals
are far fetched, but it's likely the coelacanth
is descended from the same ancestor.
Both species are now listed as critically
endangered on the Red List.

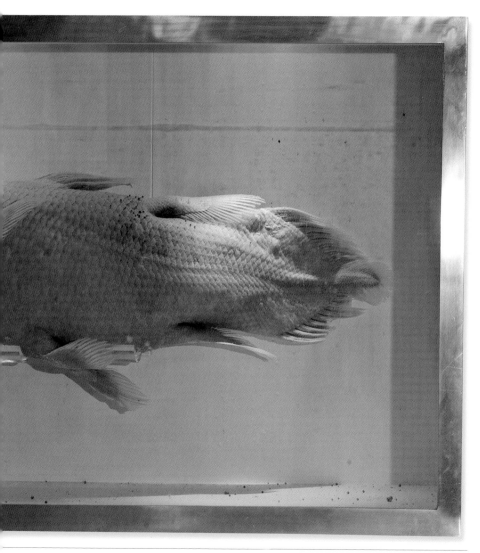

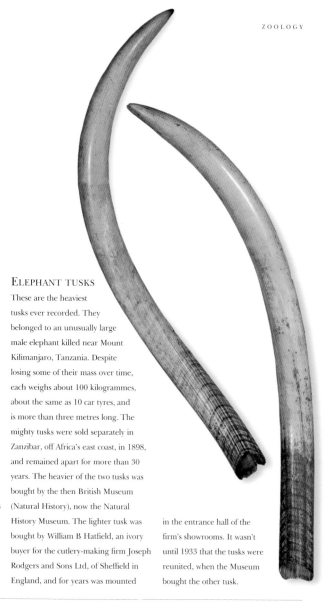

GUY THE GORILLA

Guy the gorilla was one of London Zoo's best-loved animals. Born in 1946 in what was then French Cameroon, Guy was captured for Paris Zoo when he was only a year old and arrived at London Zoo the same year, clutching a hot water bottle. Despite having a reputation among keepers for a bad temper and, as an adult, weighing a massive 240 kilogrammes, Guy was a gentle animal, known to carefully scoop up sparrows that flew into his enclosure, peer at them and then let them go. He was a western lowland gorilla (*Gorilla gorilla*), the largest of primates although the eastern species (*Gorilla beringei*) is generally considered to be slightly larger. Despite their great size and strength, gorillas feed only on plants and, on occasions, insects. Guy died in 1978 of heart failure during a dental operation. His jaws were found to be full of abscesses, which may explain his occasional bad temper. The Museum's head taxidermist, Arthur Hayward, spent almost nine months mounting the skin, which went on display in 1982 but was later moved into the scientific study collections.

ELEPHANT TUSKS

These are the heaviest tusks ever recorded. They belonged to an unusually large male elephant killed near Mount Kilimanjaro, Tanzania. Despite losing some of their mass over time, each weighs about 100 kilogrammes, about the same as 10 car tyres, and is more than three metres long. The mighty tusks were sold separately in Zanzibar, off Africa's east coast, in 1898, and remained apart for more than 30 years. The heavier of the two tusks was bought by the then British Museum (Natural History), now the Natural History Museum. The lighter tusk was bought by William B Hatfield, an ivory buyer for the cutlery-making firm Joseph Rodgers and Sons Ltd, of Sheffield in England, and for years was mounted in the entrance hall of the firm's showrooms. It wasn't until 1933 that the tusks were reunited, when the Museum bought the other tusk.

KOMODO DRAGON

Discovered as recently as 1912, Komodo dragons are the largest lizards on Earth, found only on a cluster of rocky and desolate Indonesian islands, east of Bali. They are aggressive and fearless animals and even the young keep out of the way of adults, spending the first few years of their lives in trees to escape their cannibalistic elders prowling underneath. Komodos exist entirely on meat, using needle-sharp, backward-facing teeth to rip flesh from pigs, deer and goats. They eat with such vigour they often bite through their gums, their mouths a pool of blood and saliva, a deadly breeding ground for bacteria. To take down bigger animals, such as horses, they bite them on their haunches, letting the bacteria in their saliva poison the

animal, eventually disabling it enough for the dragons to eat later. The Museum has at least four specimens, all from London Zoo. It was at the zoo that keepers noticed some of the females were pregnant despite the absence of any male. It became apparent that Komodos can experience parthenogenesis, where females create embryos without the need for males.

MUMMIFIED CAT.
TEMPLE OF BUBASTIS, NEAR ZAGAZIG, EGYPT.
Presented by the Misses Villeneuve-Smith, 1914.

EGYPTIAN MUMMIFIED CAT

Just over 2,000 years ago, an ancient Egyptian painstakingly embalmed and wrapped this domestic cat as a religious offering to an animal-headed god. Millions of animals were killed in this way, most commonly baboons, cats and falcons but also jackals, shrews, fish, cows and even crocodiles. Pets were also buried with their owners. This specimen was bought as a souvenir by two sisters in 1914, who donated it to the British Museum, and it became one of more than 250 animal mummies inherited from the British Museum when the Natural History Museum separated from

it in 1965. Making this mummy would have taken great skill and time. First, the organs were removed – all except the heart, which represented the soul. The cavity was dried with salt and padded with linen, then lightly sponged with frankincense and myrrh. The body was bound in great lengths of cloth, the legs, whiskers and tail wrapped separately. Most cat mummies were found at the goddess Bastet's temple in the city of Bubastis, where her popularity began. Cats were also buried in cat cemeteries, sometimes in specially made cat-shaped coffins.

Rhinoceros hornbill skull

This rhinoceros hornbill skull may not be scientifically very important but, as a record of the Museum's history, it is extremely valuable. Each of the registration numbers on its beak records a different stage in the Museum's history, over a period of more than 250 years. While some specimens are scientifically irreplaceable, this one is a history lesson. The hornbill was first owned by Sir Hans Sloane, a British man who gathered thousands of scientifically and culturally precious objects. When Sloane died in 1753, his collection became one of the founding collections of the British Museum, first housed in Montagu House in central London, where each of the specimens was catalogued and ordered. As the years went by, the natural history collections were added to and eventually they became very cramped. It was the need to find them a new home that inspired the building of the Natural History Museum in South Kensington, which opened in 1881. The Museum's bird collections were then moved out to a new purpose-built building at the Natural History Museum at Tring in the early 1970s, where they continue to attract researchers from all around the world. The skull lies among about 1,150,000 skins, skeletons, nests, eggs and spirit-preserved material. The collections continue to grow as new finds and specimens are added.

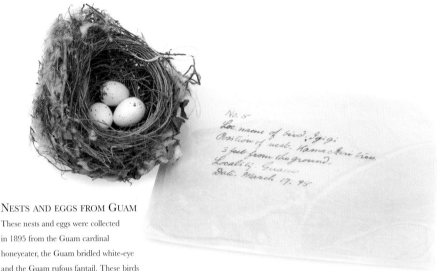

No. 5
Loc. name of bird. Igigi
Position of nest. Kama chiri tree
3 feet from the ground.
Locality. Guam
Date. March 17. 95

NESTS AND EGGS FROM GUAM

These nests and eggs were collected in 1895 from the Guam cardinal honeyeater, the Guam bridled white-eye and the Guam rufous fantail. These birds were common on the western Pacific island at the time, but trouble was only a few decades away. In the late 1940s or early 1950s, the tree-climbing and aggressive brown tree snake arrived in Guam, probably a stowaway on a ship from the Solomon Islands to the south. No one noticed at first, but soon the populations of snakes flourished. With no natural predators and bountiful lizard prey, their young thrived, huge numbers surviving to adulthood. There are now thousands of snakes per square kilometre, and they have killed off nine of the eleven species of Guam's native forest-dwelling birds, including the three featured here. There are so many snakes, it's unlikely they can be eradicated, but police armed with dogs now patrol the airport and cargo areas, to stop the spread of these deadly stowaways to other destinations. The nests and eggs were collected for Lord Rothschild, an avid collector who bequeathed hundreds of thousands of specimens to the Museum in 1937. Financial difficulties had forced Rothschild to sell most of his bird skins to the American Museum of Natural History in New York, but thousands of the eggs and nests, including these, were retained at his request.

PAPA WESTRAY GREAT AUK

The great auk is one of the most powerful symbols of the damage humans can cause. This male from Papa Westray in the Orkney Islands was taken in 1813 and is the only British specimen in existence. It is one of the last pair of great auks to attempt to breed in Britain – its female and her egg had been destroyed the year before. The penguin-like bird is now extinct, not because of habitat loss, but rather intense human exploitation. Huge colonies of this flightless bird once gathered in the summer on rocky islands off eastern Canada, Greenland, Iceland and Scotland. The colonies were a spectacle, but made easy killing grounds for hunters. The birds were slaughtered in huge numbers over hundreds of years, killed for their meat and eggs, but also their feathers which were used to stuff mattresses. By 1800, the auks were so rare collectors paid huge sums to own just a single egg or skin. The last known breeding pair of great auks was killed by hunters on Eldey island, off Iceland, in 1844. Their single egg was also smashed.

GREAT AUK,
ALCA impennis,
Papa West, Orkneys.

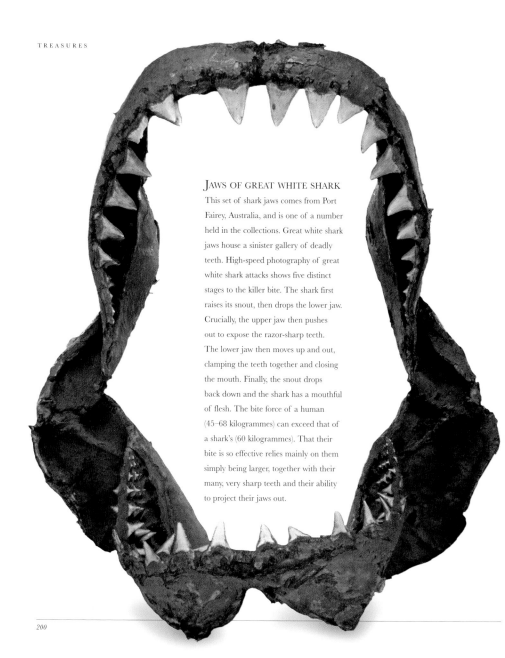

JAWS OF GREAT WHITE SHARK

This set of shark jaws comes from Port
Fairey, Australia, and is one of a number
held in the collections. Great white shark
jaws house a sinister gallery of deadly
teeth. High-speed photography of great
white shark attacks shows five distinct
stages to the killer bite. The shark first
raises its snout, then drops the lower jaw.
Crucially, the upper jaw then pushes
out to expose the razor-sharp teeth.
The lower jaw then moves up and out,
clamping the teeth together and closing
the mouth. Finally, the snout drops
back down and the shark has a mouthful
of flesh. The bite force of a human
(45–68 kilogrammes) can exceed that of
a shark's (60 kilogrammes). That their
bite is so effective relies mainly on them
simply being larger, together with their
many, very sharp teeth and their ability
to project their jaws out.

RARE BIVALVE SHELL

There are only 12 *Pholadomya candida* shells in the world's museums, and the Natural History Museum looks after three of them. This exceptionally rare and delicate bivalve is the last living species of a group of molluscs that flourished in the seas up to 350 million years ago. Most of the 12 known shells were found around the Virgin Islands, in the mid-nineteenth century, but as none has been found since, they may even be extinct. Most of what we know about its internal anatomy is based on a single specimen collected in 1835, kept preserved in alcohol at the Zoological Museum, Copenhagen, but not studied in detail until 1978. Another preserved specimen, subsequently lost in the Second World War, was studied in the 1840s by the anatomist Richard Owen, then at the Royal College of Surgeons and later Director of the Natural History Museum. Unfortunately, his account of the species was never published because crucial drawings were lost by the publisher.

Tiny snail

No bigger than a letter on this page, the *Opisthostoma* snails of Southeast Asia are tiny architectural feats. Their fragile white shells are so small they are almost transparent, but under the microscope each species has a unique shape, crafted in short spines, twists and turns with a distinct trumpet-shaped opening at the side. The shape and number of spines varies, depending on where they live and, intriguingly, possibly even from what angle different predators attack them.

Predatory slugs eat the snails, but some attack from above, boring through the shell, and some from below. It's being tested whether snails in different areas have more spines on their top or bottom depending on which tactic local slugs use. *Opisthostoma* can only live on limestone hilly outcrops, feeding on moss and algae. Species living relatively close to each other can look very different if non-limestone ground lies between them, because the snails do not move across it. In order to find them, collectors have to carefully search the surface of limestone outcrops for live specimens or sieve the leaf litter for empty shells.

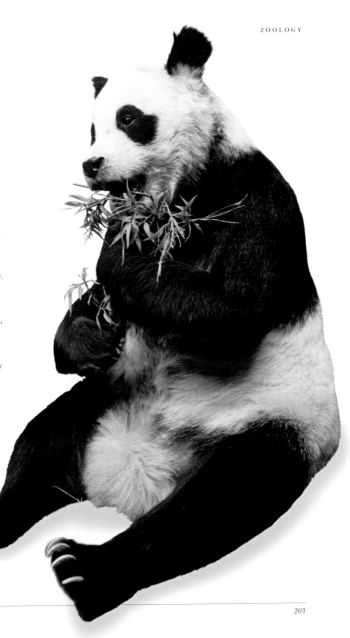

CHI-CHI

Chi-Chi is the world's most famous giant panda. She was caught as a young cub in the mountains of western China, the only place giant pandas live in the wild, but was a favourite at London Zoo for 14 years. When she died in 1972, her skin was given to the Museum and displayed as she would have been in life, feeding on bamboo. Giant pandas are endangered, threatened by continued loss of habitat and a low birth rate, especially in captivity. Captivity seems to lower the libido, especially in males, and both attempts to mate Chi-Chi with another panda, An-An, failed. There have been many advances in captive breeding however it remains a challenging process due to the complexity of panda biology. Pandas also need bamboo to survive – it's virtually all they eat. But once the bamboo plant flowers, it dies and can take another 10 years to grow. Where pandas could once move from one mountain to another to find matured bamboo crops, people now block the way. Conservation groups in China are trying to find solutions to the panda's isolation, for example by creating 'bamboo corridors' to provide safe passages between bamboo crops in different areas.

MINERALOGY

SAPPHIRE ORNAMENT

Fit for an Indian noble, this exquisite ornament, the size of a human eye, has a stunning, rose-cut, deep-blue sapphire as its centrepiece. It belonged to Sir Hans Sloane, who described it as 'a large sapphire of the finest deep colour sett in a chrystall button, inlaid with gold'. A fanatical collector, Sloane left thousands of objects to the nation when he died in 1753. They formed the core of the British Museum collection, some of which later became part of the Natural History Museum collection, and so this piece has

been in the collection for more than 250 years. Although it looks deep blue, recent examination in the Museum has shown the colour is restricted to the top part of the stone only and the rest is almost clear. Such colour zoning is caused by small chemical impurities of iron and titanium in the atomic structure. Because the clear part had less value, the original cutter has skilfully shaped the stone to disguise this and make the best use of the darker blue portion. The smaller gems around the central sapphire are rubies and emeralds.

BLUE SAPPHIRE

Sapphires cut as gemstones are well known, but these Sri Lankan specimens are rare examples of the uncut material. Rough sapphires are usually tapering spindle-shaped crystals, like the 87-carat specimen below. Over time, through natural processes such as tumbling in a river, they become rounded, such as the magnificent 233-carat polished stone to the right, which is about the size of an adult's thumb. It's very unusual for stones this size and quality to escape the cutter's hand, particularly as these have a wonderful evenness of colour, a soft blue typical of Sri Lanka's sapphires. Because of its complicated geology, Sri Lanka has produced many fine gemstones, not just

sapphires, but also topaz, amethyst and garnets and more. It is nicknamed the jewel box of the Indian Ocean, and after Portuguese sailors discovered the island at the beginning of the sixteenth century they returned to Europe with gemstones onboard. It has produced some of the world's best sapphires, where iron and titanium impurities transform what would otherwise be the colourless mineral corundum, blue. Sri Lankan sapphires occur in a rich variety of colours due to chemical substitutions, from blue through shades of brown, yellow, orange, pink, purple, green, colourless and in some cases combinations of yellow and blue in bands. Some stones also change colour in different lights.

SAPPHIRE BUDDHA PIN

That this tiny carved Buddha is less than two centimetres tall is notable, but that it was carved in sapphire, the second hardest gemstone on the planet, makes it exceptional. Little is known about its history, but given the material and the skill required to cut it, only a member of a royal family could have afforded it. The deep colour resembles sapphires from Burma. It was mounted on to the gold cravat pin much later in the mid-1800s. There is nothing else like this in the Museum collection. Sapphire is so hard it would have needed something as hard or harder to shape it, most probably another sapphire. The exquisitely detailed figure was probably made to decorate a portable shrine or for a stupa – a dome-shaped monument used to house Buddhist relics.

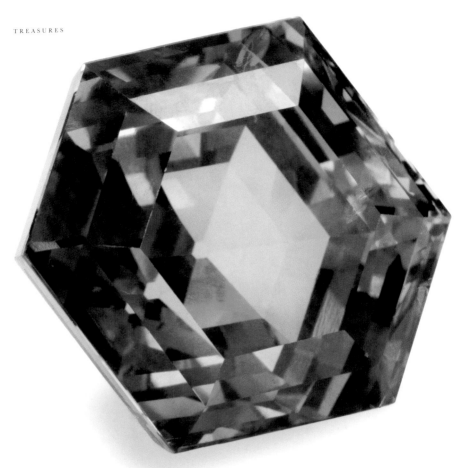

PADPARADSCHA

Padparadscha (pronounced pad-pa-rad-sha) is one of the most unusual colour varieties of the mineral corundum, which is found mainly in Sri Lanka and, more recently, Vietnam. The colour is difficult to describe, but is generally said to be a delicate cross between pink and orange, or between the colour of a lotus flower and a Sri Lankan sunset. This rarity of colour makes it one of the most expensive varieties of corundum to buy. This example is one of the finest known and, at 57 carats, is also one of the largest. It is enhanced by its unusual hexagonal shape.

A STAR IN A STONE

While sapphires may be treasures
enough, some offer even more, a shining
star when illuminated. This happens
when parallel bundles of fibres, often
of the mineral rutile (titanium dioxide),
are formed in the stone as it crystallises.
When the stones are then cut in the
correct orientation, the silky needles
reflect light to form a star effect.

Star sapphires, especially those with
a good colour and a well-centred and
clearly defined star, are highly prized by
collectors. If the bundles of fibres form
only in one direction, a cat's eye gemstone
is produced, but the symmetry of the
mineral allows the fibres to form in three
crossing directions. When this happens,
a six-rayed star is formed. Stars with four
and eight rays are known, but rare.

YELLOW SAPPHIRE

This beautiful sapphire is from Sri
Lanka, particularly famous for its
sapphires, not just every shade of yellow,
from very pale to dark, but also light
blue. At just over 101 carats this is an
exceptionally large gemstone and is
notable for its rich deep colour and
good clarity. It was acquired
by the Museum in 1874.

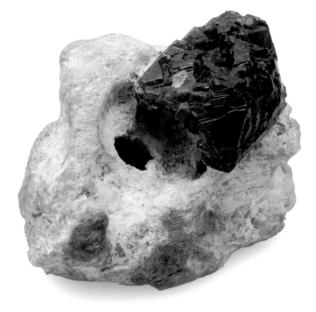

Natural Ruby in Marble

Uncut rubies, embedded in the rock in which they formed, are incredibly rare. More often, they become weathered out and are cut into gemstones, since these are more valuable than the uncut material. This walnut-sized crystal attached to marble matrix was acquired by the Museum in 1973. It is especially treasured because it comes from the world's most famous source of rubies, the mines of Mogok in Burma (Myanmar), renowned for producing spectacular gems for more than 1,000 years. When gemmologists talk of rubies, the stones from Burma (Myanmar) are widely considered the best. The valley of Mogok nestles among farmland, jungles and mountains. Mines dot the towns and the surrounding hills and range from simple open pits to deep tunnels blasted out of the marble hillsides. Gem-bearing rock is hauled up from the pit or shaft and processed to extract the rubies. Both big business and individual locals thrive on the ruby industry. Ruby is the red variety of the mineral corundum, with small impurities of chromium that turn it the intense red colour which lies at the heart of its appeal.

EDWARDES RUBY

John Ruskin, the Victorian art and social critic, once owned this gorgeous, golf ball-sized, 167-carat ruby. He presented it to the Museum on one condition, that it was always displayed with a note 'The Edwardes Ruby, presented in 1887 by John Ruskin, In honour of the invincible soldiership and loving equity, of Sir Herbert Edwardes' rule by the shores of the Indus'. It is unusual for the Trustees of the Museum to agree to such specific demands from a contributor, but Ruskin probably made quite a persuasive argument to retain the label – he was well known for his outspoken opinions. Major-General Sir Herbert Benjamin Edwardes (1819–1868) was a British soldier, best known for having probably saved British rule in India by maintaining friendly relations with Afghanistan and peace in the Punjab during the critical days of the war of independence.

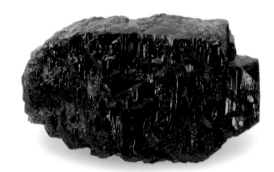

NATURAL RUBY CRYSTAL

This enormous ruby is a staggering 1,085 carats. It is one of the largest ruby crystals in the Museum collection, and was found in Burma's (Myanmar's) Mogok mines, and bought by the Museum in 1924 from Burma Ruby Mines Ltd. The Mogok mines are famous for producing the world's best rubies, stones that often fluoresce more than rubies from other countries, giving them an irresistible lure for collectors. The fluorescence makes their colour appear more intense, whereas stones from places such as Thailand, with more iron impurities, look muddier. The intense rich colour of the gems led to myths in early Burmese culture that if a ruby was embedded in your skin, it would bring protection from all harm. Rubies were also thought to predict misfortune. Catherine of Aragon (1435–1536), the first wife of Henry VIII, is said to have known of her impending downfall because she saw a darkening in one of her rubies.

Some excavated gems are now sold in local markets around the mines, where pink umbrellas shade the jewels on display, a deliberate way to make them look more appealing. As the morning light filters through the pink canvas, the stones glow even brighter.

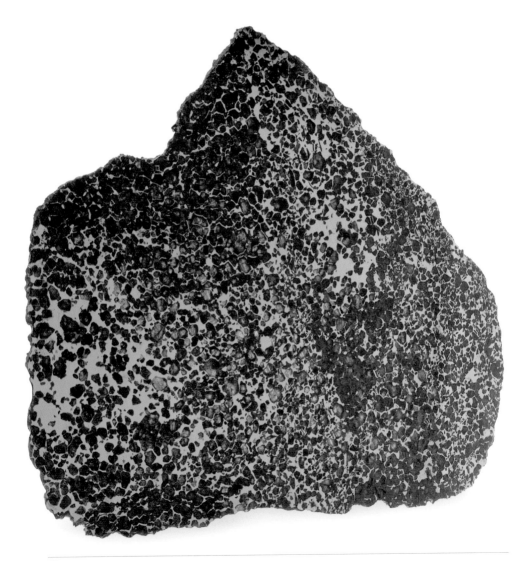

IMILAC METEORITE

This stunning slice of pallasite meteorite from near Imilac, in Chile's Atacama Desert, is one of the largest ever found. Pallasite meteorites, which are made up of iron–nickel metal and silicate minerals, and began life in an asteroid, are prized for the striking olive-green crystals of peridot they contain. Billions of years ago the decay of radioactive elements caused many asteroids to heat up and sometimes melt. This melting meant the dense metallic portions sunk to the centre of the asteroid, forming a metallic core, while the lighter silicate portions rose to form the mantle and the crust, a process known as differentiation. Scientists think that the pallasite meteorites represent the boundary material, formed between the iron-nickel core and the rocky mantle of a differentiated (melted) asteroid. Finding such a meteorite is incredibly lucky. The asteroid first has to break up, through a large impact with another asteroid, and release fragments into space. Some of those then have to drift into Earth's orbit, possibly millions of years later. The pieces then have to survive a fiery descent through Earth's atmosphere. Finally, a keen-eyed hunter has to spot it.

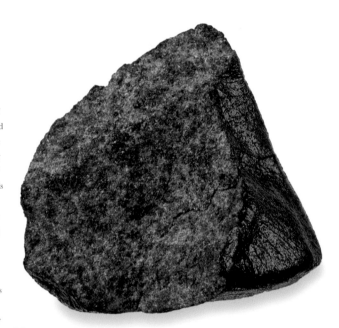

NAKHLA METEORITE

This particularly large piece of the planet Mars crashed to Earth in 1911 and is one of fewer than 40 meteorites known from the red planet. A large asteroid or comet collided with Mars about 11 million years ago, and the impact was energetic enough to throw bits of rock into space, which later fell to Earth. You can see the melted black fusion crust on the surface, which formed as it travelled through the Earth's atmosphere. Comparing data from pieces of the Nakhla meteorite with data sent back by space probes to Mars confirmed where it came from and revealed valuable insights about the mysterious planet. Clay minerals inside the meteorite prove water – a vital ingredient needed to sustain life – was once on Mars.

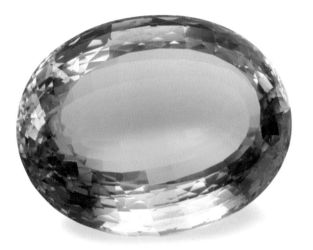

MORGANITE

This shocking pink specimen, carefully cut to show off its clarity and brilliance, is flawless and, at 600 carats, is also one of the world's largest. It was found on the island of Madagascar, off the east coast of Africa, and was acquired by the Museum in 1913. Madagascar has produced some startlingly good stones but most morganite is found in California and Brazil.

Morganite is a variety of beryl turned pink by the presence of manganese and is also known as pink emerald in the jewellery trade. It was named morganite in 1911 after the New York banker J P Morgan. He was an ardent gem and mineral collector and during his life he amassed one of the most important gem collections in the US, which he then donated to the American Museum of Natural History in New York.

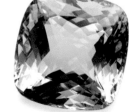

AQUAMARINE

Although aquamarine is not a rare mineral, you don't often see specimens this large. This magnificent Russian gem is about the size of a peach and weighs 898 carats. It's not only big, it also shows the phenomena of small internal parallel lines known as rain, which are in fact hollow or fluid-filled tubes. Named after the Greek for seawater, aquamarine is a variety of the mineral beryl, and comes in a range of colours, from light to dark blue due to small amounts of iron impurities.

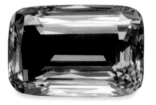

THE SUN GIFT – HELIODOR

This magnificent stone is prized for its colour, a warm yellow glow that earns it the name heliodor, derived from the Greek for sun gift. The rectangular gem, about four centimetres lengthways, is 133 carats and has been part of the collection since 1960. Like emeralds and aquamarine, heliodor is a variety of the mineral beryl. Different trace element substitutions in beryl give it different colours, such as the rose-pink morganite and the blue aquamarine. It is iron substitutions that make heliodor yellow. Despite its warming colours, you rarely see heliodor jewellery, as other yellow-green gemstones of greater intensity are more in demand.

EMERALD

When James Sowerby, a renowned mineralogist and collector, saw these stones in the early 1800s, he described them as the 'pride of the collection' (below is just one example). The rich deep green colour is typical of emeralds from Colombia, long known as one of the finest sources of gem-quality emeralds in the world. They are so fine in fact, they became a prime target for the invading Spanish in the sixteenth century. The indigenous Muzo indians fiercely defended the secret of the gems' source, but eventually the Spanish won, and once samples were sent back to Europe, their popularity was sealed. Even today, a good emerald can cost more than a good diamond. These came from a private collector, possibly the Rt Hon Charles Greville, in 1810. Greville's mineral collection was of huge importance. Although the Natural History Museum was formed partly from the vast collection of Sir Hans Sloane, it contained few minerals, and most of them were carved objects. It was Greville's collection that formed the real basis of the mineralogy collection here, some 14,800 specimens. A special sum of money was given by Parliament for its acquisition.

TOURMALINE

This gorgeous gemstone is also known as
watermelon tourmaline because if you cut
a slice across the crystal it resembles a slice
of the fruit. The original stone was found
in the Minas Gerais region of southeast
Brazil. It has been facetted by a skilled gem
cutter to show the dramatic junction
between the two colours of the original
crystal. Tourmaline comes in about 10
different colours and is found in crystal-
lined pockets deep underground. These
pockets are sometimes disturbed by mining
or natural forces in the Earth's crust, which
can cause the crystals to break up and
so it is not so common for crystals to
survive intact.

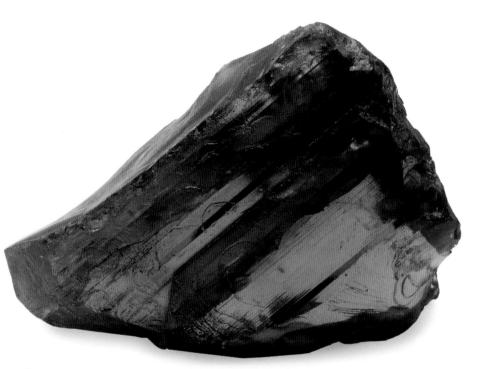

PERIDOT

These are exceptional examples of both the raw material and cut gem of the mineral peridot, from a tiny island in the Red Sea known as Zabargad, Arabic for peridot. The beautiful olive-sized gem is flawless and was bought by the Museum in 1932; and the rich-green, rough crystal of gem-quality olivine is one of the largest ever found, weighing 686 carats. Zabargad is an unlikely treasure trove, a barren desert with no fresh water and only a few sparse shrubs. But it has produced the finest olivine crystals in the world. The deep green stone has lured people there for thousands of years – Egyptian pharaohs sent their gem cutters to collect them, and carved specimens are known dating from the ancient Greeks. Tiny shards of olivine can be so numerous on the island's beaches, they appear green. Over hundreds of years, Zabargad has been lost and rediscovered by different civilisations many times. At one time it was fiercely defended by the ancient Egyptians, at another it was ruled by pirates. More recently it has been mined by private Western companies.

RUIN MARBLE

Ruin marble has a hidden secret – when cut and polished an eerie decaying city-scape appears on its surface. This brick-sized slab from the premier deposit in Tuscany looks like crumbling towers, houses and spires set against a murky sky, but it's not the work of an artist. It was formed underground, where natural light and dark components in the stone have by chance formed an image.

Despite its name, ruin marble isn't a marble at all, but a very fine-grained limestone. Recent research on deposits in Slovakia has revealed how the coloured pattern forms. Water percolating through the rock causes iron compounds to be precipitated out in rhythmic bands. This would have simply coloured the entire rock in parallel bands were it not for numerous, very fine, straight joints. These joints are non-porous, so the water cannot pass through, and each area in-between is coloured individually. When polished, these patterns come to the fore.

BLUE-JOHN VASE

Almost one metre tall, this urn is one of
the biggest ever made from a variety of
the mineral fluorite known as blue-john.
It is made of at least seven pieces, and was
created around 1860 for the Duke of
Devonshire. To sculpt the blue-john into
such a smooth, round shape would have
taken great skill, and generated a
substantial bill. The Duke, however,
decided not to buy it and it was
purchased by a Mr S. Addington
who presented it to the Museum
of Practical Geology in January
1868. This became the Geological
Museum which merged in 1985 with
the British Museum (Natural History).
Fluorite comes in a variety of colours
typical for each area – pink in the Alps
and blue in Illinois. The rippled bands
of blue/purple and yellow/white fluorite
are unique to north Derbyshire, UK.
The name blue-john may be derived
from the French bleu jaune meaning blue
yellow, refering to the bands of colour.
Another possibility is that it was a
nickname given by the miners who dug
for it, inspired by black jack, their name
for the zinc mineral sphalerite.

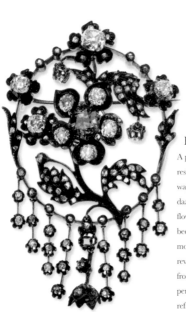

DIAMOND FLOWER BROOCH

A pretty cluster of diamonds is hard to resist, and this fantastic example shows one way the Victorians made the most of these dazzling stones. The diamond-encrusted flower with a sapphire at its centre has been set on a small spring. As the wearer moves, the diamond cluster trembles, revealing flashes of coloured light or 'fire' from within. The coronet settings on the pendants allow light to pass into, and be reflected from, the diamonds, and the pendants themselves move, creating brilliant flashes of light with each turn. This style of jewellery, particularly with designs of insects or flowers, was popular at the end of the nineteenth and beginning of the twentieth century.

DIAMOND SPIKES

Diamonds and a sapphire set in silver and gold make up this exceptional ornament, a marriage of parts from different jewels dating from the late nineteenth century. It has been specially designed to allow the wearer to enjoy it in as many ways as they like, with a fitting on the reverse allowing it to dazzle as a hairpin, brooch or pendant.

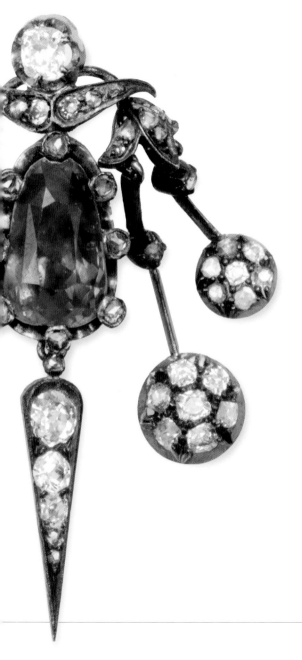

DIAMOND BUTTERFLY HAIRPIN

The Museum looks after only a few pieces of jewellery, among them this lovely little butterfly. It is covered in dozens of tiny diamonds set in silver to make them appear bigger, brighter and thus more desirable. Not much is known about its history, but we do know it was made in western Europe around 1830. The records show a Mrs E Warne gave it to the Museum in 1912.

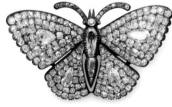

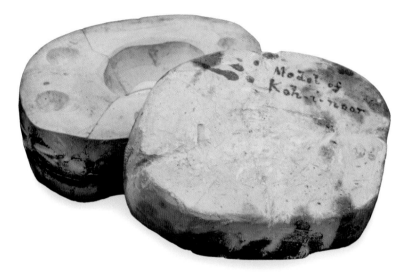

Cutting the Koh-i-Noor

These plaster moulds and casts record the original shape of the Koh-i-Noor diamond, arguably the most famous gemstone in the world. The gemstone came to England after it was claimed by the British at the end of the Sikh wars in 1846. But its Mogul-style cut was not brilliant enough to western eyes, so Queen Victoria's husband Prince Albert demanded it was re-cut. These casts and moulds were made in 1851 before the recutting, a process that dramatically reduced the stone's size, but supposedly increased its dazzling qualities. The replicas allow us to see how the diamond would have looked before it was cut and how it looks now in the Crown jewels, set in the late Queen Mother's crown.

Its history goes back many hundreds of years. It has passed between the rulers of what are now India, Iraq, Afghanistan and Pakistan, through treachery, bloodshed and political agreement, but never by purchase. Legend has it the Koh-i-Noor brings bad luck to all men who own it, and that only women can wear it safely.

DIAMOND IN PEBBLE

This rock with a pea-sized diamond embedded in it was once owned by the social critic and author John Ruskin. But its importance is probably best confirmed by the fact that it was exhibited at the Great Exhibition in London in 1851. The event was the first of its kind, organised by Prince Albert in Hyde Park to celebrate the best in international industrial technology and design. James Tennant, Queen Victoria's mineralogist at the time, exhibited the specimen, which comes from India. Silt-laden river waters smoothed and rounded the pebble, while the shape of the much harder diamond was preserved and attached to the pebble by a rim of brown ironstone. It eventually came to the Museum in 1923 and is speckled with gold.

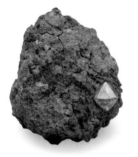

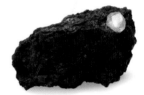

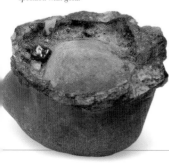

DIAMOND CRYSTALS

These crystals are very rare survivors of the South African diamond rush in the late nineteenth century. Previously, diamonds had only been found in rivers, but once the source deposits were found in rock, prospectors from around the world came to find their fortune. Thousands of people flooded into the country, so for these stones not to have been cut and sold as gems is surprising. The diamond directly above is still embedded in its original 'yellow ground', the weathered top layer of kimberlite rock. The size of the nail on your index finger, it was found in the Colesberg Kopje mine (later the famous Kimberley mine) and came to the Museum in 1872, only a couple of years after the deposit was discovered. The slightly smaller crystal (above) was found two years later, from unweathered deposits deeper in the mine known as 'blue ground'. The mine eventually closed in 1914, by which time it was more than one kilometre deep.

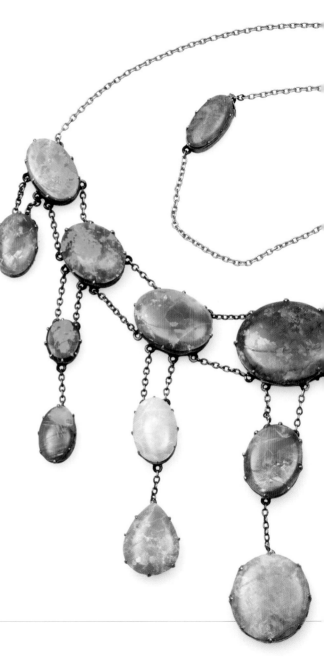

OPAL NECKLACE

This beautiful and dramatic necklace
is made even more stunning when you
consider it can take tonnes of rock to find
just one opal, and that it is rare to find
two cut opals that are alike. It is therefore
some feat to have matched the stones so
precisely. These stones were individually
selected by Guy Dollman, who worked in
the Museum's then Zoology Department
between 1907 and 1942. And the task
was a labour of love, a gift for his wife,
Violet. The necklace was eventually
given to the Museum in 1958.

The boulder opposite is an example of
the rock in its natural form. This one has
been split open to reveal the shimmering
opal inside.

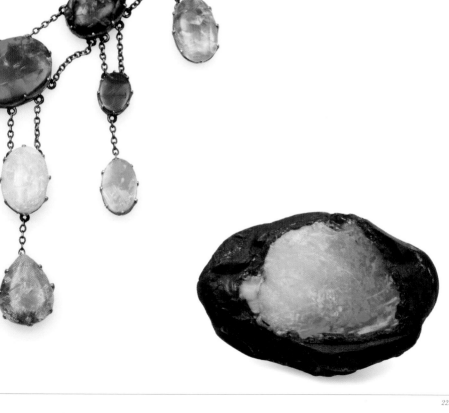

BLACK OPAL

Ever since it was discovered, precious opal, with its ever-changing rainbow of colours, has attracted collectors. And black opal, as opposed to the white variety, has the greatest appeal. This 131-carat black opal was found in the Lightning Ridge area of New South Wales, Australia, which is now regarded as the black opal capital of the world. Opal is composed of millions of tiny amorphous spheres of silicon. These spheres are in places regularly stacked together and where this happens they act like a three-dimensional diffraction grating, giving flashes of rainbow colours of light. Where the spheres are random, they appear dark.

CURSED AMETHYST

When the then Mineralogy Department received this amethyst ornament in 1943 they found a note inside the box: 'this stone is trebly accursed and is stained with the blood, and the dishonour of everyone who has ever owned it'. The supposed curse is as much a part of the stone's history as its chemical make-up. Allegedly looted during the Indian Mutiny in 1857, the amethyst was supposedly brought to the UK by a cavalryman. And so began, according to Edward Heron-Allen's story, the legacy of the curse: both the cavalryman and his son suffered terrible bad health and bad fortune, and a family friend who looked after the stone for a short while then committed suicide. It was passed to Heron-Allen himself in 1890 who, despite being an acclaimed scientist, also reported to then suffer constant misfortunes. He lent it to a friend who became 'overwhelmed by every possible disaster' and another, a singer, whose voice became 'dead and gone'. Heron-Allen was so convinced of the stone's curse, he had it bound in silver marked with protective charms, and even threw it away into the Regent's Canal in London. But someone found it and gave it back. In despair, and for fear the stone might harm his baby daughter, Heron-Allen bound it in seven boxes and shipped it to his bankers, where it stayed until he died in 1943. He left it to the Museum in his will.

BUTTERSCOTCH WULFENITE

This specimen (opposite) is a beautiful example of the mineral wulfenite, rarely found in crystals this large. The spectacular plate of undamaged, butterscotch-coloured crystals was found in 1958 in the Glove Mine, Arizona, USA. Wulfenite is a lead mineral found across the world, mainly as tiny crystals – the Glove mine is one of the few places to produce large ones. Indeed, the wulfenite was so abundant here it was mined as an ore of both lead and the more valuable molybdenum (used in special steels). Harry J Olson, who first explored the mine in the 1950s, was amazed by what he saw, saying, 'The back of the dome was a solid encrustation of golden coloured crystals which brought forth such a cry of delight and surprise from me … that the mine superintendent came charging down the passageway immediately thinking that I had had an accident.'

Collecting specimens as large as this is incredibly difficult as they easily shatter. This piece was bought by the Museum in 2005 at the Tucson Mineral Show in Arizona and is particularly special as the Glove mine is now closed.

TOPAZ

If size was everything, this topaz would be the best gemstone in the collection. It is the largest cut gem at the Museum, a staggering 2,982 carats and the size of a fist. Topaz often occurs as big crystals, from which large, flawless gemstones can be cut, and this one is from Minas Gerais in Brazil, where most of the world's topaz is mined. It took many months of planning and special equipment to produce this super-sized gem. Pure topaz is colourless, but minor impurities and defects can make it blue, green and every shade of yellow and orange.

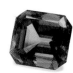

IMPERIAL TOPAZ

Imperial topaz is highly sought due to its colour. This crystal (below) was found in 1852 in one of the oldest mines in the southeastern Ouro Preto region of Brazil. Examples this size (over 10 centimetres long) are very rare. The flawless 96-carat gemstone (above) is a beautiful example of how the original material can be cut into magnificent gems, with the cut highlighting its warm, sherry-coloured glow.

THE EMPEROR'S SPINEL

This spectacular spinel is an impressive 519 carats and it was originally found in Ava, Burma. Before the end of the eighteenth century, eastern jewellers rarely cut stones. Instead they tended to polish them to show off their colour and clarity, both remarkable in this example. It was once owned by Chinese emperors and would have been considered a palace treasure because of its large clear gem areas. In 1860 it was then taken by British forces when they destroyed the Chinese emperor's summer palace in retaliation for the killing of British diplomats.

Spinels have often been confused with rubies, but though they have a similar composition and are often found together, they are different minerals with different properties.

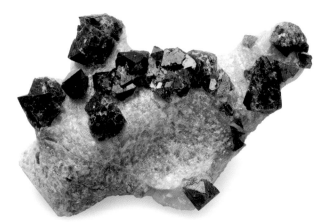

A RECENT SPINEL SPECIMEN

Normally, spinel crystals are hidden inside marble, but in this excellent example the rock has been chipped and etched away to reveal the well-defined crystals. It was bought in 2006, not only because it's a great specimen but also because it comes from one of the newest sources of spinel, Vietnam, only discovered in 1980. This is the first Vietnamese spinel bought by the Museum, and it joins others from well-known sources in Thailand, Afghanistan and the former Soviet Union. The collection is continually being added to, to make it as comprehensive as possible.

LATROBE NUGGET

There are bigger gold nuggets than this, but few have such exceptionally well-defined crystals. Gold, weathered from its parent rock, tends to be carried away by fast-flowing rivers or flash floods and, as it is a soft metal, is generally worn smooth and rounded by the action of water and sediment over time. This specimen, found in Australia's McIvor mine in 1853, has not been affected in this way and is formed entirely of cubes, some more than a centimetre across. A small impurity of copper gives it its particularly rich colour. The nugget, which weighs 717 grammes, was named after the Governor of the State of Victoria, Charles Joseph Latrobe, who was apparently visiting the mine when it was found. Gold most commonly occurs as small grains or dust, much less often as large nuggets. Gold recovered from rivers is known as alluvial and has traditionally been collected by panning. It is a laborious process, but the demand for gold is constant, and not just for jewellery. It is an excellent conductor of electricity, and tonnes of it are used each year for electronic contacts in anything from washing machines to spacecraft.

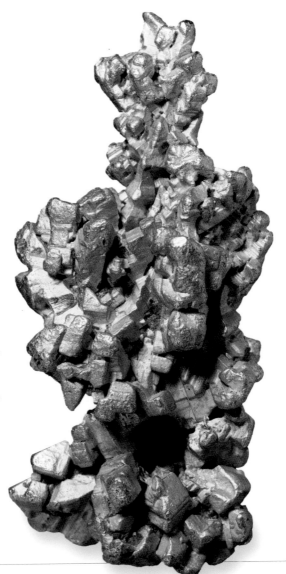

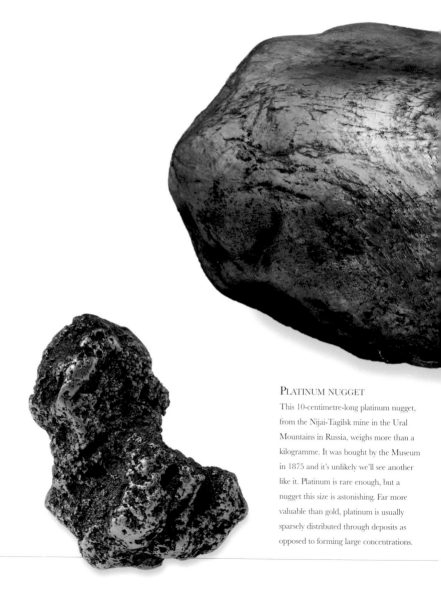

PLATINUM NUGGET

This 10-centimetre-long platinum nugget, from the Nijai-Tagilsk mine in the Ural Mountains in Russia, weighs more than a kilogramme. It was bought by the Museum in 1875 and it's unlikely we'll see another like it. Platinum is rare enough, but a nugget this size is astonishing. Far more valuable than gold, platinum is usually sparsely distributed through deposits as opposed to forming large concentrations.

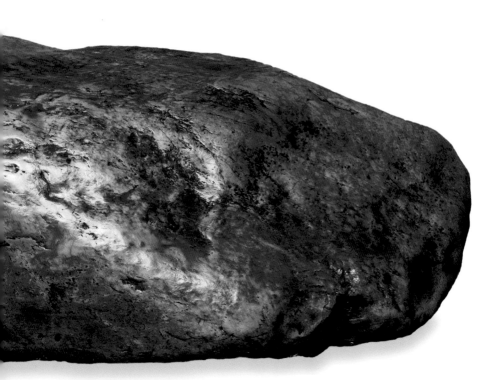

JADE

More than a metre across, this block of jade is extremely large, though specimens 50 times bigger are known. It weighs over half a tonne and was found in the southern Siberian town of Irkutsk. The name jade comes from the Spanish *piedra de ijada*, meaning loin stone, as it was once thought to cure ailments of the loin and kidneys. Jade is generally thought of as a gemstone, a mineral which when cut and polished is desired for its beauty and rarity. Most jade is a rich green, but it can also be white and lilac. It is extremely durable and the material of choice for many carvers in the Far East. In China especially, it has been used for millennia to make weapons, tools, as currency, jewellery and for carving into ornaments. There are even jade musical instruments, as blocks of it, when struck, resonate with musical sounds.

THE MURCHISON SNUFFBOX

This amazing snuffbox, made of gold (*see* base of the box above) and studded with diamonds, is one of the few worked items in the mineralogy collection. It was given to Sir Roderick Impey Murchison, the Director General of the British Geological Survey, by the Russian Tsar Alexander II in 1867. The generous gift was a thank you for Murchison's work in creating the first geological map of the Ural Mountains in Russia, in 1841. He had identified Russia's rich mineral deposits – still a source of great potential wealth for the country. Murchison left the box in his will to the Museum of Practical Geology, later the Geological Museum, and it was then part of the collections which came to the Natural History Museum in 1985. It is decorated with silver openwork of rose stems and leaves, with dozens of tiny diamonds. Sixteen large, old, brilliant-cut diamonds, some of which are almost a centimetre across and weigh up to 2.5 carats, are set around the edge. In the centre, framed by even more diamonds, is a miniature portrait, enamelled on copper, of Alexander II himself, should anyone forget where the box came from.

THE HOPE CHRYSOBERYL

This glittering 45-carat chrysoberyl gemstone from Brazil has been known among gemmologists for about 170 years and described as 'absolutely flawless… probably by far the finest cut example of this type of chrysoberyl known'. The size of a peach stone, it once belonged to Henry Philip Hope, who also owned the cursed deep-blue Hope diamond, now in the Smithsonian Institution in America. Hope bought the uncut chrysoberyl for £250 and had it cut to produce this gem. Chrysoberyl is a rare mineral and, with its hardness, makes a good gemstone. Made up of oxygen, beryllium and aluminium, its name is from the Greek chrysos meaning gold, but its colour ranges from yellowish green to pale brown, depending on how much of the aluminium is replaced by iron when it formed – the more iron, the darker the stone. Two other striking varieties of chrysoberyl can occur. One is alexandrite (*see* opposite) and the other is cat's-eye chrysoberyl, so named because in direct illumination it reflects light in a band across it, resembling a cat's eye. The band is caused by parallel needle-like impurities, often of the mineral rutile.

ALEXANDRITE

This unusual gem material was first discovered in 1834, by miners in the Tokovaya mines of central Russia. It has the strange ability to change colour under different light. In daylight it looks a deep green but at night, under candlelight, it becomes a rich purple-red. This is because, like many gemstones, it gets its colour from absorbing and reflecting different parts of the colour spectrum, which spans violet, blue, through green and yellow, then red. In daylight, it absorbs a broad section of the yellow area, and so the colours it reflects are green, giving it a green appearance. But in candlelight, which is deficient in blue light, it appears red.

The stones caused a sensation, especially because red and green were the country's imperial colours, and the new gem was named in honour of Tsar Alexander II.

This group of crystals (above) is one of the finest known from this deposit. Alexandrite has also been found in other areas and this cut stone (right) is from Sri Lanka. At 27 carats it is incredibly large considering gem-quality stones of more than two to three carats are rare.

The Wellington tree cupboard

This may appear to be an ordinary cupboard, filled with mineral specimens, but it has famous connections. The cupboard was made from an elm tree that sheltered the Duke of Wellington during the Battle of Waterloo, in Belgium. The British army leader defeated Napoleon on 18 June 1815, and this bestowed on the tree a historical relevance. So many people came to pay homage to the tree in the years immediately after the battle, that its bark was entirely stripped off by souvenir hunters and chunks were cut out of it and the farmer's crops were trampled underfoot over and over again. It was by chance that in September 1818 entomologist Mr J G Children visited the battered tree just as it was being cut down. Knowing its history he decided to buy the wood and commissioned three chairs to be carved from it. One of the chairs was given to King George IV at Windsor Castle, another to the Duke of Rutland and the third to the Duke of Wellington himself. One last chunk was used to make this cupboard which was then given to the British Museum and so later inherited by its offshoot, the Natural History Museum – then British Museum (Natural History). There is an iron chain embedded in the wood which was probably originally tied around the sapling, but later the tree grew over it.

GONIOMETER

This is one of the first instruments that allowed mineralogists to work out the shape of crystals as tiny as grains of sand. It is an advanced model, made in 1892, and works by measuring the angles between different faces of the crystal. By knowing the angles, the shape and symmetry of the crystal can be worked out, and from that what it is. While this instrument is beautifully intricate, the first goniometers were basic protractors that could only measure crystals big enough to hold in the hand. The breakthrough came in 1809, when naturalist William Hyde Wollaston devised a way to measure tiny crystals using light. Each crystal was held on a fibre and slowly rotated through a focused beam, using a graduated wheel. The light came through the tube on the right and was reflected into the magnifier on the left. When the reflection from a point on one face was seen at the same point on the next, the angle the wheel had turned, and hence the angle between the two faces, was read. The method started becoming obsolete in 1912 when X-rays were shown to be able to reveal a crystal's internal structure at a touch of a button.

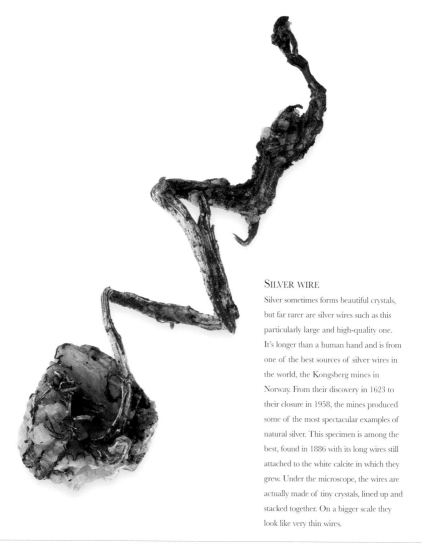

SILVER WIRE

Silver sometimes forms beautiful crystals, but far rarer are silver wires such as this particularly large and high-quality one. It's longer than a human hand and is from one of the best sources of silver wires in the world, the Kongsberg mines in Norway. From their discovery in 1623 to their closure in 1958, the mines produced some of the most spectacular examples of natural silver. This specimen is among the best, found in 1886 with its long wires still attached to the white calcite in which they grew. Under the microscope, the wires are actually made of tiny crystals, lined up and stacked together. On a bigger scale they look like very thin wires.

COPPER MASS

It is not just rare metals that are prized; this unusual copper specimen is treasured because it has survived being melted down and because it has a story to tell. The block was the first piece of copper found within the Arctic Circle. In 1771, explorer Samuel Hearne was sent by the Hudson's Bay Company to search for mineral deposits, which had been described by the local Dene people. Hearne was the first European to explore the area on foot, a long and gruelling expedition that took him across the barren lands of northern Canada and the Arctic Circle. But, having found this specimen, which weighs nearly 3 kilogrammes, and been convinced there was more copper to find, he carried it for a full year as he finished his trek. On his return, he presented it to the Hudson's Bay Company, who gave it to the Museum in 1818. Few large masses of copper survive as they are usually melted down, but thanks to Hearne's huge efforts, this was preserved for posterity.

NATURALIS HISTORIA
355pp. this edn 1469
Pliny the Elder; p.14

THE PLUKENET COLLECTION
1,700 pressed insects glued into a book, 1690
Leonard Plukenet; p.15

METAMORPHOSIS INSECTORUM
SURINAMENSIUM
Hand-coloured plate: spectacled caiman (*Caiman crocodilus*) and red pipe snake (*Anilius scytale*), 1719
Maria Sibylla Merian; p.16

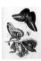

METAMORPHOSIS INSECTORUM
SURINAMENSIUM
Hand-coloured plate: owl butterfly (*Caligo idomeneus*),
silkmoth larvae, wasp, plant (*Pachystachys coccinea*), 1719
Maria Sibylla Merian; p.17

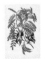

PARROT'S BILL PLANT
Watercolour of *Clianthus puniceus*, 525x350mm, 1775
Sydney Parkinson; p.18

GEORG EHRET ARTWORK
Watercolour and pencil sketch of rare fruits and seeds,
425x275mm, 1748 Georg Ehret; p.19

PORTRAIT OF BALLODERREE
Watercolour, 287x215mm, c.1788–1797
Port Jackson Painter; p.20

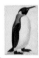

KING PENGUIN
Watercolour of *Aptenodytes patagonicus*, 530x369mm, 1775
Georg Forster; p.21

AMERICAN LOTUS AND VENUS FLY-TRAP
Black ink drawing of *Nelumbo lutea* and *Dionaea*
muscipula, 398x300mm, 1767
William Bartram; p.22

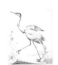

FLORIDA SANDHILL CRANE
Black ink and watercolour of *Grus canadensis pratensis*,
270x220mm; 1774
William Bartram; p.23

SEA DRAGONS
Watercolour of *Phyllopteryx taeniolatus*, 502x355mm, 1801
Ferdinand Bauer; p.24

BEE ORCHID
Watercolour of *Ophrys apifera*, 380x265mm, 1800
Franz Bauer; p.25

INVITATION AND MENU
Invitation, black ink on paper, 178x127mm; menu,
blue ink printed on paper, 143x225mm; both 1853
Benjamin Waterhouse Hawkins; p.26

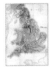

FIRST GEOLOGICAL MAP
Hand-coloured printed map, 2645x1890mm, 1815
William Smith; p.27

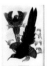

BLACK SICKLEBILL
Hand-coloured lithograph of *Epimachus fastuosus*,
550x370mm, 1875–1888
John Gould; p.28

GOULD ARTWORK
Hand-coloured lithographs from 3 of Gould's
published works, 550x370mm, mid-19th century
John Gould; p.29

ON THE ORIGIN OF SPECIES
First Japanese edition, Tokyo,1914
Handwritten notes for book, 330x210mm, 1859
Charles Darwin; pp.36–37

OLD MAN BANKSIA AND ARTWORK OF BANKSIA
Banksia serrata, sheet size 440x280mm; artwork based
on a drawing by Sydney Parkinson
Australia; pp.44–45

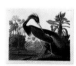

TRICOLORED HERON, *THE BIRDS OF AMERICA*
Hand-coloured engraving of *Egretta tricolor*, 1834
John James Audubon; p.30

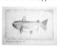

FISH OF THE RIO NEGRO RIVER
Pencil, 180x230mm, 1848–1852
Alfred Russel Wallace; p.39

ST HELENA BOXWOOD
Mellissia begonifolia
St Helena, Atlantic Ocean; p.46

MARGARET FOUNTAINE'S NOTEBOOK
Watercolour, 224x139mm, 1926
Margaret Fountaine; p.32

FISH OF THE RIO NEGRO RIVER
Pencil, 180x230mm, 1848–1853
Alfred Russel Wallace; p.39

SIKKIM RHUBARB
Rheum nobile
Tibet; p.47

BLUE AND YELLOW MACAW
Hand-coloured lithograph of *Ara ararauna*,
550x370mm, 1832
Edward Lear; p.33

KATHLEEN SCOTT'S LETTER
Ink on paper, 3pp., 227x176mm, 1913
Kathleen Scott; p.40

PLANT FROM MEXICO
Lacandonia schismatica
Mexico; p.48–49

HENRY BATES'S NOTEBOOKS
Notes in ink and pencil with watercolour illustrations,
1851–1859
Henry Walter Bates; pp.34–35

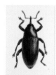

MARK RUSSELL WEEVIL
Acrylic, *Baris cuprirostris*, 360x500mm, 1998
Mark Russell; p.41

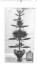

CLIFFORD HERBARIUM LION'S TAIL
Leonotis leonurus, sheet size 390x210mm
Cultivated Netherlands, 1730s; p.50

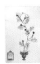

CLIFFORD HERBARIUM CARDINAL CREEPER
Ipomoea quamoclit, sheet size 430x280mm
Cultivated Netherlands, 1730s; p.51

PRESSED SEAWEED BOOK
Various seaweeds, sheet size 550x760mm
Jersey; pp.52–53

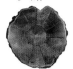

GIANT SEQUOIA
Sequoiadendron giganteum
Sierra Nevada, California; pp.54–55

AURICULAS AND TULIPS
Primula auricula and *Tulipa*, 14 vols. pressed plants
Vol. size 560x420mm
Early 1700s, vol. size 560x420mm; pp.56–57

VEGETABLE LAMB OF TARTARY
Cibotium barometz
China, 1698; p.58

HERMANN HERBARIUM
Pressed Plants of Sri Lanka
Vol. size 530x390mm, 1670s; p.59

SLOANE'S HERBARIUM COCOA PLANT
AND ARTWORK
Theobroma cacao, vol. size 540x430mm
Drawing by Everhardus Kickius, specimen collected by
Sloane, Jamaica, 1687–1689; pp.60–61

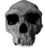

RHODESIAN MAN SKULL
Homo heidelbergensis or *Homo rhodesiensis*, 24cm
Broken Hill, Zambia; p.64

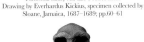

PILTDOWN 'CRICKET BAT'
41cm
Sussex, England; p.65

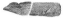

PILTDOWN JAW
13cm
Sussex, England; p.65

ICHTHYOSAUR SKULL
Temnodontosaurus platyodon, 1m long
Lyme Regis, England; p.66

FOSSIL LEAF
Glossopteris indica, field of view 3cm
Buckley Island, Beardmore Glacier, Antarctica; p.67

FOSSIL WOOD
27cm long
Priestly Glacier, Antarctica; p.67

OPALISED SNAILS AND CLAM
Clam 5cm long, largest snail 2.5cm across
Coober Pedy, South Australia; p.68

LARVAL AMPHIBIAN
Apateon pedestris, 7cm long
Germany; p.69

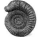

WHITBY SNAKESTONE AMMONITE
Dactylioceras commune, 50mm across
Whitby, Yorkshire; p.70

NACREOUS AMMONITE
Psiloceras planorbis, largest 55mm across
Somerset, England; p.71

SEA LILY
Sagenocrinus expansus, 6cm long
West Midlands, England; p.72

SEA LILY
Seirocrinus subangularis, 1.3m tall
Germany; p.73

IGUANODON TEETH
Iguanodon sp., tooth crowns 4 and 5cm long
Lewes, England; p.74

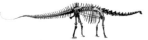

DIPLODOCUS SKELETON
Diplodocus, 26m long
Wyoming, USA; pp.74–75

ARCHAEOPTERYX
Archaeopteryx lithographica, wingspan 60cm
Southern Germany, p.76

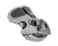

PROTOCERATOPS SKULL
Protoceratops, 50cm long
Mongolia; p.77

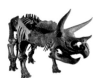

TRICERATOPS
Triceratops, 6m long
Montana, USA; pp.78–79

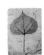

FOSSIL LEAF
Populus latior, 11cm wide
Ohningen, Germany; p.80

BLUE-GREEN ALGA (CYANOBACTERIUM)
Primaeviflum amoenum, filament 4μm thick
Marble Bar, Western Australia; p.81

JAR OF DEEP SEA OOZE
Globigerina, height 12.5cm
HMS *Challenger*, 2,600m depth, SE Pacific Ocean; p.82

SPECIMENS FROM HMS *CHALLENGER*
Cabinet 10x27x22cm, reports 33x26cm
Various deep-sea locations; pp.82–83

PETRIFIED PALM
Palmoxylon sp., log 60cm long
Egypt, North Africa; p.84

PEA POD
Prosopis linearifolia, pod 6cm long
Florissant, Colorado, North America; p.85

SHIPWORM BORINGS IN FOSSIL WOOD
Teredo sp., log 16cm across
Isle of Sheppey, Kent, England; p.86

SLIPPER LIMPETS
Crepidula gregaria, stack 6cm high
Santa Cruz, Patagonia, Chile; p.87

FAKE RODENT SKELETON
p.88

MYSTERY TRACE FOSSIL
Dinocochlea ingens, 3m long
Hastings, East Sussex, England; pp.88–89

FOSSILISED SQUID
Belemnotheutis antiquus, 250mm long
Wiltshire, England; pp.90–91

BARYONYX CLAW
Baryonyx walkeri, 31cm round outside curve
Surrey, England; p.92

MAMMAL-LIKE REPTILE SKULL
Cynognathus crateronotus, 40cm long
South Africa; p.93

FISH DAPEDIUM
Dapedium, 30cm
Lyme Regis, England; p.94

GOGO FISH
Eastmanosteus, 16cm
Gogo, Australia; p.95

WOOLLY RHINO TOOTH
p.96

PORTRAIT OF SIR RICHARD OWEN
p.97

SLIDES OF FORAMINIFERA
Various species, each slide 7.5cm long
Various locations; p.98

WOODWARD TABLECLOTH
1m square; p.99

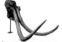

MAMMOTH SKULL
Mammuthus trogontherii, 2.5m long
Ilford, England; pp.100–101

ELEPHANT AND PYGMY ELEPHANT TEETH
Elephant tooth 40cm long, Clacton, UK
Pygmy elephant tooth, 12cm long, Cyprus; p.102

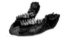

MASTODON JAW
Mammut americanum, 75cm long
Missouri, North America; p.103

FOSSIL INSECT
Rhynognatha hirsti, 1mm long
Aberdeenshire, Scotland; p.104

INSECT IN BALTIC AMBER
Corydasialis inexpectatus, 2cm long
Southeastern shore, Baltic Sea; p.105

GLYPTODON
Glyptodon claipes, 3m long
pp.106–107

OLDEST FOSSIL CRAB
Eocarcinus sp., 3cm long
Gloucestershire, England; p.108

FOSSIL HORSESHOE CRAB
Mesolimulus, 40cm long
Solenhofen, Germany; p.109

TRILOBITE
Erbenochile erbeni, 4cm long
Atlas Mountains, Morocco; p.110

VICTORIAN TRILOBITE BROOCH
Calymene blumenbachii, 8cm long
West Midlands, England; p.111

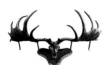

GIANT DEER ANTLERS
Megaloceros giganteus, 3.5m wide
Ireland; pp.112–113

LEMUR SKULLS
Megaladapis sp., 32cm long;
mouse lemur skull 34mm long
Madagascar; p.114

SLOTH SKIN
Chile; p.115

GROUND SLOTH LOWER JAW
Mylodon darwinii
Argentina; p.115

GLASS SPONGE
Calyptrella tenuissima, 30x25mm
Hanover, Germany; p.116

COCOLITHOPHORE
Calcidiscus quadriperforatus; combination coccosphere
with coccoliths from 2 life-cycle stages, 0.016mm wide
Alboran Sea, W. Mediterranean; p.117

EXOTIC INSECTS
Orthoptera, Hemiptera, Coleoptera and *Hymenoptera*
Indonesia and Malaysia; p.120

WALLACE'S GOLDEN BIRDWING BUTTERFLY
Ornithoptera croesus, 14cm
Moluccan Islands, Indonesia; pp.120-121

ORCHID BEES
Subfamily Euglossini, up to 3.5cm
South and Central America; pp.122-123

FLYING DEER STAG BEETLE
Chiasognathus granti, 8cm
Chile and Argentina; p.124

SIR JOHN LUBBOCK'S PET WASP
Polistes biglumis, 2cm
Europe; p.125

NEST OF A COMMON WASP
Vespula vulgaris
Europe; pp.126-127

ANTLERED FLIES
Phytalmia cervicornis, P. alcicornis, P. biamarta; 1.5cm
Papua New Guinea; p.128

STALK-EYED FLY
Achias rothschildi; 3.5cm wide
Papua New Guinea; p.129

'DRESSED' HUMAN FLEAS
Pulex irritans, 1cm
Mexico; p.129

CAPE STAG BEETLE
Colophon primosi, 2.5cm
Western Cape Province, South Africa; p.130

BOWMAN'S STAG BEETLE COLLECTION
Worldwide; p.131

WINGLESS FLY
Mormotomyia hirsuta, 1cm long
Kenya; p.132

WORLD'S LARGEST FLY
Gauromydas heros, 6cm long
Brazil; p.132

SPHINX MOTH
Xanthopan morganii praedicta, 30–35cm tongue
Madagascar; p.133

BEDFORD-RUSSELL'S TREE-NYMPH
Idea tambusisiana, 14cm
Indonesia; p.134

GROUND BEETLE
Ceroglossus darwinii, 2.5cm
Chile; p.135

WEEVIL RING
Tetrasothynus regalis, ring 1.5cm; beetle 8mm
West Indies; p.135

BANKS' INSECT COLLECTION
Lepidoptera: *Peridae*, more than 4,000 insects in total
From the 18th-century voyages of discovery;
pp.136-137

TAILED WAX BUG
Alaruasa violacea, bug 3cm long, wax-tail 7.5cm long
South America; p.138

PEANUT HEAD BUG
Fulgora laternaria, 14cm wingspan
Central and South America; p.138

SILVER CHAFER BEETLE
Chrysina limbata, 2.5cm long
Costa Rica; p.139

CHALMERS-HUNT COLLECTION
Collection of historic entomological collecting
equipment pp.140-141

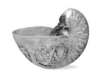

SLOANE'S NAUTILUS SHELL
Nautilus pompilius
Philippines; pp.144–145

BROWN JACK
Racehorse; pp.146–147

MICK THE MILLER
Greyhound; p.147

BARBARY LION SKULL
Western north Africa; p.148

CAPE LION
Southern tip of South Africa; p.149

JAPANESE WOLF
Houshu, Japan; p.150

ELEPHANT BIRD EGG
Aepyornis maximus; p.151

MARION'S TORTOISE
Aldabrachelys gigantea (sumeirei), 97cm shell length
Farquhar atoll, Indian Ocean (died on Mauritius);
p.152–153

PASSENGER PIGEON
Ectopistes migratorius
Eastern North America; p.154

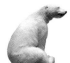

POLAR BEAR
p.155

OKAPI HIDE
Okapia johnstoni; p.156

TASMANIAN TIGER
Thylacine; pp.156–157

INDIAN WATER BUFFALO HORNS
Bubalus bubalis
Each almost 2m long; p.158

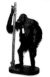

WALLACE'S ORANG UTAN
Pongo pygmaeus
Borneo; p.159

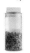

TAPEWORM
Diphyllobothrium polyrugosum, approx. 5m long
Falmouth, Cornwall; p.160

THAMES BOTTLENOSE WHALE
6m long
River Thames, central London, Jan. 2006; pp.160–161

SIX VARIETIES OF DOMESTIC PIGEON
Columba livia (domestic varieties); p.162

'FRILL BACK' DOMESTIC PIGEON
Columba livia (domestic variety)
Labelled by Darwin on sternum; p.162

FLOREANA MOCKINGBIRD
Nesomimus trifasciatus
Floreana Island, Galapagos; p.163

SIX SPECIES OF GALAPAGOS FINCH
*Certhidea olivacea, Geospiza fortis, Camarhynchus psittacula,
G. difficilis, G. scandens, G. magnirostris*
Galapagos Archipelago; p.163

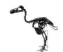

DODO COMPOSITE SKELETON
Raphus cucullatus
Mauritius; p.164

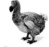

DODO MODEL
Raphus cucullatus
p.165

DUCK-BILLED PLATYPUS
Ornithorhynchus anatinus
Australia; pp.166–167

OWLET FORGERY
Heteroglaux blewitti
Central India; p.167

EMPEROR PENGUIN EGG
Aptenodytes forsteri
Antarctica; p.168

SECTIONS OF AN EMPEROR PENGUIN EMBRYO
Aptenodytes forsteri
Antarctica; p.168

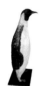

EMPEROR PENGUIN
Aptenodytes forsteri
Antarctica; p.169

CONE AND FIG SHELLS
Conus and *Ficus*, collected on *Endeavour* 1768–1771
Various locations: Brazil, Tahiti, New Zealand,
Australia; p.170

FIRST SHELL BOOK
Philippo Buonanni, 1684; p.171

ZIGZAG NERITE
Neritina waigiensis, largest 17.5x19.5mm
Southwest Pacific; pp.172–173

NEW ZEALAND STORM PETREL
Oceanites maorianus, (originally *Pealeornis maoriana*)
Hauraki Gulf, New Zealand; p.174

HAMILTON'S FROG
Leiopelma hamiltoni, male, 39mm
Stephen Island, New Zealand; p.175

GLOVE
From byssal threads of noble pen shell
Pinna nobilis; 290.5x150mm
Andalusia, Spain; p.176

VENUS COMB SHELL
Murex pecten, 152x64mm
Indo-Pacific; pp.176–177

CUCKOO AND HOST EGGS
Collection of Edgar Percival Chance (1881–1955);
pp.178–179

DISCODERMIA SPONGE
p.180

GIANT SQUID
Architeuthis dux; 8.62m long
Falkland Islands, 2km offshore; p.181

TUATARA
Sphenodon punctatus; 50cm long
New Zealand; p.182

CHINESE MITTEN CRAB
Eriocheir sinensis
River Cray, Kent, 1854; p.183

CHINESE MITTEN CRAB CLAW OR PINCER
Eriocheir sinensis, 22cm long
River Cray, Kent, 1854; p.183

HUMMINGBIRD CASE
pp.184–185

GUY THE GORILLA
Gorilla gorilla (Western lowland gorilla)
240kg; p.192

EGGS OF GUAM RUFOUS FANTAIL AND
GUAM CARDINAL HONEYEATER
Rhipidura rufifrons uraniae and *Myzomela cardinalis saffordi*
Guam Island; p.198

BLUE WHALE
27m long
pp.186–187

ELEPHANT TUSKS
Mount Kilimanjaro, Tanzania; p.193

GREAT AUK
Pinguinis impennis
Papa Westray, Orkney Islands; p.199

BLASCHKA OCTOPUS
Sold as *Philonexus catenulatus* Férussac, 1828. Modelled
on form in Mediterranean and Atlantic, 19cm long,
*c.*1883; p.188

KOMODO DRAGON
Varanus komodoensis, 259cm long
Rintja, near Komodo, Indonesia; pp.194–195

JAWS OF GREAT WHITE SHARK
p.200

BLASCHKA SQUID
Sold as *Onychia platyptera* d'Orbigny, 1834. Modelled
on form in Indian Ocean, 85mm long, *c.* 1883; p.189

EGYPTIAN MUMMIFIED CAT
p.196

CARIBBEAN PIDDOCK
Pholadomya candida, 80x41.5mm
British Virgin Islands; p.201

TINY SNAIL
Opisthostoma mirabile, 4mm
Gomantong, Borneo; p.202

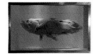

COELACANTH
pp.190–191

RHINOCEROS HORNBILL SKULL
Buceros rhinoceros
Distribution: Malay Peninsula, Sumatra,
Java, Borneo; p.197

GUAM CARDINAL HONEYEATER NEST
Myzomela rubratra saffordi
Guam Island; p.198

CHI-CHI GIANT PANDA
Western China; p.203

SAPPHIRE ORNAMENT
35mm diameter, 31.5 carats
Sir Hans Sloane collection; p.206

BLUE SAPPHIRE SPINDLE-SHAPED
CRYSTAL
30x17x17mm, 87 carats
Sri Lanka; p.206

BLUE SAPPHIRE ROUNDED PEBBLE
42x20x23mm, 233 carats
Sri Lanka; p.207

SAPPHIRE BUDDHA PIN
Buddha 20mm long
Burma (Myanmar), 1842; p.207

PAPARADSCHA
18x18x16mm, 57 carats
Sri Lanka, 1967; p.208

STAR SAPPHIRE
25x18x15mm, 88 carats
Sri Lanka, 1835; p.209

YELLOW SAPPHIRE
30x20x12mm, 101 carats
Sri Lanka; p.209

NATURAL RUBY IN MARBLE
60x45mm
Burma (Myanmar), 1973; p.210

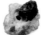

EDWARDES RUBY
34x25x10mm, 162 carats
1887; p.211

NATURAL RUBY CRYSTAL
71x42x21mm, 1,085 carats
Burma (Myanmar), 1924; p.211

IMILAC METEORITE
Stoney-iron meteorite (pallasite), 550x450x9mm
Atacama Desert, Chile, 1822; p.212

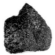

NAKHLA METEORITE
65x65x70mm
Abu Hommos, Egypt, 1911; p.213

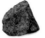

AQUAMARINE
48x65mm, 898 carats
Russia; p.214

MORGANITE
45x45mm, 598 carats
Madagascar, 1913; p.214

THE SUN GIFT HELIODOR
33x20mm, 133 carats
Russia, 1960, p.215

EMERALD
80x63mm
Colombia, 1810; p.215

WATERMELON TOURMALINE
27x19mm
Minas Gerais, Southeast Brazil, 1935, p.216

PERIDOT CRYSTAL AND GEM
Crystal is 60x50x20mm and 686 carats,
gem is 24x24mm and 146 carats
Zabargad, Red Sea, 1924; p.217

RUIN MARBLE
270x110x10mm
Tuscany, Italy; p.218

BLUE-JOHN VASE
1m tall
Derbyshire, England; p.219

DIAMOND FLOWER BROOCH
55x40mm
1850, p.220

DIAMOND AND SAPPHIRE ORNAMENT
Set in silver and gold
38mm in length, late 19th century
Western Europe; p.221

DIAMOND BUTTERFLY HAIRPIN
43mm across
Western Europe, 1830–1840; p.221

REPLICAS OF KOH-I-NOOR DIAMOND
Before and after cutting
p.222

PLASTER MOULD OF KOH-I-NOOR
70x55x44mm
1851; p.222

DIAMOND IN A PEBBLE
55x55x40mm
Golconda, India, 1923; p.223

DIAMOND CRYSTAL
40x37x40mm
Kimberley, South Africa; p.223

DIAMOND CRYSTAL
70x42x40mm
Kimberley, South Africa; p.223

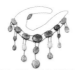

OPAL AND GOLD NECKLACE
Mounted gems 15cm across
1958; pp.224–225

ROCK WITH OPAL
55x35x25mm
Queensland, Australia; p.225

BLACK OPAL
40x40x8mm, 131 carats
New South Wales, Australia, 1949; p.226

CURSED AMETHYST
80mm long
p.227

WULFENITE CRYSTALS
250x250x100mm
Arizona, USA; p.228

TOPAZ
85x65mm, 2,982 carats
Minas Gerais, Southeast Brazil, 1865; p.229

IMPERIAL TOPAZ CRYSTAL
110x30x20mm
Minas Gerais, Southeast Brazil, 1883; p.229

IMPERIAL TOPAZ GEM
23x21mm, 96 carats
Minas Gerais, Southeast Brazil, 1889; p.229

SPINEL CRYSTALS
140x100x100mm
Luc Yen, Vietnam, 2007; p.230

SPINEL
50x50x20mm, 519 carats
Burma (Myanmar), 1862; p.230

LATROBE GOLD NUGGET
120x60x35mm
Victoria, Australia, 1853; p.231

PLATINUM NUGGET
80x50x40mm
Ural Mountains, Russia, 1875; p.232

JADE
More than 1m across, 527kg
Irkutsk, Siberia; pp.232–233

MURCHISON SNUFFBOX
88x62x20mm
1867; pp.234–235

HOPE CHRYSOBERYL
22x20mm, 45 carats
Brazil, 1866; p.236

ALEXANDRITE CRYSTALS
90x120x100mm
Urals, Central Russia, 1841; p.237

ALEXANDRITE CUT STONE
15x15mm, 27 carats
Sri Lanka, 1873; p.237

WELLINGTON ELM TREE CUPBOARD
122x76x47cm
p.238

GONIOMETER
300mm height
1892; pp.238–239

SILVER WIRE
Wire is 150mm long (curved)
Buskerud, Norway, 1886; p.240

COPPER MASS
200x110x70mm, 3kg
Northwest Territories, Canada, 1771; p.241

Unless otherwise stated all measurements given here are
height x width x depth

PICTURE CREDITS
Front cover: greater spearwort, *Ranunculus lingua*; jewel weevil, *Lamprocyphus augustus*; back cover: spurge laurel, *Daphne laureola*; p.40 © Wayland Kennet; p.41 © Mark Russell; p.81 © Bill Schopf. All other images © The Trustees of the Natural History Museum, London.

Every effort has been made to contact and accurately credit all copyright holders. If we have been unsuccessful, we apologise and welcome correction for future editions and reprints.

First published in 2008
ISBN 978 0 565 09235 1

This edition © The Trustees of the Natural History Museum, London, 2017

ISBN 978 0 565 09439 3

Reproduction by Kingpin Media and Saxon Digital Services
Printing by C&C Offset

Treasures was written by Vicky Paterson. Though too numerous to mention by name, we would also like to acknowledge and thank the many Museum staff from the Science and Library departments whose invaluable help made this book possible.